CHINESE ART

BY

STEPHEN W. BUSHELL, C.M.G., B.Sc., M.D.

Member of Council of Royal Asiatic and Royal Numismatic Societies.
Late Physician to H.M. Legation, Peking.

VOLUME I.

WITH 104 ILLUSTRATIONS.

LONDON :
PRINTED FOR HIS MAJESTY'S STATIONERY OFFICE,
BY WYMAN AND SONS, LIMITED, FETTER LANE, E.C.

1904.

To be purchased, either directly or through any Bookseller, from
EYRE AND SPOTTISWOODE, East Harding Street, Fleet Street, E.C.; or
OLIVER AND BOYD, Edinburgh; or
E PONSONBY, 116, Grafton Street, Dublin,
or on personal application
at the Catalogue Stall, Victoria and Albert Museum S.W.

Price One Shilling and Sixpence in Paper Wrapper, or
Two Shillings and Threepence in Cloth.

PREFACE.

The following chapters on Chinese Art have been written in obedience to a request which I had the honour of receiving from the Board of Education to write a handbook on the art and industries of China. In venturing to undertake the task I am anxious, at the outset, to disclaim any pretension to authority on the subject, and to state my position to be merely that of an inquirer. During a residence of some thirty years at Peking I have been a diligent collector of Chinese books relating to antiquities and art industries and tried to gain a desultory knowledge of their scope. There is such a vast amount of Chinese literature on every conceivable subject, of all shades of authenticity, that one of the chief difficulties of the student is that of selection.

The best method for the inquirer seems to be an exact illustration and description of a typical object selected from the museum galleries, with a passing reference to any source of information calculated to throw light upon its origin and association. These have been the lines followed here as far as the brief space assigned to each branch of art has allowed.

Much of the ground is almost new, as the ceramic field is the only one that appears, hitherto, to have attracted investigators in England. On the Continent one general book of light and authority has been published covering more or less the same ground, the graceful sketch entitled L'Art Chinois, *by M. Paléologue, sometime Secretary of Embassy at the French Legation at Peking, which was issued in* 1887, *as one of the excellent series of art books of the* Bibliothèque de l'Enseignement des Beaux-Arts, Paris.

7911. 1000—Wt, 1927. 11/04. Wy. & S. 2459r, A 2

A few words on the writing and pronunciation of Chinese words, addressed to novices in Sinology, may not be out of place here. The Chinese language, it need hardly be said, is monosyllabic, and each word is represented by a separate " character " in the written script. These characters were originally pictures of natural objects or ideas, used singly or in combination, and it was not until later that they were distinguished into two categories, as phonetics, and determinatives or radicals. The radicals in modern use are 214, *a number arbitrarily fixed for dictionary purposes, as a means of classifying the* 20,000 *or more written characters of the language, and of providing a ready means of coining new combinations. The large majority of characters of the modern script are composed of a* radical, *which gives a clue to the meaning by indicating the particular class of things or ideas to which the combination of which it forms a part belongs, and a* phonetic, *which conveys some idea of the sound.*

With regard to pronunciation Sir Thomas Wade's scheme of orthography has been followed. It is the system of transliteration which has been adopted by Professor Giles in his large Chinese Dictionary, *and by Mr. Goodrich in his invaluable* Pocket Dictionary and Peking Syllabary, *and it is now very generally accepted by Chinese scholars.*

The consonants are generally to be pronounced as in English, with the exception of j, *which is nearly the French* j *in* jaune, *the English* s *in* fusion *or* z *in* brazier. *The initials* ch, k, p, t, ts, tz, *are either unaspirated or aspirated. When aspirated, the aspirate which intervenes between them and the vowel following is indicated by an apostrophe in preference to an* h, *lest the English reader should pronounce* ph *as in triumph,* th *as in* month, *and so on. To pronounce* ch'a, *drop the italicised letters in* much-harm, *for* t'a, *drop the italics in* hit-hard. *The initial* hs, *where a slight aspirant precedes and modifies the sibilant, is a peculiar sound of the Peking mandarin dialect which can only be acquired by practice.*

The vowels and diphthongs are to be pronounced as in Italian, in accordance with the following table,

Vowel Symbols.	Webster's System.	English Value.
a	*ä*	*a as in* father.
e	*ĕ*	*e as in* yet.
ê	*ẽ*	*e as in* fern.
i	*ï-ē*	*i as in* marine.
ih	*ĭ*	*i as in* pin.
o	*ô*	*o as in* lord.
u	*ų*	*u as in* prune.
ü		*ü as in German* München.
ŭ	*ĭ or ū*	*between i in* bit *and u in* shut.

The last vowel sound ŭ, which only occurs with the initials ss, tz, tz', has no equivalent in English. In the diphthongal sounds each of the vowels should be separately pronounced in the Italian fashion; thus, ai, nearly our aye, is better represented by the Italian ái in hái, amái; ia, by the Italian ia in piazza; ie is pronounced as in the Italian siesta, niente, etc. In speaking, the words of the limited vocabulary of about 500 monosyllabic sounds are differentiated into four tones, or musical intonations, but these may be disregarded in writing, although all-important colloquially.

The remaining chapters of this little sketch of Chinese arts and crafts will be published in a second volume under the headings of:—

Pottery, Earthenware, Stoneware, and Porcelain.

Glass.

Enamels, Cloisonnés, Champlevés, and Painted Jewellery.

Textile Fabrics and Embroidery.

Pictorial Art.

S. W. B.

CONTENTS

PART I

LIST OF ILLUSTRATIONS.

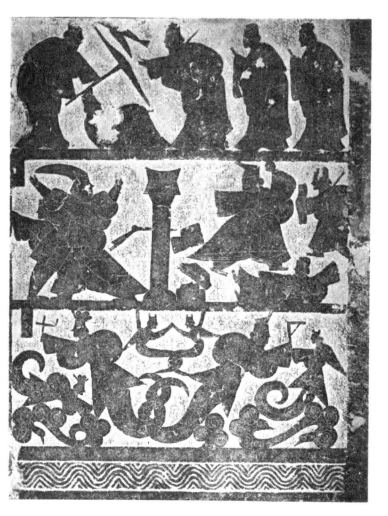

FIG. 1.—BAS RELIEF. HAN DYNASTY.
Frontispiec (see page 39).

2½ ft. × 2 ft.

CHAPTER I.

HISTORICAL INTRODUCTION.

THE study of any branch of art supposes, as Mr. Stanley Lane-Poole justly observes in his handbook on the *Art of the Saracens in Egypt*, some acquaintance with the history of the people among whom the art was practised. This applies with additional force to China and to Chinese art, a still more distant and less familiar field of study. The native story of the development of Chinese culture makes it nearly as old as the civilisations of Egypt, Chaldæa, and Susiana. These empires have, long since, culminated and disappeared below the horizon, while China has continued to exist, to work out its own ideas of art and ethics, and to elaborate the peculiar script which it retains to the present time. The characters of the ancient Chinese script would appear to have originated and developed in the valley of the Yellow River, and no connection has hitherto been satisfactorily traced with any other system of picture writing.

Our knowledge of the ancient empires of Western Asia has been widely increased by recent discoveries due to systematic exploration of the ruins of cities and temples. There are, doubtless, many such relics of ancient China awaiting the spade of the future explorer along the course of the Yellow River, and of its principal affluent, the Wei River, which runs from west to east through the province of Shensi, where the early settlements of the Chinese were situated. But they lie deeply buried beneath piles of river silt, blown to and fro by the wind to form the thick deposits of yellow loess which are so characteristic of these regions. It happens only occasionally that a site is laid bare by the river changing its course, or during the digging of canals for irrigation or other purposes, a fruitful source of the

discovery of bronze sacrificial vessels and other antiquities. Th
Chinese attach the highest value to such relics of the ancien
dynasties, although they are generally averse, for geomantic reason
to any intentional disturbance of the soil for their discovery. Th
sepulchral bas reliefs of the Han dynasty, for example, which were du
up in the seventeenth century in the province of Shantung, are no
housed in a building which was specially constructed for their pr
servation, and endowed with some land purchased by volunta
subscribers interested in the preservation of the antiquities. The
will be more fully noticed later and are just mentioned here becau
some of the carvings have been selected to illustrate this chapter

Chinese history is carried back by some to a mythical period
fabulous antiquity ; their first man, Pan Ku, emerging from ch
as the embryo of an all-productive cosmic egg or atom. He is follov
by a mythical series of celestial, terrestrial, and human rulers, sc
of the last of which were called Yu Ch'ao (the Nest-having)
because they lived in trees in those days, and others Sui Jên .(the
Fire Producers), as the discoverers of the primitive friction hand-
drill of wood.

The legendary, as distinct from the purely mythical, period begins
with Fu Hsi, the reputed founder of the Chinese polity. He is
represented in the lowest panel of the bas relief in the frontispiece,
and also in Fig. 2 in the right hand corner of the bas relief, as the
first of the three ancient sovereigns known as San Huang, holding a
mason's square, in company with a female personage wearing a
coronet and holding a pair of compasses. This last is Nü Wa, who
is variously represented as either the consort, or sister, of Fu Hsi ;
their bodies terminating in the forms of dragons, or seipents, are
intertwined below, and so are those of the attendant sprites of
anomalous outline supported by rolled clouds ending in birds' heads.
The inscription on the left, reads :—

" Fu Hsi, styled Ts'ang Ching, was the first to rule as king; he traced the trigrams
and knotted cords as a means of governing all within the seas."

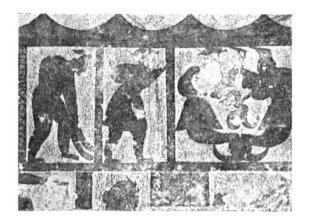

Fig. 2.—The San Huang.
Han Dynasty Bas Relief.

18 in. × 12 in.

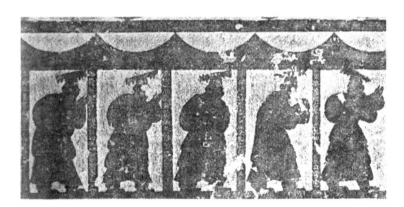

Fig. 3.—The Wu Ti.
Han Dynasty Bas Relief.

24 in, × 12 in.

The *pa kua*, or "eight trigrams," referred to here, are the well known symbols of ancient divination and mystic philosophy, which are said to have been revealed to Fu Hsi by a supernatural being called the dragon horse, rising from the waters of the Yellow River, with a scroll upon its back inscribed with the mystic diagrams. The figure of the dragon horse is often represented in jade, porcelain, or bronze. (See Fig. 77.) The "knotted coids" referred to have been compared with the *quippus*, the cord records of the ancient Peruvians.

Chu Yurg occupies the next panel in Fig. 2, as the second of the three ancient sovereigns, represented in a combatant attitude. He is chiefly celebrated as the conqueror of Kung Kung, the first rebel, and the leader of a titanic insurrection in times of old, when he well-nigh overwhelmed the earth with a watery deluge. The inscription reads :—

"Chu Yung had nothing to do, there were no desires nor evil passions, and neither punishments nor fines were instituted."

The third of the San Huang is Shên Nung, the Divine Husbandman, who first fashioned timber into ploughs, and taught his people the art of husbandry. He discovered the curative virtues of herbs, and founded the first markets for the exchange of commodities. The inscription reads :—

"Shên Nung, seeing the value of agriculture, taught how to till the ground and sow grain, and stirred up the myriads of the people."

The Wu Ti, or Five Rulers, who succeeded the above, are depicted in Fig. 3, which is taken from the same bas relief as the last. The cartouches, proceeding from right to left, read :—

1. "Huang Ti made many changes ; he fabricated weapons, dug wells in the fields, lengthened the official robes, built palaces and dwelling-houses."

2. "The emperor Chuan Hsü is the same as Kao Yang, the grandson of Huang Ti and the son of Ch'ang I."

3. "The emperor K'u is no other than Kao Hsin, he was great grandson of Huang Ti."

4. "The emperor Yao was named Fang Hsün, his benevolence was celestial, his knowledge that of a god, near at hand he was like the sun, afar off like a cloud."

5. "The emperor Shun was named Ch'ung Hua ; he tilled the ground on the · Li Mountain, for three years he laboured far from his home."

B

The five figures are all dressed in the same style with long robes and wear the square-topped hat hung with pendants of jade called *mien* which was adopted by Huang Ti. This last is a most prominent personage at the dawn of Chinese history. His capital was near the modern Hsi-an Fu, in the province of Shensi. Many of the industrial arts are traced back to his time, and his principal consort Hsi-ling Shih, who first taught the people to rear silkworms, is still worshipped as a deity on that account. The Taoists have transformed Huang Ti, the "Yellow Emperor," into a miraculous being who invented alchemy and succeeded in gaining immortality. He has been identified by Terrien de Lacouperie with Nakhunte, and made the leader of the so-called Bak tribes, which are supposed by him to have traversed Asia from Elam to China and started a new civilisation in the valley of the Yellow River ; while Shên Nung is identified with Sargon who according to him, ruled in Chaldæa about 3,800 B.C. But such speculations are difficult to follow, although there would really appear to have been some connection between the nascent civilisations of Chaldæa and China at an early period.

With the emperors Yao and Shun we stand on firmer ground, as they are placed by Confucius at the head of the Shu King, the classical annals compiled by him, and idealized as perfect models of disinterested rule for all time. Their capital was at P'ing-yang Fu in Shansi. Their memorial temple still stands outside the walls of this city with gigantic images of the two heroes, thirty feet high, erected in the central pavilion of the principal courtyard, before which the reigning emperor Kuang-hsü burned incense on his return journey from Hsi-an Fu to Peking in 1900.

Yao set aside his own son, and called on the nobles to name a successor, when Shun was chosen ; and Shun, in his turn, passing by an unworthy son, transmitted the throne to an able minister, the great Yu. Yu departed from these illustrious precedents and incurred the censure of " converting the empire into a family estate," and since his time the hereditary principle has prevailed. Yu gained

his great reputation by the success of vast hydrographic works con-
tinued for nine years till the country was rescued from floods and
finally divided into nine provinces. His labours are described in
the " Tribute of Yu," which is found with some modifications in the
Shu Ching compiled by Confucius, and in the first two of the dynastic
histories—the Historical Memoirs of Ssŭ-ma Ch'ien (*D.* B.C. 85), and
the Annals of the Former Han dynasty by Pan Ku (*D.* A.D. 92).
He is said to have cast nine bronze tripod vessels (ting) from metal
sent up from the nine provinces to the capital, situated near Kai-
fêng Fu, in the province of Honan, which were religiously preserved
for nearly 2,000 years as palladia of the empire. The great Yu is
represented as the founder of the Hsia dynasty in Fig. 4, in company
with Chieh Kuei, a degenerate descendant, the last of the line, a
monster of cruelty, whose iniquities cried out to heaven, till he was
overthrown by T'ang, "the Completer," the founder of the new
dynasty of Shang. The label attached reads :—

" Yu of Hsia was celebrated for his geometric knowledge of watercourses and
springs ; he knew the hidden principles and the proper seasons for embanking
the lands ; after his return he instituted mutilations as punishments."

The great Yu has a pronged spade in his hand. Chieh Kuei, armed
with a halbert (*ko*), is carried by two women, a cruel custom attri-
buted by tradition to him.

The Hsia dynasty was succeeded by the Shang, and the Shang by
the Chou, as indicated in the following table of the period, which is
always known to the Chinese as that of the " Three Dynasties "—
San Tai.

THE THREE EARLY DYNASTIES.

NAME OF DYNASTY.	NUMBER OF RULERS.	DURATION OF DYNASTY.
夏 Hsia	Eighteen	B.C. 2205-1767
商 Shang	Twenty-eight	1766-1122
周 Chou	Thirty-five	1122-255

The dates given above are in accordance with those of the official chronology, which is not contemporary, but has been calculated backwards from the lengths of the reigns, the cyclical days of eclipses of the sun and moon, and other data recorded in the annals. It has been shown that the cycle of sixty was used only for days at this time, not for years. The early dates must be consequently taken as only approximative, since it is not till the accession of Hsüan Wang (B.C. 822) that there is a general agreement in the native sources. From this year downwards the Chinese dates may be accepted with every confidence.

The Chou dynasty was really founded by Wên Wang, although not actually proclaimed till the 13th year of his eldest son and successor, Wu Wang, after the great battle in the plains of Mu, in which the last tyrant of the house of Shang was defeated. The latter forthwith fled to burn himself with all his treasures in the Stag Tower (Lu T'ai) which he had built in his capital, now Kuei-tê Fu in the province of Honan, and Wu Wang reigned in his stead. The following table gives the succession of the rulers of the new line:

THE CHOU DYNASTY.

DYNASTIC TITLE.		ACCESSION.	REMARKS.
		B.C.	
文 王	Wên Wang	1169	Accession to the Principality of Chou.
武 王	Wu Wang	1134	Proclaimed Emperor B.C. 1122.
成 王	Ch'êng Wang	1115	First seven years under regency of his uncle, the Duke of Chou.
康 王	K'ang Wang	1078	
昭 王	Chao Wang	1052	
穆 王	Mu Wang	1001	Journey to the West. Celebrated in Taoist legends.
共 王	Kung Wang	946	
懿 王	Yi Wang	934	

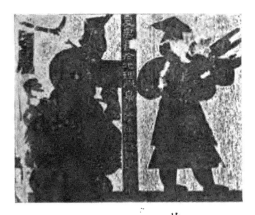

FIG. 4.—THE GREAT YU AND CHIEH KUEI.
Han Dynasty Bas Relief.

11 in. × 9 in.

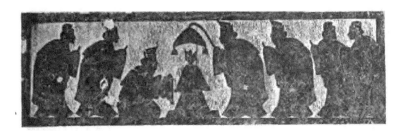

FIG. 5.—KING CH'ÊNG OF THE CHOU DYNASTY.
Han Dynasty Bas Relief.

27 in. × 9 in.

DYNASTIC TITLE.	ACCESSION.	REMARKS.
	B.C.	
孝 王 Hsiao Wang	909	
夷 王 Yi Wang	894	
厲 王 Li Wang	878	Last 14 years an exile in the Chin State.
宣 王 Hsüan Wang	827	
幽 王 Yu Wang	781	Killed by Tartar invaders.
平 王 P'ing Wang	770	Removal of capital from Hao (H-i-an Fu) to Lo Yang (Ho-nan Fu). Hence known as Eastern Chou dynasty (B.C. 770–481).
桓 王 Huan Wang	719	
莊 王 Chuang Wang	696	
僖 王 Hsi Wang	681	
惠 王 Hui Wang	676	Period comprised in the Ch'un Ch'iu Annals, compiled by Confucius B.C. 721–478.
襄 王 Hsiang Wang	651	
頃 王 Ch'ing Wang	618	
匡 王 K'uang Wang	612	
定 王 Ting Wang	606	Lao Tzŭ, the founder of Taoism, was a keeper of the records at Lo Yang at the close of the 6th century.
簡 王 Chien Wang	585	
靈 王 Ling Wang	571	
景 王 Ching Wang	544	Confucius lived 551–475.
敬 王 Ching Wang	519	
元 王 Yuan Wang	475	
貞 定 王 Chên Ting Wang	468	Period of the contending States, B.C. 475–221, during which the seven feudal states of Ch'in, Ch'i, Yen, Ts'u, Chao, Wei, and Han were fighting for supremacy.
考 王 K'ao Wang	440	
威 烈 王 Wei Lieh Wang	425	
安 王 An Wang	401	
烈 王 Lieh Wang	375	
顯 王 Hsien Wang	368	Mencius lived 372–289.
慎 靚 王 Shên Ching Wang	320	
赧 王 Nan Wang	315	Surrendered to the ruler of Ch'in in 25
東 周 君 Tung Chou Chün	255	Nominally reigned till B.C. 249.

The Chou dynasty, which was started so gloriously by the state-craft of King Wên and the military prowess of King Wu, was consolidated in the reign of King Ch'êng. The last was only thirteen years old when he succeeded, and the regency fell to his uncle Tan, the Duke of Chou, one of the most celebrated personages in history, where he is ranked in virtue, wisdom, and honours, as yielding place only to the great rulers of antiquity, Yao and Shun. He drew up the ordinances of the empire, directed its policy, and acted generally as guardian and presiding genius of the newly created line, during the reign of his brother King Wu, who conferred on him the principality of Lu, and during the first part of that of his nephew King Ch'êng.

This last youthful Sovereign is seen in Fig. 5, which is taken from another of the bas-reliefs of the Han dynasty, seated in the centre on a raised platform, with an umbrella held over his head by an attendant. The kneeling figure on the left is his celebrated uncle, the Duke of Chou, accompanied by two attendants holding tablets of office; the standing figure on the right is, judging from labels in similar scenes of the period, the Duke of Shao, another uncle and a colleague in the regency, the first feudal prince of Yen, the capital of which was on the site of the modern Peking, and who is also attended by two officials.

The division of the country into hereditary fiefs, conferred upon scions of the Royal house and representatives of the former dynasties, led to ultimate disaster. As the power of the surrounding feudatories increased, that of the central kingdom waned, till it was unable to withstand the assaults of the barbarous tribes on the south and west. Mu Wang invaded their mountain fastnesses, and he is recorded to have been driven by his charioteer, Tsao Fu, with his eight famous horses, wherever wheel-ruts ran and the hoofs of horses had trodden. He gained nothing by his campaigns, but the incidents

of the journey and his reception by Hsi Wang Mu, the " Royal Mother of the West," in her fairy palace on the Kun Luh Mountain, have been favourite subjects of Chinese art ever since, and one often sees his famous eight horses, each labelled with its name, cleverly cut in jade (see Fig. 97) or chosen for the motive of decoration of a porcelain vase. King Hsüan, a vigorous ruler, resisted the invaders with success, but little more than ten years after his death, the capital was taken by the barbarian tribes, and in the year B.C. 771, his son and successor, King Yu, was slain. The reign of King Yu is memorable for the record in the canonical Book of Odes of an eclipse of the sun on the 29th of August B.C. 776, the first of a long line of eclipses, which give points of chronological certainty to subsequent Chinese history.

His son and successor reigned at the new capital, Lo Yang, and the dynasty, known henceforward as the Eastern Chou, remained there, although its authority gradually dwindled to a shadow, in spite of all the efforts of Confucius and Mencius to reassert its rightful claims. The barbarian invaders were meanwhile driven out by a combination of the two feudal States of Chin (Tsin) and Ch'in and the old capital was ceded to the latter, who were destined in course of time to supplant the Chou.

During the 7th Century B.C. the power of the empire was swayed by confederacies of feudal princes, and the period (B.C. 685-591) is known in history as that of the Wu Pa, or " Five Leaders," who figured in succession as maintainers of the Government of the Son of Heaven. They were :

1. Duke Huan of Ch'i.
2. Duke Wên of Chin.
3. Duke Hsiang of Sung.
4. Prince Chuang of Ch'u.
5. Duke Mu of Ch'in.

This system of presiding chiefs, or rather of leading States, checked for a time the prevailing disorder ; but it was succeeded by the

period of the contending States, when the country was again devastated by civil wars, prolonged for more than two centuries, till King Nan, in 256, surrendered finally to the Prince of Ch'in and brought the Chou dynasty to an end.

King Chêng succeeded to the throne of Ch'in in B.C. 246, and in 221, after he had conquered and annexed all the other States, founded a new and homogeneous empire on the ruins of the feudal system. He extended the empire widely towards the south, drove back the Hiung-nu Turks on the north, and built the Great Wall as a rampart of defence against these horse-riding nomads. He tried to burn all historical books, declared himself the First Divus Augustus (Shih Huang Ti), and decreed that his successor should be known as the Second, the Third, and so forth, even down to the ten-thousandth generation. But his ambitious projects came to nought, as his son, who succeeded as Erh Shih Huang Ti, or Emperor in the second generation, in B.C. 209, was murdered by the eunuch Chao Kao two years after, and in 206 his grandson, a mere child, gave himself up to the founder of the house of Han, Liu Pang, bringing with him the jade seals of State, and was assassinated a few days later. A table of the regular succession of dynasties follows here, for reference, with the dates of their commencement. The figures in brackets indicate the number in the series of twenty-four dynastic histories devoted to their annals. (see Wylie's *Notes on Chinese Literature*, p. 13.)

NAME OF DYNASTY.	BEGAN.	REMARKS.
秦 Chi'n ⎫ (1, 2)	B.C. 221	
漢 Han ⎭	206	Capital at Ch'ang-an.
東漢 Eastern Han (3)	A.D. 25	Capital at Lo-yang.
蜀漢 After Han	221	Epoch of the Three Kingdoms, *viz.*, Han, Wei, and Wu (4).

NAME OF DYNASTY.	BEGAN.	REMARKS.
晉 Chin ⎫ (5)	265	
東晉 Eastern Chin ⎭	323	
劉宋 Sung, Liu House (6)	420	Epoch of Division between North and South, Nan Pei 'Ch'ao (14, 15), the (10) Wei (Toba), 386-549, ruling the north; followed by (11) the northern Ch'i 550-577; and (12) the Northern Chou, 557-581.
齊 Ch'i (7)	479	
梁 Liang (8)	502	
陳 Ch'ên (9)	557	
隋 Sui (13)	581	
唐 T'ang (16, 17)	618	
後梁 Posterior Liang	907	
後唐 „ T'ang	923	These short-lived lines are known collectively as the Five Dynasties, or Wu Tai (18, 19).
後晉 „ Chin	936	
後漢 „ Han	947	
後周 „ Chou	951	
北宋 Northern Sung ⎫ (20)	960	North China ruled by the Kitan Tartars, as Liao dyn. (21), 916-1119; by the Juchan Tartars, as Chin or Golden dyn. (22), 1115-1234.
南宋 Southern Sung ⎭	1127	
元 Yuan (23)	1280	Mongolian dynasty.
明 Ming (24)	1368	
清 Ch'ing	1644	Reigning Manchu dyn.

The civilisation of China during the three ancient dynasties would appear to have been, so far as we know, mainly, if not entirely, an indigenous growth. Towards the close of this period, in the fifth and fourth centuries B.C., the Ch'in State (Shensi Province) extended its boundaries towards the south and west, and from its name was doubtless derived that of China, by which the country generally became known to the Hindus, Persians, Armenians,

Arabs, and ancient Romans.　About the same time, or some-what earlier, signs of an overland traffic with India, by way of Burma and Assam appeared in the south-west, started by traders of the Shu State (Szechuan Province), by which route Hindu ideas of forest seclusion and asceticism penetrated and gave a marked colour to the early Taoist cult which sprang up in these parts.

The Ch'in emperor, who aimed at universal dominion, may have heard rumours of the conquests of Alexander the Great in Central Asia, although it must be confessed that the name of the latter is unknown to the Chinese annals. |The next dynasty, the Han, was the first to open up regular communication with western countries by sending Chang Ch'ien on a mission to the Yueh-ti, or Indo-Scyths, whose capital was then on the northern bank of the Oxus River. The envoy started B.C. 139, was kept ten years a prisoner by the Hiung-nu Turks, who ruled Eastern Turkistan, but at last reached his destination through Ta Yuan (Fergana).　Travelling through Bactria, he tried to return by the Khotan Lobnor route, but was again stopped by the Hiung-nu, till he finally escaped and got back to China in B.C. 126, after an absence of thirteen years.　Chang Ch'ien found bamboo staves, cloth and other goods offered for sale in Bactria, which he recognised as products of Szechuan, and was told that they were brought there from Shên-tu (India).　He reported to the emperor the existence of this south-western trade from China to India, and also the name of Buddha and of Buddhism as an Indian religion.　The grape vine with its Greek name (pu-t'ao from βοτρυς), the lucerne (Medicago sativa), the pomegranate from Parthia (Anhsi), and several other plants were introduced into China by him, and were cultivated in the Shang Lin Park at the capital.　The emperor Wu Ti subsequently sent friendly embassies to Sogdiana, and to Parthia in the beginning of the reign of Mithradates II, sent an army to Fergana in B.C. 102-100 which conquered the Kingdom of Ta Yuan; and brought back in triumph thirty Nisæan horses (of classical fame) blood sweating.　In the fa

south Kattigara (Cochin China) was annexed in 110 B.C., given the
Chinese name of Jih Nan, "South of the Sun," and a ship was
despatched from that port to get a supply of the coloured glass
of Kabulistan, which was becoming so highly valued at the
Chinese court.

The official introduction of Buddhism followed in the year 67 A.D.
The emperor Ming Ti, having seen in a dream a golden figure float-
ing in a halo of light across the pavilion, was told by his council that
it must have been an apparition of Buddha, and sent a special mission
of inquiry to India. The envoys returned to the capital, Lo Yang,
with two Indian monks, bringing with them Pali books, some of
which were forthwith translated, and pictures of Buddhist figures
and scenes, which were copied to adorn the walls of the palace halls
and of the new temple which was built on the occasion. This was
called Pai Ma Ssŭ, the White Horse Temple, in memory of the horse
which had carried the sacred relics across Asia, and the two Indian
sramana lived there till they died. The subsequent influence
of Buddhist ideals on Chinese art has been all pervading, but there
is no space to pursue the subject here.

In 97 A.D. the celebrated Chinese general Pan Ch'ao led an army
as far as Antiochia Margiana, and sent his lieutenant Kan Ying
to the Persian Gulf to take ship there on an embassy to Rome,
but the envoy shirked the sea journey and came back without
accomplishing his mission. Roman merchants came by sea to
Kattigara (Cochin China) in 166 A.D., appearing in the annals
as envoys from the emperor An-tun (Marcus Aurelius Antoninus),
and later arrivals of Roman traders were reported at Canton in
226, 284, etc. Meanwhile the overland route to the north, which
had been interrupted by the Parthian wars, was re-opened, and
many Buddhist missionaries came to Lo Yang from Parthia and
Samarkand, as well as from Gandhara in Northern India.

During the period of the "Northern and Southern Dynasties,"
when China, from the beginning of the fifth to nearly the end of the

sixth dynasty, was divided, Buddhism flourished exceedingly. The Toba Tartars, who ruled the north, made it a state religion, and their history devotes a special book (Wei Shu, Ch. cxiv) to the subject, which gives an interesting account of the monasteries, pagodas, and rock sculptures of the time ; with a supplement on Taoism under the heading of Huang Lao, *i.e.*, the religion of Huang Ti and Lao Tzŭ. In the south the emperor Wu Ti of the Liang dynasty, who reigned (502–549) at Chien K'ang (Nanking), often put on the mendicant's robes, and expounded the sacred books of the law in Buddhist cloisters. It was in his reign that Bôdhidharma, the son of a king in Southern India, the 28th Indian and 1st Chinese patriarch, came to China in A.D. 520, and after a short stay at Canton settled at Lo Yang. He is often represented in glyptic art carrying the famous pâtra, the "holy grail" of the Buddhist faith, or pictured crossing the Yangtsze on a reed which he had plucked from the bank of the river.

In the Sui dynasty the empire was re-united, and under the Great T'ang dynasty (618–906), which succeeded, it attained its widest limits. The T'ang ranks with the Han as one of the great "world-powers" of Chinese history, and many of the countries of Central Asia appealed to the son of Heaven for protection against the rising prowess of the Arabs. A Chinese general with an army of Tibetan and Nepalese auxiliaries took the capital of Central India (Magadha) in 648, and fleets of Chinese junks sailed to the Persian Gulf, while the last of the Sásánides fled to China for refuge. The Arabs soon afterwards came by ship to Canton, settled in some of the coast cities as well as in the province of Yunnan, and enlisted in the imperial armies on the north-west for service against rebels. Nestorian missionaries, Manichæans, and Jews came overland during the same period, but the Crescent prevailed in these parts and has lasted ever since, the number of Chinese Mohammedans to-day being estimated to exceed 25,000,000.

Buddhist propagandism was most active early in the T'ang,

after the headquarters of the faith had been shifted from India to China. Hindu monks, expelled from their native country, brought their sacred images and pictures with them, and introduced their traditional canons of art, which have been handed down to the present day with little change. Chinese ascetics, on the other hand, wandered in successive parties to India to investigate the holy land of the Buddha and burn incense before the principal shrines, studying Sanskrit and collecting relics and manuscripts for translation, and it is to the records of their travels that we owe much of our knowledge of the ancient geography of India.

Stimulated by such varied influences Chinese art flourished apace, the T'ang dynasty being generally considered to be its golden period, as it certainly was that of literature, belles lettres, and poetry. But the T'ang power during its decline was shorn, one by one, of its vast dominions, and finally collapsed in 906. The Kitans, who gave their name to Marco Polo's Cathay, as well as to Kitai, the modern Russian word for China, were encroaching on the north, a Tangut power was rising in the north-west, a Shan kingdom was established in Yunnan, and Annam declared its independence.

Of the five dynasties which rapidly succeeded one another after the T'ang, three were of Turkish extraction, and they may be dismissed with a word as being of little account from an artistic point of view.

In 960 the Sung dynasty reunited the greater part of China proper, shorn of its outer dominions. The rule of the Sung has been justly characterised as a protracted Augustan era, its inclinations being peaceful, literary, and strategical, rather than warlike, bold, and ambitious. Philosophy was widely cultivated, large encyclopedias were written, and a host of voluminous commentaries on the classics issued from the press, so that the period has been summed up in a word as that of Neo-Confucianism. The emperor and high officials made many collections of books, pictures, rubbings of inscriptions, bronze and jade antiquities,

and other art objects, of which important illustrated cata-
logues still remain, although the collections have long since been
dispersed. During this time the Chinese intellect would seem to have
become, as it were, crystallised, and Chinese art gradually developed
into the lines which it still, for the most part, retains.

The Yuan dynasty (1280–1367) was established by Kublai Khan,
a grandson of the great Mongol warrior Genghis Khan. The Mongols
annexed the Uigur Turks and destroyed the Tangut kingdom ;
swept over Turkestan, Persia, and the steppes beyond ; ravaged
Russia and Hungary ; and even threatened the existence of Western
Europe. China was completely overrun by nomad horsemen, its
finances ruined by issues of an irredeemable paper currency, and its
cities handed over to alien governors called *darughas*. A Chinese
contemporary writer describes the ruin of the porcelain industry at
Ching-tê Chên at this time by exorbitant official taxation, so that
the potters were driven away from the old imperial manufactory
there, to start new kilns in other parts of the province of Kiangsi.
Marco Polo is astonished at the riches and magnificence of the
great khan, who was really a ruler of exceptional power and
made good use of his Chinese conquests. But the culture which
surprised the Venetian traveller was pre-Mongolian and its growth
was due mainly to Chinese hands. Even the wonderful cane palace
of Marco Polo celebrated by Coleridge :—

> " In Xanadu did Kubla Khan
> A stately pleasure dome decree, etc."

was actually the old summer residence of the Sung emperors at
K'ai-fêng Fu, in the province of Honan, which was dismantled and
carried away piecemeal to be built up again in the park of the new
Mongolian capital of Shangtu, outside the Great Wall of China.

The Mongolian era is responsible for some of the remarkable
similarities that have been noticed in industrial art work of Western
and Eastern Asia, which were then for the first time under the rule
of the same house. Hulagu Khan is said to have brought a hundred

families of Chinese artisans and engineers to Persia about 1256 ; and on the other hand, the earliest painted porcelain of China is decorated with panels of Arabic script pencilled in the midst of floral scrolls, strongly suggestive of Persian influence.

The Mongols were driven out of China to the north of the desert of Gobi in 1368, in which year the Ming dynasty was founded by a young bonze named Chu Yuan-chang. They raided the borders for some time, and even carried off one of the Chinese emperors in 1449, who, however, was liberated eight years later, to resume his reign under the new title of T'ien Shun, as may be seen in the accompanying list. This is noticeable as being the only change of *nien-hao* during the last two dynasties, whereas in previous lines changes were very frequent.

The early Ming emperors kept up intercourse with the west by sea, and the reign of Yung Lo and Hsüan Tê are especially distinguished by the career of a famous eunuch admiral, who went in command of armed junks to India, Ceylon, and Arabia, down the African coast to Magadoxu, and up the Red Sea as far as Jiddah, the sea-port of Mecca. Celadon porcelain (*ch'ing tz'ǔ*) is included in the list of articles taken to Mecca in the reign of Hsüan Tê (1426-35), and it was perhaps one of these expeditions that brought the celadon vases sent by the Sultan of Egypt in 1487 to Lorenzo de Medici. In the next century Portuguese and Spanish ships appeared for the first time in these seas and Chinese junks were no more seen.

Modern history begins at this point and need not be discussed here. It only seems necessary to append a list of the reigns of the emperors of the Ming dynasty, followed by another of the Manchu Tartar line, which supplanted the Ming in 1644, and is still reigning in China. The Empress Dowager rules with sadly diminished prestige when compared with her illustrious predecessors K'ang Hsi (1662-1722) and Ch'ien Lung (1736-95), but anti-foreign and

unscrupulous withal, she wields the calligraphic brush with a firm hand on the autograph scrolls which she distributes among her adherents, and is a liberal patron of native art as far as lies in her power.

EMPERORS OF THE 明 MING DYNASTY.

Dynastic Title, *Miao Hao.*	Title of Reign, *Nien Hao.*	Date of Accession.
太祖 T'ai Tsu	洪武 Hung Wu	1368
惠帝 Hui Ti	建文 Chien Wên	1399
成祖 Ch'êng Tsu	永樂 Yung Lo	1403
仁宗 Jên Tsung	洪熙 Hung Hsi	1425
宣宗 Hsüan Tsung	宣德 Hsüan Tê	1426
英宗 Ying Tsung	正統 Chêng T'ung	1436
景帝 Ching Ti	景泰 Ching T'ai	1450
英宗 Ying Tsung (resumed government)	天順 T'ien Shun	1457
憲宗 Hsien Tsung	成化 Ch'êng Hua	1465
孝宗 Hsiao Tsung	弘治 Hung Chih	1488
武宗 Wu Tsung	正德 Chêng Tê	1506
世宗 Shih Tsung	嘉靖 Chia Ching	1522
穆宗 Mu Tsung	隆慶 Lung Ch'ing	1567
神宗 Shên Tsung	萬曆 Wan Li	1573
光宗 Kuang Tsung	泰昌 T'ai Ch'ang	1620
熹宗 Hsi Tsung	天啟 T'ien Ch'i	1621
莊烈帝 Chuang Lieh Ti	崇禎 Ch'ung Chên	1628

EMPERORS OF THE 大清 GREAT CH'ING DYNASTY.

DYNASTIC TITLE, *Miao Hao.*	TITLE OF REIGN, *Nien Hao.*	DATE OF ACCESSION.
世祖 Shih Tsu	順治 Shun Chih	1644
聖祖 Shêng Tsu	康熙 K'ang Hsi	1662
世宗 Shih Tsung	雍正 Yung Chêng	1723
高宗 Kao Tsung	乾隆 Ch'ien Lung	1736
仁宗 Jên Tsung	嘉慶 Chia Ch'ing	1796
宣宗 Hsüan Tsung	道光 Tao Kuang	1821
文宗 Wên Tsung	咸豐 Hsien Fêng	1851
穆宗 Mu Tsung	同治 T'ung Chih	1862
Reigning Sovereign	光緒 Kuang Hsü	1875

CHAPTER II.

SCULPTURE.

There are no relics of carved stone in China to be compared in importance or antiquity with the ancient monuments of Egypt, Chaldæa, and Susa. The chief materials of Chinese buildings have always been wood and bricks, so that stone is generally used only for architectural accessories and for the decoration of interiors. The origin of sculpture in stone, like that of many other Chinese arts is very obscure, in spite of all that has been written on the subject, in native as well as in foreign books. In Chinese books its indigenous origin and development are always taken for granted, and it seems natural to accept such views until the contrary be proved.

Non-Chinese theories are of the most varied character and depend mainly on the ideas of the individual writer as to the source and subsequent history of the Chinese race. Dr. Legge, like many other missionaries, starts in his speculations from the Book of Genesis and—

" supposes that the family, or collection of families—the tribe—of the sons of Noah, which has since grown into the most numerous of the nations, began to move eastwards, from the regions between the Black and Caspian Seas, not long after the confusion of tongues,"

and finally reached the valley of the Yellow River, where they met with other early immigrant tribes of ruder manners, whose route is not sketched so minutely, and ultimately prevailed over their opposition. M. Terrien de Lacouperie brings his fanciful " Bak ·tribes " from nearly the same region—the southern slopes of the Caspian—under the leadership of a certain Nakhunte, who is presumed to be the ancient Chinese ruler Huang Ti, provided with an Akkadian cuneiform script, and with many items of ancient lore, for

a complete list of which we must refer to his book entitled *Western Origin of the Early Chinese Civilisation*, 1894. A totally opposite view is upheld by Perrot and Chipiez in their well-known *Histories of the Ancient Arts of Egypt, Chaldæa and Assyria, etc.*, where they say :—

"During the period with which we are concerned, China might as well have been in the planet Saturn for all she had to do with the ancient world, and we need refer to her no more, except now and then perhaps for purposes of illustration."

The truth must lie somewhere between these extremes, but there is hardly space to discuss the subject here, or to make any attempt to reconcile such conflicting authorities.

The peculiar Chinese script would seem to be, at any rate, of purely indigenous origin and growth. Native scholars trace out carefully and correctly its main stages of development ; how the original pictures (*wên*) of objects and conditions were first used singly or in multiple combination ; how they were subsequently employed phonetically for other monosyllables of similar sound ; till the device was finally hit upon of prefixing or affixing a radical, or determinative, to distinguish words of the same sound but of different meaning. This last is the principle on which the multitudinous characters (*tzǔ*) of the Chinese lexicon have been formed, composed as they are of a *radical*, which determines the sense, and a *phonetic*, which suggests the sound, and in the same lines all newly invented characters must be pencilled.

Chinese scholars reverence the written script and hire men to collect every scrap of manuscript or printed paper to be burned afterwards with due ceremony. Calligraphy is a branch of the fine arts in China, and the penman who can write elegantly in sweeping lines with a flowing brush is ranked above the artist. The highest reverence is paid to any ancient relics of stone and bronze with inscriptions, a long series of books under the heading of *Corpus Inscriptionum* having been printed during the last thousand years, the bibliography of which would fill many pages. Two indispensable dictionaries of the ancient script for the

antiquary are the *Shuo Wên*, compiled by Hsü Shên in A.D. 100, as an aid in the decipherment of the old books carved on tablets of bamboo, which had been buried to avoid the fires of Ch'in Shih Huang, and unearthed again under the Han dynasty when literature was no longer proscribed : and the *Shuo Wên Ku Chou Pu* by Wu Ta-chêng, a high official and celebrated scholar of the present reign, published in 1884 ; with a preface by Pan Tsu-yin, President of the Board of Punishments, another famous collector of antiquities ; being a collection of some 3,500 characters of the script of the Chou dynasty (B.C.1122–249), reproduced in exact fac-simile from actual specimens of stone, bronze, seals and pottery of the period.

The most cherished relics of the Chou dynasty are ten stone drums, now installed in the two side halls of the principal gateway of the Confucian Temple at Peking, where they were placed in the year 1307 by Kuo Shou-ching, the famous minister and astronomer of the reigns of Kublai Khan and his successor. They are really mountain boulders roughly chiselled into the shape of drums, about three feet high, the form of which may be seen in Fig. 6, repro-duced from a photograph taken in Peking by Mr. J. Thomson, the learned photographer now attached to the Royal Geographical Society.* The picture shows how the drum on the right has been truncated and scooped out to make a mortar for pounding grain, involving the loss of nearly half of its inscription, an allusion to which occurs in the well-known verses by the celebrated poet Han Yü, written in 812, which have been engraved on a marble stele erected in the Confucian Temple by the Emperor Ch'ien-lung, accompanied by a laudatory ode of his own composition.

The stone drums were discovered in the early part of the 7th century, lying half buried in the ground in the vicinity of Fêng-

* It is fitting to express here our deepest acknowledgment to Mr. Thomson for his generous contribution of Figs. 6, 24, 27, 33, 37, 44, 64 and 65 to our list of illustrations.

hsiang Fu·in the province of Shensi, on the south of the hills called Ch'i Shan, from which the district city Ch'i-shan Hsien takes its name. T'ai Wang, an ancestor of the Chou, moved to this locality in the year B.C. 1325, and it continued to be the capital of the Chou State till the time of Wên Wang, who is said to have made the hunting park on the south of Mount Ch'i, surrounded by a wall seventy *li* square, which is supposed to have been the "Great Park" of our inscription (Fig. 7). The drums were set up in the Confucian Temple of Fêng-hsiang Fu about A.D. 820. When the Sung emperor fled from the Kitan Tartars to the province of Honan and founded a new capital there, a hall was specially built in the new grand palace, finished in 1119, for the exhibition of the drums, an edict having been issued that the inscriptions should be filled in with gold, to betoken their value, and, at the same time, to prevent their further injury by the hammer in taking rubbings.* But they rested here a few years only, for the Juchen Tartars sacked the city in 1126, dug out the gold inlay, and carried off the drums to their own central capital, the modern Peking.

The inscriptions on the stone drums comprise a series of ten odes, a complete one being cut on each drum, composed in rhyming stanzas of irregular verse, in the style of the odes of the early Chou period which are preserved in the *Shih Ching*, the canonical *Book of Odes* compiled by Confucius. They celebrate an imperial hunting and fishing expedition in the country where the drums were found, and relate how the roads had been levelled and the

* The Chinese obtain fac-simile rubbings of inscriptions with sheets of thin, tough, cohesive paper, moistened and applied evenly to the surface of the stone or bronze. The paper is first hammered in by a wooden mallet, a piece of felt being interposed to prevent injury to the object, and afterwards forced into every crevice and depression by a brush with long soft bristles. If torn during the process a little plug of wetted paper will join the rent or fill up the gap perfectly. As soon as the paper has become sufficiently dry, a stuffed pad of silk or cotton dipped in sized ink ground down to a semi-solid consistency is passed lightly and evenly over the paper. It is finally peeled off, imprinted with a perfect and durable impression of the inscription, which comes out, of course, in white reverse on a black or red ground according to the colour of the cake of ink used.

river courses cleared for a grand battue carried out by troops of warriors marshalled under the command of the feudal princes. The cyclical number of the *day* is given in one line, but there is nothing to indicate the year, and Chinese authorities unfortunately differ as to the probable date. It must, at any rate, be before B.C. 770, when we have seen that the capital of the Chou was moved eastwards to Loyang, and their ancestral territory ceded to the rising State of Ch'in, which was destined eventually to supplant them. The older authorities generally referred the inscriptions, on literary grounds chiefly, to the reign of Hsüan Wang (B.C. 827–782), but several competent scholars of more recent date attribute them to Ch'êng Wang (B.C. 1115–1079), on grounds which seem to me to be well founded. Both the *Bamboo Books* and the *Annals of Lu* mention a grand hunting expedition to the south of Mount Ch'i in the spring of the sixth year of Ch'êng Wang, on his return from a military expedition to the Huai river in the east, and the drums are reasonably supposed to have been inscribed on this occasion. The archaic character of the script and its analogies with inscriptions of the time on bronze vessels newly unearthed, tend to strengthen the argument, although it is not universally accepted. Waiving the question of their exact date, the stone drums may be accepted as certainly early relics of the Chou dynasty.

A fac-simile of the first of the ten inscriptions taken from one of the old rubbings of the Sung dynasty, subsequently cut in stone in the College of Hang-chou, by the great viceroy and scholar Yuan Yuan (1764–1849), is given in Fig. 7. It runs somewhat as follows :—

> " Our chariots were solid and strong,
> Our teams of well-matched steeds ;
> Our chariots were shining and bright
> Our horses all lusty and sleek.

> " The nobles gathered round for the hunt,
> And hunted as they closed in the ring,
> The hinds and stags bounded on,
> With the nobles in close pursuit.

FIG 6.—STONE DRUMS OF THE CHOU DYNASTY.
Confucian Temple, Peking.

FIG. 7.—INSCRIPTION ON STONE DRUM.
Confucian Temple, Peking.

6 in × 4 in.

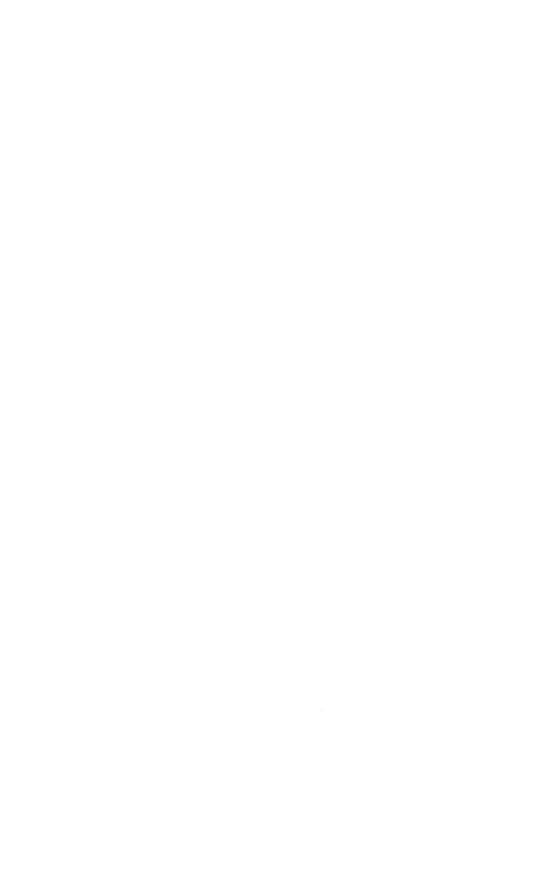

"Drawing our polished bows of horn,
And fitting arrows to the strings,
We drove them over the hills ;
The hoofs of the chase resounded,
And they herded in close-packed mass,
As the drivers checked their horses.

"The hinds and stags pressed swiftly on,
Till they reached the great hunting park.
We drove on through the forest,
And as we found them one by one,
We shot with our arrows the wild boar and elk."

Passing on next to the mural decoration of buildings and tombs by sculptured figures, we find many references to such in early literature. The life of Confucius describes a visit of the sage in B.C. 517 to the court of the Chou at Loyang, and how he saw on the walls of the Hall of Light, where the feudal princes were received in audience, portraits of Yao and Shun, figures of the last tyrants of the lines of Hsia and Shang, with words of praise or blame affixed to each, and a picture of Chou Kung in attendance as minister upon his infant nephew Ch'êng Wang (see Fig. 5.) :

"Now," exclaimed Confucius, "I know the wisdom of the duke of Chou and understand how his house attained to imperial sway ; we see antiquity as in a glass and can apply its lessons to the present day."

Other writers from the 2nd century B.C. onwards speak of ancestral temples and tombs of princes and high officials, in the provinces of Ssŭchuan, Hupei, and Shantung, containing intaglio carvings and sculptured bas-reliefs, representing all kinds of scenes, terrestrial and celestial, historical and mythological.

The best known examples that have come down to us are derived from two localities in the province of Shantung, and are attributed to the 1st century B.C. and to the 2nd century A.D. respectively. Rubbings are prepared from the stones in the way that has been described and circulated throughout China, for the use of scholars, in a collection numbering about eighty sheets, and they have been published, as a whole or in part, in several

native archæological works. I may be permitted to mention that I was probably the first to bring one of these collections to Europe, to present them to the Oriental Congress at Berlin, in 1881, after which two were photographed at the South Kensington Museum, at the instance of Sir Philip Owen, who unsuccessfully urged the publication of the whole series. Lieut. D. Mills, on a journey through the district in 1886, saw the stones housed in the building which had been dedicated about a century before by the native authorities for their pre-servation, and brought home another set of the rubbings, which he gave to the British Museum. Professor E. Chavannes also visited the site in 1891, and has published the whole with a learned commentary in a fine quarto volume, entitled *La Sculpture · sur pierre en Chine au temps des deux dynasties Han*, which was issued in 1893 at Paris, under the auspices of the *Ministère de l'Instruction Publique et des Beaux-Arts*.

The earlier series comprises eight slabs of stone found on the hill called Hsiao T'ang Shan, about sixty *li* north-west of the city Fei-ch'êng Hsien, in the province of Shantung. The figures are lightly incised when compared with the bolder bas-reliefs of the later series, but the birds and other details are often sketched with a singularly naturalistic touch. There is no contemporary record of the date, but the incised *grafitti* of early pilgrims to the tombs con-firm their general attribution by Chinese archæologists to the close of the Formei Han dynasty, *i.e.*, the 1st century B.C. The first of these *grafitti*, cut on the sixth stone, runs thus :—

" On the 24th day of the 4th month of the 4th year (A.D. 129) of the epoch Yung-chien, Chao Shan Chun of T'o Yin, in the province of P'ing Yuan, came to visit this hall ; he prostrated himself in token of gratitude for its sacred illuminating influences."

The slabs are too large for our page, and a cutting or two must suffice to show the style of the varied scenes depicted, ranging as they do from Taoist deities and mythological animals to battles

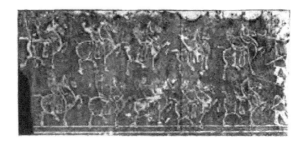

FIG. 8.—STONE CARVING. HSIAO T'ANG SHAN.
1st Century B.C.
30 in. × 13 in.

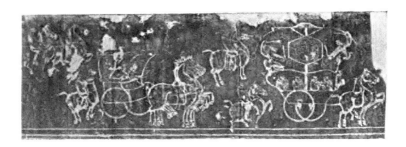

FIG. 9.—STONE CARVING. HSIAO T'ANG SHAN.
1st Century B.C.
38 in. × 13 in.

FIG. 10.—STONE CARVING. HSIAO T'ANG SHAN.
1st Century B.C.
38 in. × 13 in.

with Tartar bowmen, clad in furs and wearing pointed Scythian caps of felt, hunting and cooking scenes, tribute bearing processions, historical and legendary episodes, etc. Cuttings from one of the processions are reproduced in Figs. 8, 9, 10. We see the " Great King "—*Ta Wang*—in the middle of Fig. 9, seated in a chariot drawn by a team of four horses harnessed abreast, the curved yoke mounted with a phœnix, under which the reins pass. A large two-horse chariot in front, with a canopy supported upon a central pole mounted with dragons' heads, carries two drummers, beating a leather drum, with hanging bells of metal attached, and a band of four musicians with pandean pipes, besides the charioteer ; reminding one of the chariot which always accompanied the general to battle in olden times, when, we are told, the drum was sounded for advance, the metal bells as a signal for retreat. Two more pair-horse chariots follow (Fig. 10), the front one with the pronged bronze heads of halbert-like spears (*ko*), a characteristic weapon of the time, sticking out behind ; similar weapons being carried by the foot-men, who herald the cortege (Fig. 8), in addition to short swords in their belts. The horsemen have saddles, pads of leather, and stirrups, and the horses' tails are tied up in knots, in the fashion that still prevails in China ; occasional gaps are filled in here and elsewhere, with birds flying in the direction of the movement.

The next two sections have been selected for illustration as the earliest known representations of the Chinese dragon, *lung*, and phœnix, *fêng-huang*. The horned dragon, in Fig. 11, with serpentine scaly body, four legs and rudimentary wings, is pursuing a rat, indistinct in the picture ; between ornamental bands of primitive design, one strewn with "cash," the other pencilled in lozenges. The phœnixes in Fig. 12, something between the peacock and the argus pheasant, are being fed by a monkey on the roof of a two-storeyed pavilion, the upper storey only being seen in the picture, occupied by Hsi Wang Mu with her courtiers ; the phœnix always

figures as king of the feathered tribe, and among the other birds a wild goose can be identified on the left, a hawk pouncing upon a hare on the right.

The cuts in Figs, 13, 14 represent the sun and moon, with their mythological attributes, posed within bands of constellations with the stars connected by lines in Chinese fashion ; these happen to be omitted in Professor Chavannes' illustrations, the Editor explaining in a note that they had not reached him in time. The moon is in-habited by the toad and the hare, which appear in Fig. 13 in realistic relief, stippled with punctured dots. According to old legends Ch'ang-O, the wife of the " Archer Lord " of the time of the ancient emperor Yao, stole from her husband the drug of immortality and fled with it to the moon, when she was transformed into a toad ; the mythological toad in later Chinese art has three legs only, here it has four. The hare, according to a later Buddhist story, offered its body as a willing sacrifice, lying upon a pile of dry grass, and was re-warded for its devotion by transmigration to the moon ; in other parts of these bas-reliefs the hare is seen busy with pestle and mortar pounding herbs ; Taoist herbalists must always gather in the mountains materials to compound their *elixir vitæ* by the light of the full moon. The red crow with three feet is the tenant of the solar disk, and is the origin of the *triquetra* symbol of ancient bronzes. Huai Nan Tzŭ, who died B.C. 122, grandson of the founder of the Han dynasty and an ardent Taoist votary, says that the red crow has three feet because three is the emblem of the masculine principle of which the sun is the essence : the bird often flies down to Earth to feed on the plant of immortality, as indicated in the bas-relief. Among the constellations depicted here the Spinning Damsel is recognised by the figure of a girl working at a loom, with three stars over her head, which are a, η, and γ, Lyræ. The constellation of seven stars on the left of the moon is the Great Bear, which occupies a prominent position in the Taoist heavens as the seat of their supreme deity, Shang Ti, round whom all the other star-gods

FIG. 11.—CARVING OF DRAGON.
1st Century B.C.

2½ ft. × 1 ft.

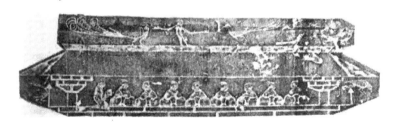

FIG. 12.—CARVING OF PHŒNIXES, ETC.
1st Century B.C.

3 ft. × 10 in.

FIG. 13.—MOON AND CONSTELLATIONS.
1st Century B.C.

2 ft. × 9 in.

D 2

FIG. 14.—SUN AND CONSTELLATIONS.
1st Century B.C.

2½ ft. × 9 in.

circulate in homage ; on another bas-relief it figures as the aerial throne of Shang Ti, who is answering the prayers of a band of pilgrims, appealing for aid against the apparition of a comet, which is borne before him by an attendant sprite.

The second group of bas-reliefs comes from the ancient cemetery of the Wu family, situated about ten miles to the south of the city Chia-hsiang Hsien, which is also in the province of Shantung. This family claimed to be descended from Wu Ti, one of the most famous kings of the Shang dynasty, according to the inscription on the memorial stele of Wu Pan, who died in the year A.D. 145, which was discovered on the same site. Three separate tombs have been unearthed, and the sculptured stones from the three sites are preserved in a building which was endowed for the purpose in the year 1787. In front of the building stand two square pillars of stone, which have not been disturbed, and one of these pillars has a panel with the inscription :—

" In the 1st year (A.D. 147) of Chien Ho, the cyclical year *ting-hai*, in the third month which began with the day *kêng-hsü*, on the 4th day *kuei-ch'ou*, the filial sons, Wu Shih-kung and his younger brothers, Sui-tsung, Ching-hsing and K'ai-ming, erected these pillars, made by the sculptor Li Ti-mao, styled Mêng-fu, at a cost of 150,000 pieces of money. Sun-tsung made the lions which cost 40,000 ' cash,' etc."

The lions are lost, but some other steles of about the same date have been discovered on the site, so that the bas-reliefs may be confidently attributed to the middle of the second century of our era. One of the smaller stones unearthed here is illustrated in the frontispiece of this volume (Fig. 1). It is carved in three panels with three different scenes. The upper panel displays the " strong man " of Chinese story, the charioteer who wrenched off the canopy of his chariot, which he holds up by the pole to shelter his lord, lying wounded on the ground ; while the enemy, bow in hand, accompanied by two retainers holding tablets, *hu*, comes up to commend him for his loyalty. The middle panel contains one of the historical assassination attempts so vigorously related in the annals of the Han

dynasty by the " father of history," Ssŭ-ma Ch'ien. Ching K'o was
sent by Tan, hereditary prince of the state of Yen, in B.C. 227, to
assassinate the celebrated Ch'in Shih-huang, bringing with him as
credentials the head of a rebel general in a box and a map of the
territory pretended to be ceded with a poisoned dagger rolled up
inside. He is given audience in the palace of Hsien Yang together
with a colleague, and immediately attacks the future emperor, who is
attended only by his physician. The first stroke severs his sleeve,
he rushes behind a pillar, which shields him from the second stroke,
and is saved by the physician who seizes the assassin and shouts tor
the guard. In the picture the dagger is seen thrust through the
pillar, on one side of which is the future emperor holding up a per-
forated medallion symbol of jade, on the other the arrested assassin
with dishevelled hair ; his fellow envoy is " prostrate from fright,"
and a guardsman is coming up armed with sword and shield. The
lowest panel presents another representation (compare Fig. 2) of Fu
Hsi ana Nü Wa, the mythical founders of the Chinese polity, holding
mason's square and compasses ; the attendant sprites are winged and
the scrolled clouds end in birds' heads ; the peculiar coroneted
female headdress and the horned heads distinctive of supernatural
beings may also be noticed.

The larger bas-relief in Fig. 15, which measures in the original
three feet by two, pictures the discovery, in the 28th year (B.C. 194)
of the reign of Ch'in Shih-huang, of one of the celebrated bronze
tripods, the ancient palladia of the kingdom.

"The nine sacred tripods," according to the *Shui Ching*, an old geographical
work, "were lost in the Ssŭ River during the reign of Hsien Wang in B.C. 233.
It was reported that they had been seen there and the emperor sent an expedition
to recover them who searched a long time in vain, and when at last they fished
out one of the number, a dragon suddenly appeared and bit the rope in two, so
that it fell back into the river and was never seen again."

We see here the commissioners with their attendants assembled
on the bank above, looking at the tripod as it is being pulled up out of
the river with the help of men with poles in two boats, while a

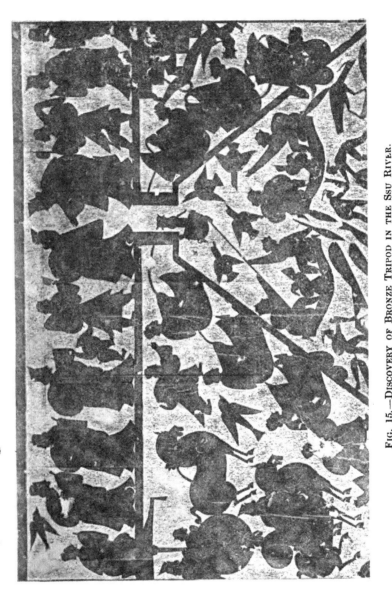

FIG. 15.—DISCOVERY OF BRONZE TRIPOD IN THE SSU RIVER.
Han Dynasty Bas Relief.

3 ft. × 2 ft.

FIG. 16.—RECEPTION OF KING MU BY HSI WANG MU, ETC.

Han Dynasty Bas Relief.

4 ft. × 2 ft.

dragon's head emerging from the tripod has bitten the rope in two, making the haulers fall backwards in two lines along the parapet. There is a companion dragon in the background on the right, a prancing bear and birds flying fill in the intervals, and fishermen are seen catching fish with basket traps in the water below—natural accessories of the scene unconnected with the story.

Another large stone from the same site is represented in Fig. 16, measuring about two feet by four, on which two scenes are depicted, having no connection with each other. The upper and larger part gives the reception of the ancient emperor Mu Wang by the Taoist divinity, Hsi Wang Mu, the " Royal Mother of the West." The lower part is devoted to an official procession, presenting a phase in the career of the deceased mandarin to whose sacrificial temple it belonged. The reception is held in a two-storied pavilion, with two straight untilted tiled roofs, flanked by twin columns, which are also double-roofed ; the lower roof in each case is supported by plain round pillars, the upper roof by caryatides. A pair of gigantic phœnixes are disporting on the top of the roof, fed by a winged sprite ; the head of a dragon projects on the right, astonishing one of the visitors ; a bear and monkey of naturalistic outline appear on the left, and birds fill in every available gap ; while a winged sprite, with serpentine body coiled round one of the right hand pillars of the pavilion, supplies another mythological touch to the composition. Mu Wang, large in scale, as befits his dignity, is seated below under a canopy, attended by a servitor with fan and towel, while another comes up with a tray of food ; four courtiers stand behind holding their tablets of office. Hsi Wang Mu, wearing a coronetted hat, is installed with her court in the upper storey, attended by ladies carry- ing cup, mirror, and fan ; besides another on the left with her special attribute, the triple jewelled fruit of long life with which she endows her faithful votaries. In the courtyard stands a stately *ho huan* tree with forked trunk and interlacing branches, the sacred cosmic tree of Taoist lore, with a charioteer at its foot unharnessing Mu Wang's

chariot, a couple of hunting dogs, like greyhounds, and an archer shooting towards the sacred tree, despite the dissuasions of its guardian. In the procession below the chariot on the right is labelled *Chun Chü*, "Chariot of the Sage," a laudatory term usually applied to the deceased in the epitaphs. It is preceded by two men on foot, with staves and fans, two horsemen with pronged lances, and two chariots labelled "Secretary of the Prefecture," and "Chief of Police of the Prefecture," respectively.

The picture of the bas-relief in Fig. 17 is taken from a stone measuring four feet by three, unearthed on the same site from the tomb of one of the other scions of the Wu family. The sculptures of this tomb present a still more marked mythological air. The upper panel exhibits a mortal standing in a respectful attitude on the left, watching a nightmare procession of winged dragons and sprites revealed in the intervals of rolling clouds, heralding a winged deity seated in a chariot drawn by a team of three dragons. The lower and larger panel displays the aerial abode of the Taoist divinity Tung Wang Kung, the "Royal King of the East." The deity is seated on the clouds in a central position, a winged figure precisely like the one labelled with his name so often moulded on the backs of bronze mirrors of the period. His consort, Hsi Wang Mu, is enthroned on the right, recognised by her attribute, the three-beaded sceptre, which is held by a winged attendant. Their horses, even their chariots, are winged, and the scrolled cloud ends in birds' heads. Tung Fang So, a devotee of Taoism, writes in the 2nd century B.C. :—

" On the summit of the Kunlun mountains there is a gigantic bird named Hsi-yu which faces the south, it stretches out its left wing to support the venerable king of the east and its right wing to support the maternal queen of the west ; on its back is a spot without feathers 19,000 *li* across. Hsi Wang Mu, once a year, rides along the wing to make a visit to Tung Wang Kung."

The clouds here unroll from the summit of a mountain, defended apparently against a mortal in official robes, who has just alighted from a three-horse chariot, attended by two lancers, whose saddled

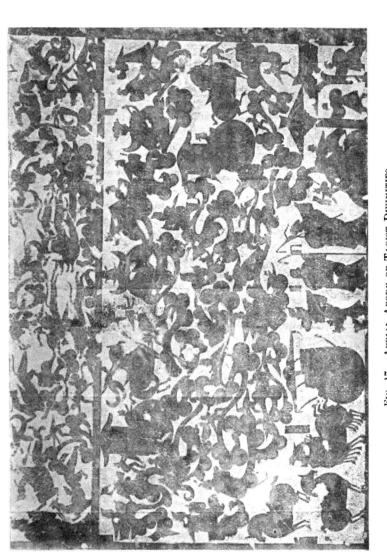

FIG. 17.—AERIAL ABODE OF TAOIST DIVINITIES.
Han Dynasty Bas Relief.

4 ft. × 3 ft.

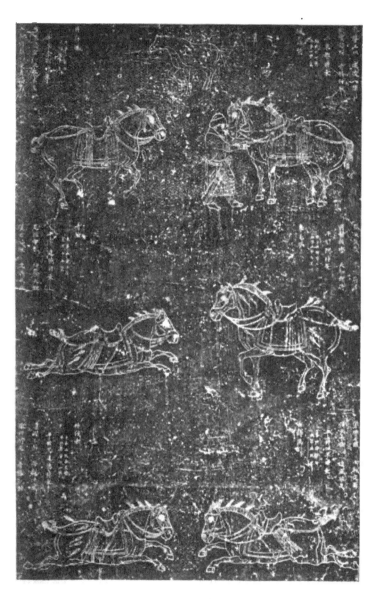

FIG. 18.—ENGRAVED STONE STELE.
T'ang Dynasty. 7th Century

5 ft. × 3 ft.

horses have been left behind. Who this may be it is impossible to decide, as the labels attached are defaced and illegible, if they were ever inscribed.

The rubbing reproduced on Fig. 18 is taken from an engraved stele of the 7th century, 5 feet by 3 in size, to show the Chinese artist's treatment of horses at this period. The stele was erected by the celebrated T'ai Tsung, the real founder of the T'ang dynasty, to commemorate the services of six chargers, which he had ridden to battle on various occasions during the period 618–626, before he came to the throne. The inscription attached to each horse gives its name, its colour, the victory to which it contributed, and the number of arrows with which it was wounded, whether from the front or back, concluding with a laudatory verse of four lines. A man-at-arms is seen drawing an arrow from the breast of one of the horses, which is described as a chestnut bay, named "Autumn Dew," of the colour of the red wild goose, which the crown prince rode in the year 621 to the conquest of Tung Tu, the eastern capital in Honan. The animals, thick-set like the Mongolian strain of the present day, have braided manes and knotted tails, and they are bridled and saddled in a fashion which still holds good in China. Some of the painted pictures of the period display horses sketched in precisely similar lines.

The treatment of the human figure in sculpture of a later period is indicated in Fig. 19, the photograph of one of the colossal men in armour which guard the entrance of the mausoleum of the emperor Yung Lo (1403–24), about twenty-five miles north of Peking. Another figure appears in the background, and two of the three gates leading to the tomb are seen in the distance. The avenue of approach is lined with monoliths of men and animals carved in blue limestone. The military mandarins, six in number, of whom this is one, have mailed coats reaching down below the knees, close-fitting caps hanging over the shoulders, a sword in the left hand and a marshal's baton in the right. The civil

officials have robes with long hanging sleeves, tasselled sashes, bound with jade-mounted belts, embroidered breastplates, and square caps. The animals which follow, facing the avenue, comprise two pairs of lions, two of unicorn monsters, two of camels, two of elephants, two of *ki-lin*, and two of horses ; one pair being represented standing, the other seated or kneeling.

The remaining selections for this chapter are of Buddhist origin. The name of Buddha was first heard in China after the return of the Chinese envoy, Chang Ch'ien, from his adventurous journey to Central Asia in B.C. 126, and the religion was officially recognised in A.D. 67 in the way alluded to in the introduction (p. 23). The Tartar dynasties have always been its chief patrons in China, especially the Northern Wei (A.D. 386–549), and the Mongolian Yuan (A.D. 1280–1367), to which our illustrations belong.

The first (Fig. 20) is an early representation of Amitâbha, the ideal Buddha of boundless age and light, whose paradise is in the Western Heavens. He stands on a lotus pedestal, with a threefold nimbus round the head, under a jewelled canopy surmounted by a diadem and hung with strings of silken tassels. The following inscription is engraved underneath :—

" Spiritual truth is deep and wide, of infinite excellence but difficult comprehension. Without words it would be impossible to expound its doctrine, without images its form could not be revealed. Words explain the law of two and six, images delineate the relations of four and eight. Is it not profound and co-extensive with infinite space, beyond all comparison lofty ?

" Chang Fa-shou, the liberal founder of this temple Wu Shêng Ssŭ, was able under the manifold net of a five-fold covering, to cut the bonds of family affection and worldly cares. In the 2nd year (A.D. 517) of the Hsi P'ing epoch, he gave up his house and built the temple there, and in fulfilment of old vows had the images carved, so that his happiness will be endless. He joyfully accepted the salvation of the law and after searching out its intricate doctrine entered its sacred borders. It must verily have been the fruit of seed sown during previous existences and cherished for many generations, how else could he have accomplished such a grand votive deed?

" His descendants Jung-ch'ien and Hsün-ho, benevolent in deed and filial piety, have carried on in their generation the good work, and proved their far-reaching love in completing the fulfilment of the great vow. They have carved in stone

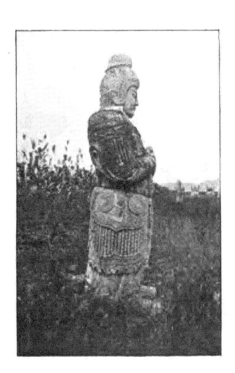

FIG. 19.—COLOSSAL STONE FIGURE.
Ming Tombs. 15th Century

FIG. 20.—STELE WITH AMITABHA BUDDHA.
Northern Wei Dynasty, A.D. 535.

Ht. 3 ft.

and erected statues of Shih-chia-wên Fo (Sâkyamuni Buddha), Kuan Yin (Avalokitesvara), and Wên Chu (Manjusri), thus reverently accomplishing the wishes of their late grandfather in his prosperity.

"In addition to these images they have also had engraved the above likeness of Wu-liang-shou Fo (Amitâbha Buddha), in the hope that felicity will be extended to their deceased father and mother. They have given their means for the faith and devoted all to make a monastic retreat, and may they both pierce the clouds of Bodhisatvaship and ultimately attain the enlightenment of Buddhaship.

"Inscribed in the Great Wei (dynasty) in the 2nd year (A.D. 535) of the T'ien P'ing (epoch), being the cyclical year yi-mao, on the 11th day of the 4th month, by the Pi-ch'iu (Bhikshu) Hung Pao."

An example of bas-relief carving of the same period from the front, measuring six by one and a half feet, of a stone pedestal of Maitreya Buddha (Mi-lo Fo), is shown in Fig. 21. Two Buddhist monks with shaven heads are worshipping, one reciting with folded hands uplifted, the other putting incense, taken from the covered round casket which he holds in his left hand, into the tray of the elaborately mounted censer which stands on the ground between them. The rest of the space is occupied by two grotesque lion-like monsters with protruded tongues and flowing manes. The inscriptions attached give the names of the resident monks, the date of the dedication of the image, and of the completion of the temple of Chieh Kung Ssŭ in which it was installed, both being dated the 3rd year (A.D. 527) of the Hsiao Ch'ang epoch of the Wei dynasty.

The rubbings illustrated in Fig. 22, two feet broad, are taken from the four sides of a square stone pedestal, which once supported an image of Maitreya, the Buddhist Messiah, recently discovered in the province of Chihli. The inscription records its dedication by the governor of Wei Hsien, the modern T'ai-ming Fu, in the sixth year of the Chêng Kuang epoch of the Great Wei dynasty (A.D. 524). This personage is seen in the procession, on the second panel, accompanied by two boys, perhaps his sons, and followed by attendants holding up an umbrella, banner screens, and other symbols of office ; one is leading a horse laden with rolls of silk, another an ox harnessed to a cart. Two mythical lions guard an

incense urn, and the intervals are filled in with conventional birds and flowers, the lotus predominating, emphasizing the *horror vacui* of the primitive artist. The general effect is that of a woven silk brocade rather than a stone bas-relief.

The Mongolian Khans of the Yuan dynasty patronised Lamaism, the Tibetan form of Buddhism. Bashpa, a Tibetan lama, was made State Preceptor in A.D. 1260, and was recognised by the Khan as supreme head of the Buddhist Church. In 1269 he composed an alphabet, modelled on that of the Tibetan script, for the transliteration of all languages under the sway of Kublai Khan. An example of the Bashpa script is preserved in the well-known arch at Chü Yung Kuan (Fig. 23), a gateway through a branch of the Great Wall as it spans the Nankou Pass, forty miles north of Peking. The arch dated 1345, is built of massive blocks of marble, deeply carved with Buddhist figures and symbols, besides the inscriptions in six languages which have been recently published at Paris by Prince Roland Bonaparte in a magnificent album. The keystone of the arch displays the garuda bird in bold relief, between a pair of Nâga kings, with seven-cobra hoods, whose serpentine bodies are lost in the rich coils of foliage which succeed. The four corners, inside, are guarded by the four mahârajas, sculptured in marble blocks after the fashion exhibited in Fig. 24, which represents Dhritarâshtra, the great guardian king of the east, identified by the mandolin on which he is playing.

The six scripts of the Chü Yung Kuan archway are the same as those which were engraved in 1348, three years later, on a stone stele at Sha Chou, in the province of Kansu, on the verge of the Great Desert, a facsimile of which is given in Fig. 25. This is headed *Mo Kao Wo*, *i.e.*, The Grotto of Peerless Height. The central niche presents a figure of the four-handed Avalokita, seated upon a lotus pedestal, with two hands folded in the "attitude of meditation," the others grasping a rosary, and a lotus blossom. It is posed as a Bodhisattva, with a nimbus encircling the head, on

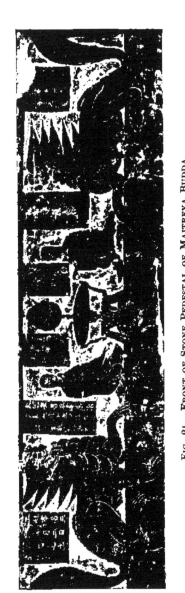

Fig. 21.—Front of Stone Pedestal of Maitreya Budda.
Northern Wei Dynasty. A.D. 527.

6 ft. × 1¾ ft.

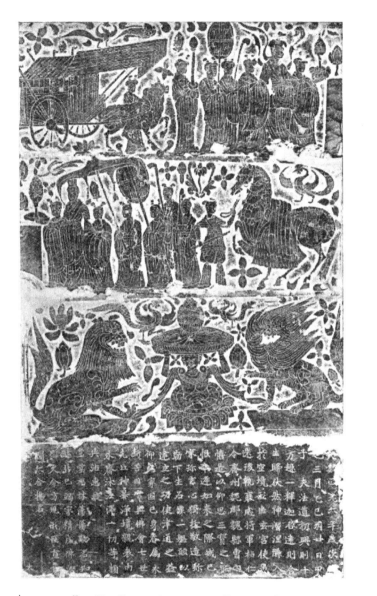

FIG. 22.—CARVED PEDESTAL OF BUDDHIST IMAGE.
Northern Wei Dynasty. A.D 524.

3½ ft × 2 ft.

which rests a small figure of Amitâbha, the corresponding Dhyâni Buddha. The hexaglot inscription round the figure is the oft-repeated spell *Om maṇi padme hûm*, which is consecrated to Avalo-kita and consequently to his living incarnation the Grand Lama of Tibet. The two horizontal lines above are in Devanagari and Tibetan script. The vertical lines on the left are in Uigur Turk, derived from the Syriac and parent of the modern Mongol and Manchu ; and in the Bashpa Mongol script referred to above, which is derived from the Tibetan. The vertical lines on the right are in the rare Tangut script of the locality, Shachou (the Sachiu of 'Marco Polo) having been one of the cities of the Tangut kingdom which was destroyed by Genghis Khan in 1227 ; and Chinese. The rest of the Chinese inscription gives the names of the restorers of the shrine headed by those of Sulaiman, king of Sining, and his consort Kiuchou ; and the date, the 8th year of the epoch Chih Chêng (A.D. 1348) of the great Yuan (dynasty).

As an example of modern sculpture in stone no better example could be selected than the marble stupa of Pai T'a Ssŭ, which was built in the northern suburbs of Peking by the Emperor Ch'ien Lung in memory of the Panchan Bogdo, the Grand Lama of Tashil-hunpo, who died there of smallpox on November 12th, 1780. His robes were buried under this stupa, although his cremated remains were carried back in a gold casket to Tibet. An interesting account of his visit to Peking is given in *Bogle's Mission to Tibet*. The stupa, as seen in Fig. 26, is modelled in Tibetan lines, adhering generally to the ancient Indian type, but differing in that the dome is inverted. The spire, or *toran*, composed of thirteen step-like segments, symbolical of the thirteen Bodhisat heavens, is surmounted by a large cupola of gilded bronze. It is mounted on a series of angular plinths, posed upon a solid base of octagonal form. On the eight sides are sculptured in high relief scenes in the life of the deceased Lama, including the preternatural circumstances attendant on his birth, his entrance into the priesthood, combats with heretics,

instruction of disciples, and death. The birth scene is presented in Fig. 27, which shows the Bodhisattva with haloes round the body and head, seated upon a lotus pedestal, borne by a white elephant supported by clouds, while more scrolls of clouds fill in the background ; picturing the appearance of the celestial divinity for his final incarnation as a living Buddha, the mountain pavilion on the left being the family residence of the future saint. The surroundings indicate the extraordinary richness and delicate finish of the carved details in the ornamental bands, composed of phœnixes flying through sprays of flowers, grotesque sea monsters in the midst of rolling waves, bats appearing in the intervals of serried scrolls of clouds, and many other designs of diverse character.

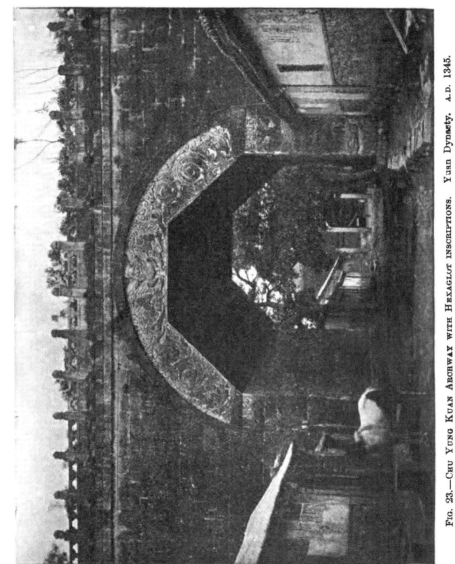

FIG. 23.—CHU YUNG KUAN ARCHWAY WITH HEXAGLOT INSCRIPTIONS. YUAN DYNASTY. A.D. 1345.

F

FIG. 24.—STONE SCULPTURE OF DHRITARASHTRA.
Chu Yung Kuan Archway. A.D. 1345.

FIG. 25.—AVOLOKITA WITH HEXAGLOT INSCRIPTION.
Yuan Dynasty. A.D. 1348.

26 in. × 18 in.

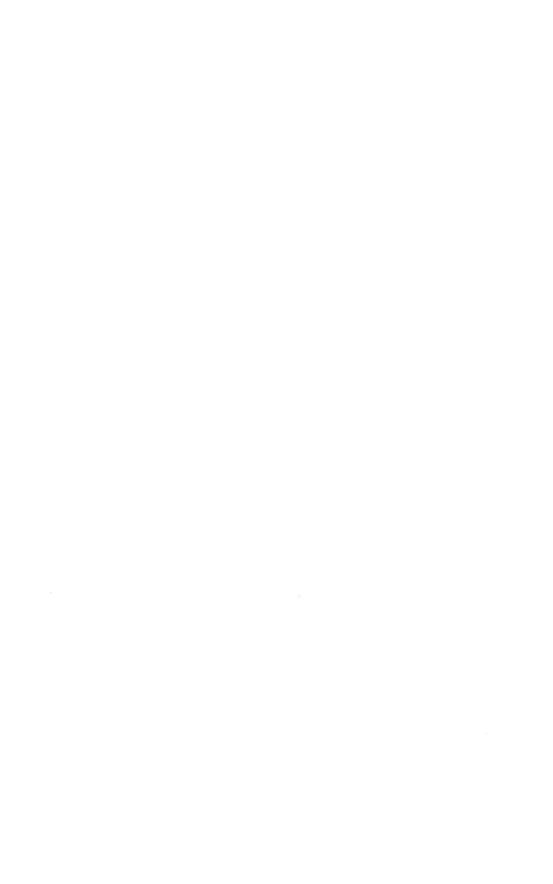

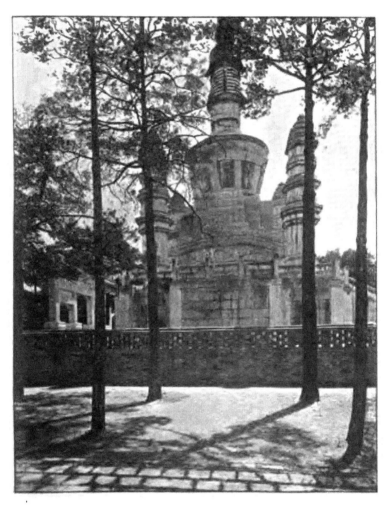

Fɪɢ. 26.—Stupa of Sculptured Marble.
Pai T'a Ssŭ, Peking. 18th Century

FIG. 27.—INCARNATION OF A BODHISATTVA.
Sculptured in Marble at Pai T'a Ssŭ, Peking. 18th Century.

CHAPTER III.

The first impression given by the view of a Chinese city from the parapet of the city wall—whether it be Tientsin, with the 150,000 houses of its population of shopmen and artisans, or Peking, with its temples, its imperial and princely palaces and its public buildings —is that of a certain monotony, resulting from the predominance of a single type of architecture. After a long residence this impression still remains, and it is very rarely that a building stands out which is not reduceable to one general formula.

China, in fact, in every epoch of its history and for all its edifices, civil or religious, public or private, has kept to a single architectural model. Even when new types have been introduced from the west under the influence of Buddhism and Mohammedanism, the lines have become gradually toned down and conformed to his own standard by the levelling hands of the Chinese mason. It is a cardinal rule in Chinese geomancy that every important building must face the south, and the uniform orientation resulting from this adds to the general impression of monotony.

The most general model of Chinese buildings is the *t'ing*. This consists essentially of a massive roof with recurved edges resting upon short columns. The curvilinear tilting of the corners of the roof has been supposed to be a survival from the days of tent dwellers, who used to hang the angles of their canvas pavilions on spears ; but this is carrying it back to a very dim antiquity, as we have no records of the Chinese except as a settled agricultural people. The roof is the principal feature of the building and gives to it, when finished, its qualities of grandeur or simplicity, of strength or grace. To vary its aspect the architect is induced occasionally

to double, or even to triple it. This preponderance of a part usually sacrificed in Western architecture is justified by the smaller vertical elevation of the plan, and the architect devotes every attention to the decoration of the roof by the addition of ante-fixal ornaments, and by covering it with glazed tiles of brilliant colour, so as to concentrate the eye upon it. The dragons and phœnixes posed on the crest of the roof, the grotesque animals perched in lines upon the eaves, and the yellow, green and blue tiles which cover it are never chosen at random, but after strict sumptuary laws, so that they may denote the rank of the owner of a house or indicate the imperial foundation of a temple.

The great weight of the roof necessitates the multiple employment of the column, which is assigned a function of the first importance. The columns are made of wood; the shaft is generally cylindrical, occasionally polyhedral, never channelled; the capital is only a kind of consol, squared at the ends, or shaped into dragons' heads; the pedestal is a square block of stone chiselled at the top into a circular base on which the shaft is posed. The pedestal, according to rule, ought not to be higher than the width of the column, and the shaft not more than ten times longer than its diameter. Large trunks of the *Persea nanmu* from the province of Ssŭchuan are floated down the Yangtsze river to be brought to Peking to be used as columns for the palaces and large temples.

The *nanmu* is the tallest and straightest of Chinese trees, the grain improves by age, and the wood gradually acquires a dead-leaf brown tint while it preserves its aromatic qualities, so that the superb columns of the sacrificial temple of the Emperor Yung Lo, Fig. 28, which date from the early part of the fifteenth century, still exhale a vague perfume. The pillars are brightened with vermilion and gold, but it is the roof which still attracts most attention, in the interior as well as outside, the beams being often gorgeously inlaid with colours and the intervening ceiling

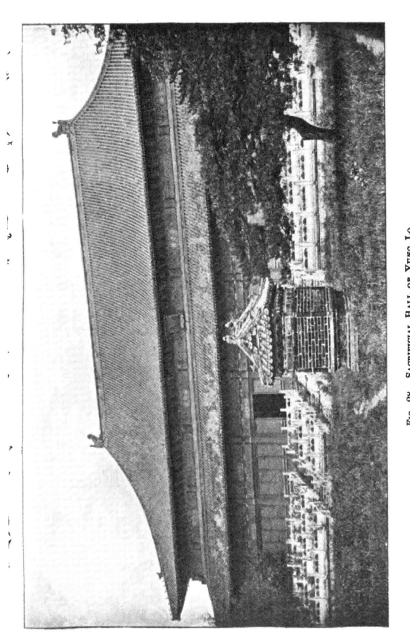

Fig. 28.—Sacrificial Hall of Yung Lo.
Ming Tombs near Peking. 15th Century.

geometrically divided into sunken panels worked in relief and lacquered with dragons or some other appropriate designs.

The stability of the structure depends upon the wooden framework ; the walls, which are filled in afterwards with blocks of stone or brickwork, are not intended to figure as supports ; the space in fact, is often occupied entirely by doors and windows carved with elegant tracery of the most flimsy character. A Chinese fabric so far, is curiously analogous to a modern American building of the newest type, with its skeleton framework of steel filled in with dummy walls.

The Chinese seem to have a feeling of the innate poverty of their architectural designs and strive to break the plain lines with a profusion of decorative details. The ridge poles and corners of the sagging roofs are covered with finial dragons and long rows of fantastic animals, arranged after a symbolism known only to the initiated, the eaves are underlaid with elaborately carved woodwork brilliantly lacquered, the walls are outlined with bands of terra cotta reliefs moulded with figures and floral sprays ; but in spite of everything, the monotony of the original type is always apparent.

Chinese buildings are usually one-storied and are developed horizontally as they are increased in size or number. The principle which determines the plan of projection is that of symmetry. The main buildings and the wings, the side buildings, the avenues, the courtyards, the pavilions, the motives of decoration, all the details in fact, are planned symmetrically. The architect only departs from this formal rule in the case of summer residences and gardens, which are, on the contrary, designed and carried out in the most capricious fashion. Here we have pagodas and kiosques elevated at random, detached edifices of the most studied irregularity, rustic cottages and one-winged pavilions ; dotted down in the midst of surroundings of the most complicated and artificial nature, composed of rockeries, lakes, waterfalls, and running streams spanned by fantastic bridges, with an unexpected surprise at every turn.

Ruins in China are rare, and we must turn to books to get some idea of ancient architecture. The first large buildings described in the oldest canonical books are the lofty towers called *t'ai*, which were usually square and built of stone, rising to the height sometimes of 300 feet, so that they are stigmatised as ruinous follies of the ancient kings. There were three kinds of *t'ai*, one intended as a storehouse of treasures, a second built within a walled hunting park for watching military exercises and the pleasures of the chase, and a third, the *kuan hsiang t'ai*, fitted up as an astronomical observatory. The Hsia dynasty, of the second millenium B.C., was renowned for its buildings and irrigation works ; their predecessor Shun as a patron of the potter's art ; while among their successors, the Shang dynasty was celebrated for its sacrificial vessels and wine cups, the Chou dynasty for the finish of its hunting and war chariots. Among the later representatives of the *t'ai* are the towers of the Great Wall, which are built of stone with arched doors and windows—the Chinese would seem always to have employed the arch in stone architecture ; the storied buildings dominating the gateways and angles of the city walls, often used to store arms ; and the observatory of Peking, which is also a square tower mounted upon the city wall. When the tower is planned of oblong section, broader than it is deep, it is technically called a *lou*.

Chinese buildings might be classified as civil, religious, and funereal, but it is more convenient to group all together in the few illustrations allowed in our limited space. The Hall of the Classics, called Pi Yung Kung, Fig. 29, was built after an ancient model by the emperor Ch'ien Lung in Peking, adjoining the national university called Kuo Tzŭ Chien, where the Temple of Confucius and the stone drums, as described above, are installed. The emperor goes there in state on certain occasions to expound the classics, seated upon the large throne within the hall, which is backed by a screen fashioned in the form of the five sacred mountains. It is a lofty square building with a four sided roof covered with tiles enamelled imperial yellow,

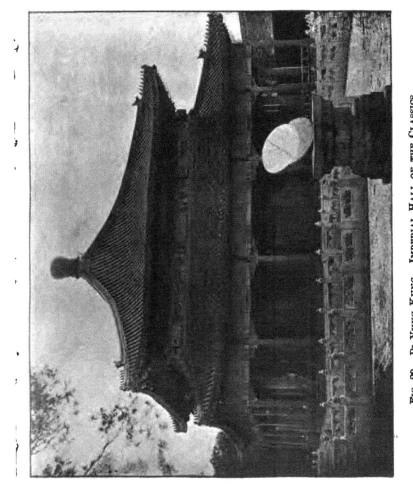

FIG. 29.—PI YUNG KUNG. IMPERIAL HALL OF THE CLASSICS.
National University, Peking. 18th Century.

7911.

G

and surmounted by a large gilded ball, encircled by a pillared verandah under a second projecting roof of yellow tiles. The four sides consist, each one, of seven pairs of folding doors with tracery panels. It is surrounded by a circular moat with marble balustrades crossed by four bridges leading to the central doors. On the sides of the courtyard in which it stands are two long cloistered buildings sheltering about 200 upright stone steles covered with inscriptions over the front or back. The inscriptions comprise the complete text of the " nine classics," and were engraved by the emperor Ch'ien Lung, in emulation of the Han and T'ang dynasties, both of which had the canonical books cut in stone at Si An Fu, the capital of China in their times. The text is divided on the face of the stone into pages of convenient size, so that rubbings may be taken on paper and bound up in the form of books. It was the custom as early as the Han dynasty to take such impressions, a practice which may possibly have first suggested the idea of block printing.

A sun-dial of antique form is seen mounted on a stone pedestal in the foreground of the picture. On the other side of the hall, the south, stands a magnificient " porcelain " pailou, resembling the one illustrated in Fig. 30, which spans the avenue leading to Wo Fo Ssŭ, the " temple of the sleeping Buddha " in the Western Hills near Peking. The pedestals and three arches are built of sculptured marble, separated by walls of vermilion stucco from the panelled facing of faience covering the rest of the structure, which is enamelled in three colours, yellow, green, and blue, and forms an elaborate framework for the inscribed tablet of white marble enshrined in the centre. This tablet, the motive of the erection, displays a short dedicatory formula, composed and presented by the emperor, which is chiselled and filled in with red in the actual lines of his original brushwork. These archways, which are a characteristic feature of Chinese architecture, are only erected by special authority. They are generally made of wood with tiled roof and are usually intended as memorials of distinguished men and women. Some, however, are

built entirely of stone like the immense gateway with five portals at the avenue of the Ming tombs. The stone *toran* of Indian *stupas* is doubtless the original form from which the Chinese *pailou*, as well as the Japanese *tori* is derived.

One of the grandest and most interesting sights of Peking is the Temple of Heaven, which is within the southern or Chinese city, surrounded by stately cypress trees in the midst of a walled park over three miles round. The oxen used in sacrifice are kept in the park, and there are separate inclosures provided for the other sacrificial animals, which include sheep, deer, pigs, and hares. The consecrated meats are prepared in accordance with an ancient ritual in kitchens built for the purpose, to which are attached special slaughter houses, well houses, and stores for vegetables, fruit, corn, and wine. The Chinese have no idea of vicarious sacrifice, the offerings to their supreme deity are like the precious objects, raiment, and foods, which are set forth in ancestral worship. Heaven is not worshipped alone ; the ancestral tablets of four of the imperial forefathers are always associated with the tablet of Shang Ti, the " supreme deity," followed by those of the sun, moon, planets and starry constellations, while the spirits of the atmosphere, winds, clouds, rain and thunder are ranged in subordinate rank below. Heaven is distinguished by the offering of blue jade *pi*, a foot in diameter, round and with a square hole in the middle, like the ancient mace-head symbols of sovereignty, and by the bullock being sacrificed as a whole burnt offering. The jade and silk are also burnt ; twelve rolls of plain white silk and hempen cloth being sacrificed for heaven, one for each of the other spirits ; while the banquet piled on the altar in dishes of blue porcelain is proportionately lavish.

The great altar of heaven, T'ien T'an, the most sacred of all Chinese religious structures, is seen in Fig. 31. It consists of three circular terraces with marble balustrades and triple staircases at the four cardinal points to ascend to the upper terrace, which is ninety feet wide, the base being 210 feet across. The platform is laid with

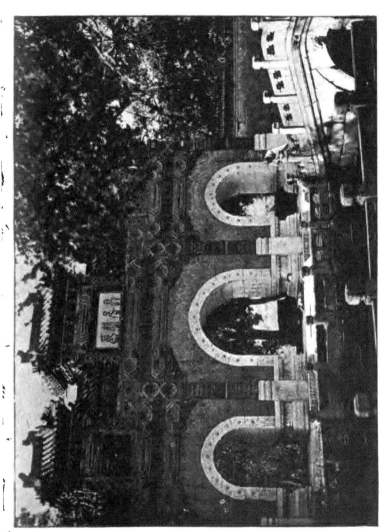

FIG. 30.—PAILOU. MEMORIAL ARCH OF MARBLE AND GLAZED TERRACOTTA.
Buddhist Temple of the Sleeping Buddha, near Peking.

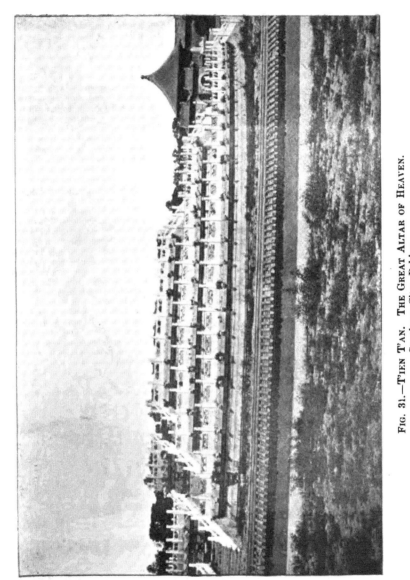

FIG. 31.—TIEN T'AN. THE GREAT ALTAR OF HEAVEN.
Southern City, Peking.

marble stones in nine concentric circles and everything is arranged in multiples of the number nine. The emperor, prostrate before heaven on the altar, surrounded first by the circles of the terraces and their railings, and then by the horizon, seems to be in the centre of the universe, as he acknowledges himself inferior to heaven, and to heaven alone. Round him on the pavement are figured the nine circles of as many heavens, widening in successive multiples till the square of nine, the favourite number of numerical philosophy, is reached in the outer circle of eighty-one stones. The great annual sacrifice on the altar is at dawn on the winter solstice, the emperor having proceeded in state in a carriage drawn by an elephant the day before, and spent the night in the hall of fasting called Chai Kung, after first inspecting the offerings. The sacred tablets are kept in the building with a round roof of blue enamelled tiles behind the altar which is seen on the right of the picture. The furnace for the whole burnt offering stands on the south-east of the altar, at the distance of an arrow flight ; it is faced with green tiles, and is nine feet high, ascended by three flights of green steps, the bullock being placed inside upon an iron grating, under which the fire is kindled. The rolls of silk are burned in eight open-work iron urns, stretching from the furnace round to the eastward ; an urn is added when an emperor dies. The prayers written upon silk are also burned in these urns after they have been formally presented in worship before the tablets.

To the north of the great altar, which is open to the sky, there is a second three-tiered marble altar conceived in similar lines, but somewhat smaller, called the Ch'i Ku T'an, or altar of prayer for grain. This is dominated by the imposing triple roofed temple presented in Fig. 32, which is covered with tiles of deep cobalt blue shining in the sunlight so as to make it the most conspicuous object in the city. The name of this edifice, as set forth on the framed plaque fixed under the eaves of the upper roof, in Manchu and Chinese script, is Ch'i Nien Tien, "temple of prayer for the year."

The Emperor goes there early each year in spring to make offerings for a propitious year. It is 99 feet high, the upper roof supported by four stately pillars, the lower roofs by two circles of twelve pillars, all straight trunks of *nan-mu* trees recently brought up from the south-west, when the temple had to be rebuilt after its destruction by fire. Originally founded by the Emperor Ch'ien Lung, it was rebuilt during the present reign in every detail after the old plan. During the ceremonies inside everything is blue ; the sacrificial utensils are of blue porcelain, the worshippers are robed in blue brocades, even the atmosphere is blue, venetians made of thin rods of blue glass, strung together by cords, being hung down over the tracery of the doors and windows. Colour symbolism is an important feature of Chinese rites ; at the temple of earth all is yellow ; at the temple of the sun, red ; at the temple of the moon, white, or rather the pale grayish blue which is known as *yueh pai*, or moonlight white, pure white being reserved for mourning. The altar of the earth, Ti T'an, is on the north of the city, outside the city wall, and is square in form ; the offerings are buried in the ground instead of being burned. The temples of the sun and moon are on the east and west and are also outside the city wall of Peking ; the princes of the blood are usually deputed by the emporer to officiate at these.

A good illustration of the *t'ing*, which is so characteristic of Chinese architecture, has been given in Fig. 28, from a photograph of the large sacrificial hall of the Emperor Yung Lo. The tombs of the Ming dynasty, called colloquially Shih-san Ling, "Tombs of the Thirteen (Emperors)," are, as the name indicates, the last resting places of thirteen of the Ming emperors. The first was buried at Nanking, his capital ; the last near a Buddhist temple on a hill west of Peking, by command of the Manchu rulers when they obtained the empire. The Emperor Yung Lo (1403-1424), who made Peking his capital, chose this beautiful valley for the mausoleum of his house. It is six miles long, thirty miles distant from Peking to

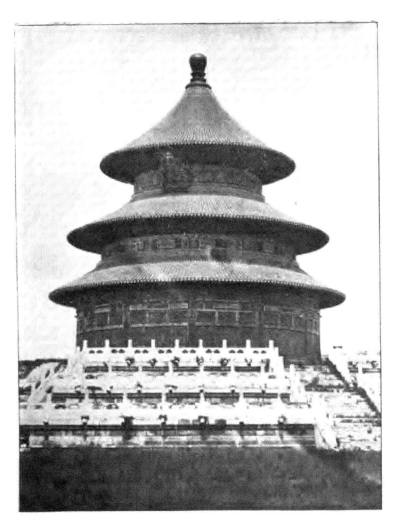

FIG. 32.—CH'I NIEN TIEN. TEMPLE OF HEAVEN.
Southern City, Peking.

the north, and the imperial tombs are in separate walled inclosures, dotting the slopes of the wooded hills which skirt the valley. The avenue with its rows of colossal stone figures has been noticed in the last chapter. At the end of the avenue one comes to a triple gateway leading to a court with a smaller hall, and passes through to reach the main courtyard with the large sacrificing hall, where, by order of the Manchu emperors, offerings are still presented to the long-deceased ruler of a fallen dynasty by one of his lineal descendants selected for the purpose. The hall is mounted upon a terrace, with three balustrades of carved marble extending all round, ascended by three flights of eighteen steps in front and behind, leading to three portals with folding doors of tracery. It is seventy yards long by thirty deep, with a massive tiled roof supported by eight rows of four pillars each. The columns, of *Persea nanmu* wood, are twelve feet round at the base and over sixty feet high to the true roof, under which there is a lower ceiling, about thirty-five feet from the floor, made of wood in sunken square panels painted in bright colours. The ancestral tablet is kept in a yellow roofed shrine mounted upon a daïs, with a large carved screen in the background, and in front stands a sacrificial table with an incense urn, a pair of pricket candlesticks and a pair of flower vases ranged in line upon it. Leaving this magnificent hall and passing through another court, planted like those preceding with pines, arbor vitæ trees and oaks, one comes to the actual tomb. A subterranean passage forty yards long leads to the tumulus, the door of which is closed by masonry, but flights of steps, east and west, lead to the top of the grave terrace. Here, in front of the mound, and immediately above the coffin passage, is the tombstone, an immense upright slab, mounted upon a tortoise, inscribed with the posthumous title, "Tomb of the Emperor Ch'êng Tsu Wên." The tumulus is more than half a mile in circuit, and, though artificial, looks like a natural hill, being planted with trees to the top, among

which the large-leafed oak (Quercus Bungeana), on which wild silkworms are fed, is conspicuous.

, The usual paraphernalia of the shrine of an ancestral temple are seen in Fig. 33, which is a view of the interior of the Confucian Temple in the Kuo Tzŭ Chien, the old national university of Peking. The ancestral tablet is seen dimly in the centre of the picture enshrined in an alcove between two pillars. The tablet, two feet five inches high and six inches broad, mounted upon a pedestal two feet high, is inscribed in gold letters upon a lacquered vermilion ground, in Manchu and Chinese, " The tablet of the spirit of the most holy ancestral teacher Confucius." The pillars are hung with laudatory couplets, and the beams with dedicatory inscriptions, one of which is pencilled by each succeeding Emperor in token of his veneration for the sage. The line of four large characters above, for example, *Wan shih shih piao*, " The Model Teacher of a Myriad Ages," was composed and written by the Emperor K'ang Hsi in the twenty-fourth year of his reign (A.D. 1685), and is authenticated by his seal attached to the inscription. The *wu kung*, " sacrificial set of five," comprising incense urn, pricket candlesticks and flower vases, made of bronze, is here posed on separate stands of white marble. In front of all is the table ready for the sacrificial offerings, which are regularly presented at spring and autumn. The rest of the large hall is lined with tablets of Tsêng Tzŭ, Mencius, and the other distinguished sages and disciples of Confucius, whose spirits are officially worshipped in turn on the same ceremonial occasions.

The ornamental lines of an open garden pavilion, which also comes under the general heading of *t'ing*, are fairly exhibited in Fig. 34, in spite of the half-ruinous condition of the picturesque structure, as it appeared when it was photographed after the destruction of the Summer Palace during the Anglo-French expedition of 1860. It stands on the border of the lake at Wan Shou Shan having recently been repaired for the Empress Dowager, who has tea served

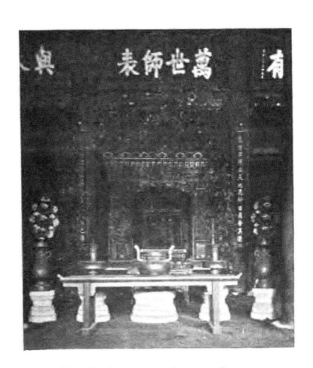

FIG. 33.—SHRINE AND ALTAR OF CONFUCIUS.
Confucian Temple, Peking.

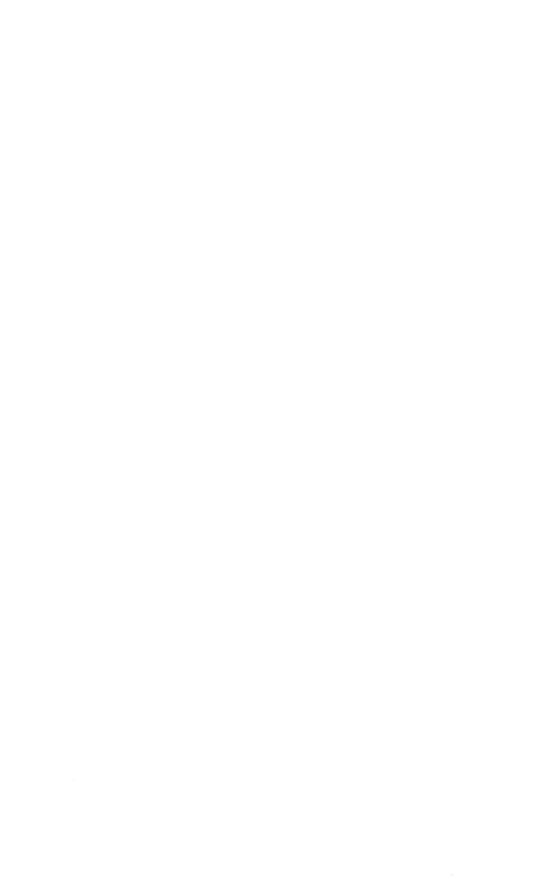

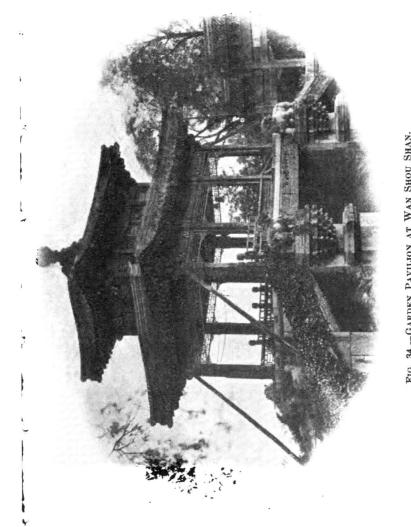

FIG. 34.—GARDEN PAVILION AT WAN SHOU SHAN.
Imperial Summer Palace, near Peking.

there for her European guests brought from Peking in state barges towed by steam tugs. It is hung with bronze bells which tinkle softly in the breeze. The central building, as well as the two *pailous* spanning the avenues through which it is approached, has its woodwork gaily decorated with painted scrolls, relieved by graceful bands of open fret, and it is roofed over all with yellow enamelled tiles. Notice the stone monsters at the four corners mounted upon short octagonal pillars with decorated capitals, which might be remote descendants of the ancient Hindu lion pillars of Asoka's time moulded in modern Chinese lines.

A view of the K'un-ming Hu, the lake which has just been referred to, is given in Fig. 35. The name comes down from the Han dynasty when it was given to a lake near Si-an Fu, the metropolis of the period in the province of Shensi, on which the Emperor Wu Ti had a fleet of war junks manœuvring to exercise the sailors for the conquest of Cochin China. The present lake, which is four miles in circuit, has been the first of the inland waters of China to have modern armed steamers in its waters, when the Empress Dowager had a review of model ships built at her command the year before the Boxer troubles. The imperial pavilion, erected by the Emperor Ch'ien Lung on the spot where the best view of the lake was to be obtained, is a prominent object in the picture. He was fond of inditing verses, and a favourite ode of his composition on the beauty of the surrounding scene is incised there on a marble stele.

The bronze ox in the foreground was also moulded under his auspices, and it is inscribed, as may be seen in the picture, with dedicatory stanzas written by the imperial brush, which are printed in the official description of Peking. The ox, as the chief agricultural animal, has been sacred in China from the earliest times, and it still has a foremost place in rustic spring ceremonial, being moulded in clay for the purpose. The verses, which are too long to be quoted in full, relate how the Emperor has taken as his model the ancient Yu of Hsia, whose eulogy was handed down on an iron ox

after he had carried off the river floods, how he has propitiated the sacred ox, a constellation of the zodiac, the queller of dragons and river monsters, and installed its figure here to preside for ever over the irrigation channels which he has dug for the benefit of the villagers, concluding with the peroration :—

" Men praise the warrior emperor of the Han,
We prefer as our example the ancient Yao of T'ang."

The marble bridge of seventeen arches in the picture is a remarkable example of the fine stone bridges for which the neighbourhood of Peking has been celebrated since Marco Polo described the many arched bridge of Pulisanghin, with its marble parapets crowned with lions, which spans the river Hunho, and is still visible from the hills which form the background of the summer palace. Our bridge, which was built in the twentieth year of Ch'ien Lung (A.D. 1755), leads from the cemented causeway to an island in the lake with an ancient temple dedicated to the dragon god and called Lung Shên Ssŭ, the name of which was changed by Ch'ien Lung to Kuang Jun Ssŭ, the " Temple of Broad Fertility," because the Emperor, as a devout Buddhist, objected to the deification of the Naga Raja, the traditional enemy of the faith.

A characteristic bridge of different form on the western border of the lake is illustrated in Fig. 36. This is called, from its peculiar shape, the Lo-ko Ch'iao, or Hunchback Bridge, and has only one arch, thirty feet high, with a span of twenty four feet. Its height allows the imperial barges to pass underneath without lowering their masts, and it is withal one of the most picturesque features of the landscape.

A bronze temple which stands on the southern slope of the hill of Wan Shou Shan is seen in Fig. 37. It is twenty feet high, double roofed, and designed in the usual lines, but every detail is executed in bronze, the pillars, beams, tiles, tracery of doors and windows, and all ornamental appendages having been previously moulded in metal. This is one of the few buildings which defied the fire in 1860. It

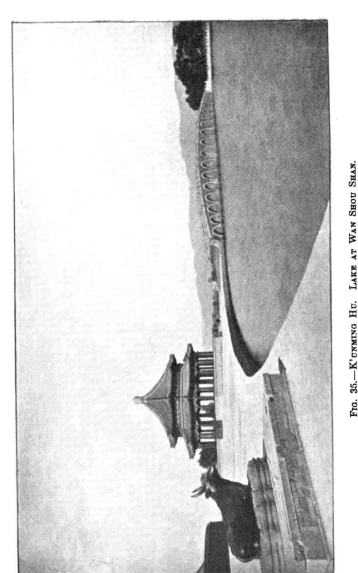

Fig. 35.—K'unming Hu. Lake at Wan Shou Shan.
Imperial Summer Palace, near Peking.

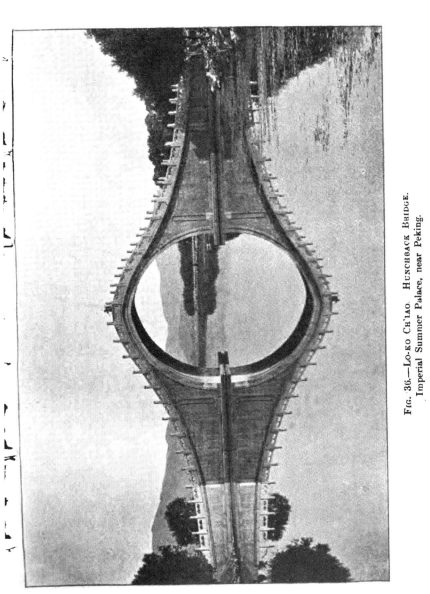

Fig. 36.—Lo-ko Ch'iao. Hunchback Bridge.
Imperial Summer Palace, near Peking.

stands on a marble foundation with carved railings and steps, which are piled with bricks and bushes to keep off pilferers of the valuable material. The miniature stupa, or dagaba, which crowns the crest of the roof, is an attribute of a Buddhist building, and this one, in fact, is intended to be a shrine for the historical Buddha, as it con‧ tains a gilded image of Sakyamuni enthroned on a lotus thalamus, with the usual set of utensils for burning incense.

The pagoda illustrated in Fig. 38 from the grounds of the Imperial Summer Palace of Yuan-ming Yuan is a fine example of architectural work in glazed faience, in the style of the famous porcelain tower of Nanking. The Nanking pagoda was razed to the ground by the Taiping rebels in the year 1854, but specimens of the tiles and ornamental fixtures are preserved in the museum. The practice of facing buildings, inside as well as outside, with slabs or tiles of faience coated with coloured glazes is very ancient in Asia. The processions of archers and lions lining the walls of the staircases of the palaces of Darius at Susa are striking examples of early date, and the art was further developed in the decoration of the mosques and tombs of Persia and Transoxiana during the middle ages. It dates in China from the Later Han dynasty, during which green glazed pottery first came into vogue, and was revived in the earlier half of the fifth century, when artisans are recorded to have come from the Yueh-ti, an Indo-Scythian kingdom on the north-western frontiers of India, and to have taught the Chinese the art of making different kinds of *liu-li*, or coloured glazes. The centre of the manufacture to-day is Po-shan Hsien, in the province of Shantung, where slabs and rods of coloured frits are produced, to be exported to all parts of the country, whenever required for the decoration of cloisonné and painted enamels on metal, porcelain, or faience. The imperial potteries for this kind of work are established in a valley of the western hills near Peking, as well as in the mountains in the vicinity of Mukden, the capital of Manchuria. Figures of Buddha and other temple divinities are fabricated at these

works, as well as the many kinds of antefixal ornaments, facings, and coloured tiles required for imperial buildings. When a suite of European palaces was designed by the Jesuits Attiret and Castiglione for Yuan-ming Yuan, enamelled fountains, elaborate screens with trophies, helmets and shields, balustrades with ornamental flower-pots and the like were executed at these potteries in orthodox Italian style.

The glazes used in the decoration of this pagoda are five in number; a deep purplish blue derived from a compound of cobalt and manganese silicates, a rich green from copper silicate, a yellow, approaching the tint of the yolk of an egg, from antimony, a *sang de bœuf* red from copper mixed with a deoxidising flux, and a charming turquoise blue derived from copper combined with nitre. The last two are more sparingly employed than the rest. The fivefold combination is intended to suggest the five jewels of the Buddhist paradise. A jewelled pagoda, *pao t'a*, of portentous dimensions is supposed, in the Buddhist cosmos, to tower upwards from the central peak of the sacred mount Meru, to pierce the loftiest heaven, and to illuminate the boundless ether with effulgent rays proceeding from the three jewels of the law and the revolving wheel with which it is crowned. Speculative symbolism of this kind is carried out in the form of the pagoda. The base, four-sided, represents the abode of the four maharajas, the great guardian kings of the four quarters, whose figures are seen enthroned here within the open arches. The centre, octagonal, represents the Tushita heaven, with eight celestial gods, Indra, Agni and the rest, standing outside as protectors of the eight points of the compass; this is the paradise of the Bodhisats prior to their final descent to the human world as Buddhas, and Maitreya, the coming Buddha, dwells here. The upper storey, circular in form, represents the highest heaven in which the Buddhas reside after attaining complete enlightenment; the figures in niches are the five celestial Buddhas, or Jinas, seated on lotus pedestals.

The ordinary pagoda of thirteen storeys, octagonal in section, solidly built of brick upon massive stone foundations, is seen in

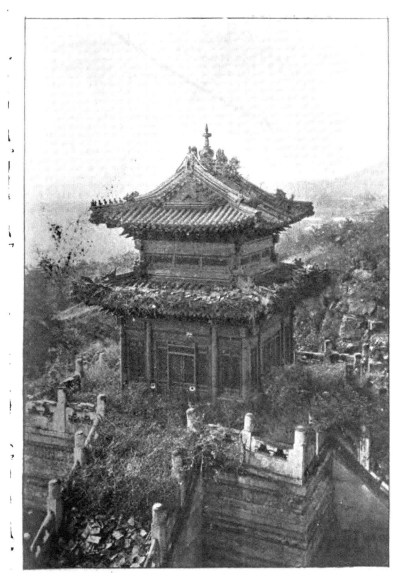

FIG. 37.—BRONZE BUDDHIST SHRINE AT WAN SHOU SHAN.
Imperial Summer Palace, near Peking.

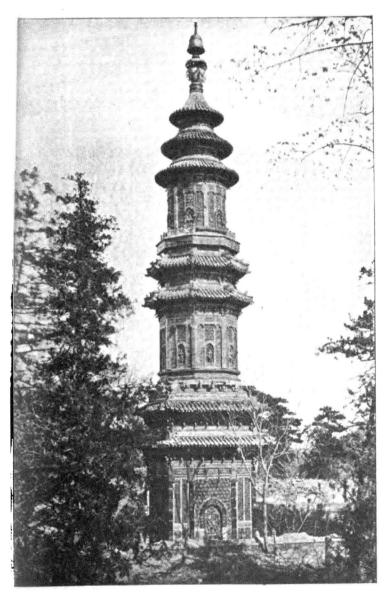

FIG. 38.—" PORCELAIN " PAGODA AT YUAN MING YUAN.
Imperial Summer Palace, near Peking.

Fig. 39. This one, which dates from the end of the seventh century, is attached to the temple of Ling-kuang Ssŭ, in the Western Hills near Peking, and it is plainly visible from the top of the city wall twelve miles distant. It is not certain, however, whether it be still standing, as it was unfortunately condemned to be blown up by dynamite in 1900, because the Boxers had made this temple their headquarters. The Buddhist monks have always chosen the most picturesque spots for their monasteries, and there are no less than eight temples on the slope of this particular hill, which is about 800 feet high, and many more in the vicinity. Some have imperial travelling palaces, called *Hsing Kung*, in adjoining courts ; all have guest rooms, *k'o t'ang*, as part of the original plan, for the entertainment of strangers and passing pilgrims.

The general plan of a Buddhist temple resembles that of a secular residence, consisting of a series of rectangular courts, proceeding from south to north, with the principal edifice in the centre, and the lesser buildings at the sides. A pair of carved stone lions guard the entrance, flanked by lofty twin columns of wood which are mounted with banners and lanterns on high days and holidays. The gateway is large and roofed to form a vestibule, in which are ranged, on either side, gigantic figures of the four great kings of the devas, *Ssŭ ta t'ien wang*, guarding the four quarters ; while in the middle are generally enshrined small effigies of Maitreya, the Buddhist Messiah, conceived as an obese Chinaman with protruberant belly and smiling features, and of Kuan Ti, the State god of war, a deified warrior, represented as a mailed figure in the costume of the Han period, seated in a chair.

Passing through the vestibule one sees on either side of the first court a pair of square pavilions containing a bronze bell and a huge wooden drum, and in front the main hall of the temple, called Ta hsiung pao tien, the " jewelled palace of the great hero," that is to say, Sakyamuni, the historical Buddha. He is always the central figure of the imposing triad enthroned upon lotus pedestals inside,

the two others are usually Ananda and Kasyapa, his two favourite disciples. Along the side walls are ranged life-size figures of the eighteen Arhans (Lohan) with their varied attributes, disciples who have attained the stage of emancipation from rebirth. Behind the principal court there is often another secluded courtyard sacred to Kuan Yin, the "goddess of mercy," where Chinese ladies throng to offer petitions and make votive offerings. Avalokitesvara (Kuan Yin) is installed here in the central hall, often supported by two other Bodhisattvas, Manjusri (Wên-shu), the "god of wisdom," and Samantabhadra (Pu-hsien), the "all-good." The surrounding walls are usually studded with innumerable small figures of celestial bodhisats, tier upon tier, moulded in gilded bronze or clay, and posed in niches. The wing buildings in this court are devoted to the deceased inmates of the monastery and contain portraits and relics of bygone abbots and monks. The side cloisters are two-storied in the large temples, the treasures of the monastery being stored above, as well as libraries, blocks for printing books, and the like.

An outer wall encircles the whole, inclosing besides a stretch of the hill slope, which affords ample space for the separate accommodation of the higher dignitaries of the establishment, for kitchens and stables, store-houses of fruit and grain, open pavilions for sipping tea and enjoying the view, and secluded quarters in terraced villas for the residence of occasional visitors.

The Buddhist triad displayed in Fig. 40 was taken from the interior of the large hall of the temple called Huang Ssŭ, which was built by the founder of the reigning Manchu dynasty for the residence of the fifth Grand Lama of Tibet, when the high dignitary came on a visit to Peking in the year 1647, and to which the stupa shown in Figs. 26, 27 is attached. This is a lama temple and the large images of gilded bronze represent Avalokita, Manjusri, and Vajrapani, seated upon lotus pedestals, the smaller standing figures being two attendant bodhisats carrying the alms-bowl and

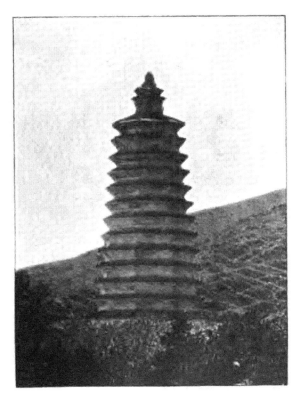

Fig. 39.—Pagoda at Ling Kuang Ssu.
Western Hills, near Peking. 7th Century.

I

7911.

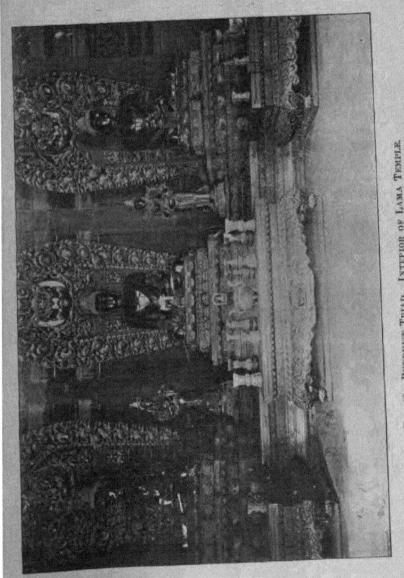

Fig. 40.—Buddhist Triad. Interior of Lama Temple.
Huang Ssŭ, near Peking.

I 2

chowry brush. The five little images posed in line in front of the pedestal of Avalokita represent the celestial Buddhas, Amitabha and the rest, and an image of Sakyamuni, the earthly reflex of Amitabha, is mounted in front. The massive altar tables and the sacrificial utensils and ritual symbols placed upon them are all chiselled in marble. The canopied background of the large figures is carved in wood and gilded, with the aureole encircled by a frieze of elephants, lions and mythical animals, culminating in coiling dragons, overawed by cherub-like *garudas*, which brood over the three jewels of the faith, the whole being enveloped in a broad rolling band of scrolled flames.

The difference between Lamaism and the ordinary form of Chinese Buddhism is shown most strongly by their discordant conceptions of Maitreya, the coming Buddha. His Chinese statuette has been described above, under the name of Milo Fo, as it is placed in the vestibule of a temple, and he is, besides, worshipped at many private houses and shops, so that he is almost as popular a divinity with men as Kuan Yin, the so-called " goddess of mercy," is with Chinese women. In Japan Hotei, the merry monk with a hempen bag is claimed by some to be an incarnation of the Bodhisat Maitreya, and is endowed there with national traits in the spirit of playful reverence which characterises the Japanese artist. The Lama conception of Maitreya, on the contrary, is that of a dignified and colossal figure, robed as a prince with the jewelled coronet of a bodhisat, towering above the other crests of the roofs of a lamassery, or occasionally carved on the face of a cliff. There is a gigantic image of Maitreya in the Yung Ho Kung, at Peking, made of wood, over seventy feet high, the body of which passes through several successive storeys of the lofty building in which it is installed. The devout votary must climb a number of winding staircases to circumambulate the sacred effigy in the orthodox way, till he finally reaches the immense head. Yung Ho Kung was the residence of the Emperor Yung Chêng before he came to the throne, and it was

dedicated to the Lama church, in accordance with the usual custom, when he succeeded in 1722. When the Emperor visits the temple a lamp is lit over the head of Maitreya, and a huge praying wheel on the left, which reaches upwards as high as the image, is set in motion on the occasion. The resident lamas, mostly Mongols, number some 1500, under the rule of a Gegen, or living Buddha, of Tibetan birth, who rejoices in the title of Changcha-Hutuktu Lalitavajra. An excellent portrait of this dignitary, from a miniature on silk, is given in Professor A. Grunwedel's *Buddhist Art in India*.

Lamaism may be said to rank as the State church of the reigning Manchu dynasty. The Lama temple illustrated in Fig. 41 was built by the Emperor K'ang Hsi, in the vicinity of the summer residence at Jehol, outside the Great Wall of China, where Earl Macartney was received by the grandson of the founder in 1793. The temple is built in the style of the famous palace-temple of Potala at Lhasa, the residence of the Dalai Lama. But the resemblance is only superficial; deceptive as it may be when seen at a distance from one of the pavilions in the imperial park, on closer inspection the apparently storied walls prove to be a mere shell, with doors and windows all unperforated. The temple buildings erected upon the hill behind, the double roofs of which appear above the walls in the picture, are really planned in the conventional lines of the *t'ing* and finished after the ordinary canons of Chinese architecture.

The picturesque stone structure illustrated in Fig. 42, which is commonly called Wu T'a Ssŭ, or the Five Towered Temple, is situated two miles west of Peking. It is said to be a copy of the ancient Indian Buddhist temple of Buddhagaya as explained in the following sketch of its history. In the early part of the reign of Yung Lo (1403–24), a Hindu sramana of high degree, named Pandita, came to Peking and was given an audience by the Emperor, to whom he presented golden images of the five Buddhas, and a model in stone of the diamond throne, the *vajrasana* of the Hindus,

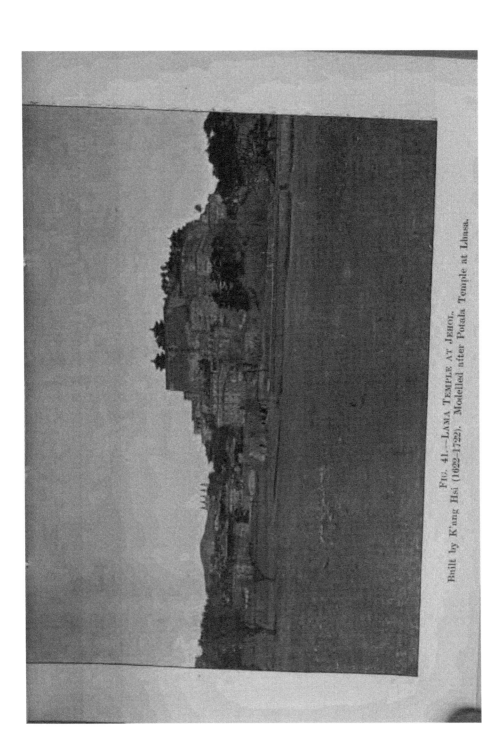

FIG. 41.—LAMA TEMPLE AT JEHOL.

Built by K'ang Hsi (1662–1722). Modelled after Potala Temple at Lhasa.

FIG. 42.—WU T'A SSU. FIVE TOWERED TEMPLE, NEAR PEKING.
Copy of Mahabodhi at Buddha-Gaya. 15th Century.

the *chin kang pao tso* of the Chinese, being the name of the memorial temple erected on the spot where Sakyamuni attained his Budda-hood which has recently been restored under British auspices. The Emperor appointed him State hierarch, conferred on him a gold seal, and fitted up for him as a residence the " True Bodhi " temple in the west of Peking, which had been founded during the preceding Mongol dynasty, promising at the same time to erect there a reproduction in stone of the model temple which he had brought with him, as a shrine for the sacred images. The new temple was not, however, finished and dedicated till the eleventh month of the cyclical year *kuei ssŭ* (1473), of the reign of Ch'êng Hua, according to the marble stele set up beside it, which was inscribed by the Emperor on the occasion. This states that in dimensions as well as in every detail it was an exact reproduction of the celebrated diamond throne of Central India. The temple is surrounded by a carved stone railing of Indian design which is hidden by the wall in the picture, and which is surmounted by a stone fencing. The body of the temple, about fifty feet high, is square and of solid construction, composed of five tiers of stones carved with Buddhas seated in niches. Inside the arched doorway, right and left, are two staircases piercing the solid stonework and leading to the flat platform above, which displays in prominent relief a pair of Buddha's footprints, and an infinite variety of symbols and Sanscrit letters strange to Chinese architecture. Within the five pagodas of Indian form, the central one larger than the rest, which are posed on the platform, the golden Buddhas brought from India are said to be enshrined, while their figures are repeated in stone and sunk in niches on the four sides of the walls outside each pagoda. For a description of the original temple reference may be made to General Sir A. Cunningham's book, *Mahabodhi, or the Great Buddhist Temple under the Bodhi Tree at Buddha-Gaya, London*, 1892.

Taoist temples are built upon the same general plan as the temples dedicated to the Buddhist cult. The adherents of Lao Tzŭ have borrowed from the Buddhist bonzes the interior decoration of their sacred halls, as well as the plastic representation of divinities, the worship of idols, and many of their ritual ceremonies. The Buddhist triad is replaced by an imposing triad of supreme deities called Shang Ti, who preside over the jade paradise of the Taoist heavens ; statues of Lao Tzŭ, and of the eight immortals, called Pa Hsien, are posed in prominent places ; and there are separate shrines for the three star-gods of happiness, rank, and longevity, and for a multitude of lesser lights of the faith whose name is legion. The sacrificial vases, candlesticks and incense burners, as well as the other ritual surroundings, bear distinctive Taoist symbols and emblems.

This slight sketch of Chinese architecture may be closed by a brief reference to Mohammedanism, which counts in China some twenty-five million adherents, so that the Emperor rules as many Muslim subjects as the British *raj*, about as many as the Sultan of Turkey and Shah of Persia together. There are about 20,000 Muslim families in Peking, with eleven mosques, many of their shops and eating-houses are marked with the sign of the crescent, and they have almost a monopoly of certain trades, including drivers of carts and pack-mules, horse dealers, butchers and public bath keepers. Every large city has its mosque, the Chinese name of which, Li Pai Ssŭ, or " temple of ritual worship," has been generally adopted by Protestant missionaries for their churches. The most ancient Chinese mosque is that of the " Sacred Souvenir " at Canton, which is said to have been founded by Saad-ibn-abu-Waccas, maternal uncle of Mohammed, who is supposed to have come to Canton to preach Islamism. This mosque was certainly in existence in the ninth century, when there was an Arabian colony in Canton ; it was burned down in 1341, rebuilt soon after, and again thoroughly restored in 1699.

Chinese mosques resemble Buddhist temples in the fact that there is nothing in their exterior to indicate the foreign origin of the religion to which they belong. They are of Chinese style throughout, with the exception of lines of verses from the Koran written on the interior walls in Arabic script in the intervals of intricate scrolls of the usual Muslim formulæ, which form the only motives of decoration. The main building is divided into five naves by three rows of wooden pillars, the Mirhab, or *wang-yu-lo*, being at the end of the central nave. The general impression, on entering, is one of severe simplicity, contrasting strongly with the interior of a Buddhist or Taoist temple full of gilded images and embroidered hangings. The only furniture is one broad table of wood, carved in ordinary Chinese style, near the entrance, on which is posed on a pedestal the inevitable imperial tablet with the inscription *wan sui wan wan sui*, "a myriad years, a myriad, myriad years !" which is officially prescribed for every temple, no matter what the faith, as a pledge of the loyalty of the worshippers. An incense burning apparatus in bronze of three pieces, the conventional "Set of Three," *San Shih*, composed of a tripod urn, a round box with cover, and a vase to hold tools, all chased with Arabic scrolls, usually stands on the same table.

One of these Mohammedan incense burners is illustrated in Fig. 43. It is of cast bronze, shaped as a shallow bowl with two monster-head handles, standing on three feet also ornamented with masks of monsters. The sides, encircled above and below by rows of bosses suggestive of rivets, are engraved in two panels with foliated edges with Muslim inscriptions in debased Arabic, executed in relief on a punched ground. It is marked inside with two dragons inclosing the seal *Ta Ming Hsüan Tê nien chih, i.e.,* "made in the reign of Hsüan Tê (A.D. 1426–35) of the great Ming dynasty." On the base, underneath, is another seal-mark inscribed *Nui t'an chiao shê, i.e.,* "For tutelary worship at the inner altar."

In the same courtyard as the mosque there are side buildings which serve as cloisters for the mullahs and the other resident officials, including usually a school where young Muslims are taught the elements of their religion from books printed in Chinese Turkistan, where the natives are all Mohammedans. There is as a general rule no minaret in Chinese mosques; the muezzin calls out the time of prayer from the entrance gateway. A half-ruined gateway of unusual height is illustrated in Fig. 44. It belongs to a mosque built close outside the palace wall within the city of Peking by the emperor Ch'ien Lung for the benefit of a favourite concubine, a princess of the old royal line of Kashgaria, so that she might hear the call to prayer from a pavilion built for her, just opposite, on a hillock inside the wall of the prohibited palace. The Emperor tells the story himself on a marble stele erected by him in the precincts of the mosque with a trilingual inscription, engraved in three scripts, Manchu, Chinese, and Turki, which has been translated in the *Journal Asiatique* by M. Devéria.

FIG. 43.—BRONZE INCENSE BURNER. HSIANG LU.
Mohammedan Scrolls. Mark, Hsuan Tê (1426-35).
No. 198-'99.

H. 15 in., W. 12¼ in.

Fig. 44—Ruined Gateway of a Mosque.
Imperial City, Peking. 18th Century.

CHAPTER IV.

From the earliest antiquity the Chinese are recorded in their annals and traditions to have been acquainted with the art of moulding and chiselling bronze, and the examples which have survived to the present day reveal something of their archaic history and primitive superstition. During the half-mythical period of the third millennium B.C., the technical methods were gradually improved, till we come to the reign of the great Yu, the founder of the Hsia dynasty, who is recorded to have cast the metal sent up as tribute from the nine provinces of his empire into nine tripod caldrons (*ting*) of bronze. These tripods are said to have been carved with maps and figures illustrating the natural productions of the provinces. Other traditions say that the Emperor had them carved with representations of the evil spirits of the storm and of the malignant demons of the woods and wild places, so that the people might recognise and avoid them. The nine tripods were long preserved as palladia of the kingdom till they were lost in the troubles which ushered in the close of the Chou dynasty, the conqueror of which, Ch'in Shih Huang, tried in vain to recover them, as indicated in the bas-relief of Fig. 15 in Chapter II., which shows the traditional form of one of these tripods. The model is kept up to the present day, and eighteen large tripods shaped in the same lines still stand on the sides of the open court of the principal palace at Peking, in token of the eighteen provinces into which China proper is now divided.

Copper was highly valued during the three ancient dynasties, and it is often referred to in the older books under the name of *chin*, or "metal," being the metal, *par excellence*, of the period.

The distinctive name of *ch'ê-chin*, or "red metal ' is, however, occasionally used. Gold, *huang chin*, or " yellow metal," and silver, *pai chin*, or white metal, were principally employed in these early times for the decoration of bronze, being inlaid or incrusted on the surface of the red metal. Copper, however, was not often used alone, but alloyed with tin (*hsi*) in various proportions to make bronze. Bronze has been known in China from prehistoric times under the name of *t'ung*, a compound character which seems originally to have meant " mixed metal."

The proportions of copper and tin employed in the fabrication of bronze objects during the Chou dynasty (B.C. 1122–249) have been handed down in the *K'ao kung chi*, a contemporary work on the industries of the period. This canonical book gives a succession of six alloys, in which the proportion of tin was gradually increased from one-sixth of the total weight to one-half :—

1. Copper, five parts, tin one part. Used in the fabrication of bells, caldrons, and gongs ; sacrificial vases and utensils ; measures of capacity.

2. Copper four parts, tin one part. For axes and hatchets.

3. Copper three parts, tin one part. For halbert heads and trident spears.

4. Copper two parts, tin one part. For straight two-edged swords, which were made of two sizes, according to the height of the wearer ; and for agricultural implements, such as spades and hoes.

5. Copper three parts, tin two parts. For arrow heads, employed in war and hunting ; and for curved pointed knives, used for incising the script of the period on strips of bamboo, the ordinary writing material before the introduction of woven silk and paper.

6. Copper one part, tin one part. For mirrors, plane and concave. The former, in addition to their ordinary use, were employed at midnight to obtain " pure water " from the moon, in the shape of drops of dew condensed and distilled from their surface when the moon was full. The concave mirrors were intended to obtain

" pure fire " from the sun for ceremonial use, in accordance with a cult common to many ancient races. The large proportion of tin, which has been confirmed by the actual analysis of ancient mirrors, gave a whitish colour to the alloy and correspondingly strengthened its power of reflection.

The white metal combined with copper in ancient Chinese bronzes is rarely, if ever, composed of pure tin ; but contains, in addition, notable proportions of zinc and lead, which produce certain altera- tions in the colour of the body. They also influence the colour of the patina which is gradually developed on the surface of all bronzes that have lain long buried underground, by natural chemical processes. The soil of China, charged as it often is with nitre and ammonium chloride, materially conduces to this kind of decomposi- tion, and the Chinese antiquary notes carefully the crystalline coating of many colours veined with red, malachite green and turquoise tints, as a valuable test of authenticity. The natural patina is occasionally counterfeited with artificial colours laid on with wax, but the deception is at once revealed by scraping the surface with a knife, or by immersing the suspected piece in boiling water.

Chinese bronzes have always, as far back as we have any record, been executed by the *cire perdue* process, and finished,when neces- sary with the hammer, burin and chisel. The largest pieces have been produced by this method. In the Annals of the Wei dynasty, for example, it is recorded that in the 2nd year (A.D. 467) of the T'ien An period, the Emperor had a standing figure of Sakyamuni cast for a Buddhist temple, composed of 100,000 catties (the catty= 1⅓ lb.) of copper, overlaid with 600 catties of gold—a worthy fore- runner of the Dai-Butsu, or Great Buddhas of Japan, the earliest of which is attributed to the eighth century. The five colossal bells at Peking, again, which were cast in the reign of the Emperor Yung Lo (A.D. 1403–24) weigh about 120,000 lbs. each, are fourteen feet high, thirty-four feet in circumference at the rim,

and nine inches thick. They are covered, inside and outside, with voluminous Buddhist scriptures in Chinese script, interspersed with Sanskrit formulæ. The heavy bell always remains in the place where it was founded, suspended on a beam supported by a framework of wood, with the earth excavated underneath, and it is struck outside by a swinging wooden bar, which produces a deep boom heard for many miles round.

The study of ancient bronzes has been industriously pursued in China by generations of scholars, who have the greatest veneration for the written script and find it better preserved on bronze than on stone, while the more perishable materials used in early times, such as tablets of wood and rolls of silk, have long since disappeared. There are many references to bronze vessels in the canonical books, especially in the three rituals of the Chou dynasty, in which the names and dimensions of the various sacrificial utensils are recorded, but little else is known about them. Many of them are figured in the illustrated commentaries, such as the *San Li T'u,* " Illustrations of the Three Rituals," in twenty books, by Nieh Tsung-yi, who lived in the 10th century A.D., but the figures in these books are mostly imaginary and fanciful. The first special work on bronze was the *Ting Lu,* a brief historical record of celebrated urns, by Yu Li, who lived in the 6th century, but this book also contains much that is legendary. More exact knowledge dates from the 11th century, when archæological collections were made and voluminous catalogues printed with illustrations of the actual objects and facsimile woodcuts of the inscriptions. The most important of the catalogues still in circulation is the *Hsüan Ho Po Ku T'ou Lu,* "Illustrated Description of the antiquities in the Hsüan Ho (Palace)," in thirty books, which was written by Wang Fu in the beginning of the 12th century, and has been frequently reprinted since. It is usually printed together with the *K'ao Ku T'ou,* " Illustrated Examination of Antiquities," which comprises catalogues of several private collections compiled by Lü

Ta-lin in 1092, in ten books ; and with a smaller work in two books, entitled *Ku Yü T'ou*, "Illustrations of Ancient Jade." Another well-known collection of the Sung dynasty is described in the *Shao Hsing Chien Ku T'ou*, "Illustrated Mirror of Antiquities of the Shao Hsing Period (1131–62)," which was published at Hangchou after the removal of the Imperial Court of the Sung dynasty to the south of the river Yangtsze.

Several more works of the kind appeared during the Ming dynasty, but these may be passed over to notice the magnificent illustrated catalogue of the imperial collection of bronzes in the palace at Peking, entitled *Hsi Ch'ing Ku Chien*, which was published by the Emperor Ch'ien Lung in 1751, in forty-two folio volumes. The *Hsi Ch'ing Hsü Chien*, in fourteen folio volumes, is a supplement to the above catalogue, still unpublished, and circulating in a few manuscripts only ; and the *Ning Shou Ku Chien* is another similar work, also as yet unpublished, which is written and illustrated in the same superb style, twenty-eight volumes in folio, being the description of the collection of ancient bronzes in the Ning Shou Kung, another of the palaces within the prohibited city at Peking. The original edition of the *Hsi Ch'ing Ku Chien* is rare and costly, but it has lately been so perfectly reproduced at Shanghai by photographic process, in small octavo form, as to be within the reach of every collector, for the study of bronze forms and designs.

Among more recent illustrated works the one most frequently referred to is the *Chin Shih So*, researches on inscriptions upon metal (chin) and stone (shih), by two scholarly brothers, Fêng Yun-p'êng and Fêng Yun-yuan, natives of the province of Kiangsu, which was published in 1822 in twelve books. Six of these books are devoted to inscriptions on bronze, six to inscriptions on stone. A brief abstract of the contents of the first section of this work, a copy of which is in the library of the British Museum, will give an idea of its scope and of the wide range of the native study of Chinese bronzes. The introduction, an additional feature

of the second edition, is devoted to a description of ten sacrificial vessels of varied form presented, in 1771, by the Emperor Ch'ien Lung to the ancestral temple of Confucius at Küfou, the birthplace of the sage in the province of Shantung. The Emperor relates in an ode composed for the occasion, which is here printed, how " he had selected the vessels from his collections at Peking all belonging to the Chou dynasty under which Confucius flourished, so that not one was less than 2,000 years old." They comprise notable examples of the usual ritual vases for meat offerings, steamed cereals and vegetables, fruit and wine, mostly with inscriptions, together with two cooking utensils, without inscriptions, of less usual form and design. The first of these two is a four-footed caldron (li) with hollow legs, two-thirds of a foot high, with a swelling body of square section, two and a half feet in circumference, primitively decorated with a pair of oval rings standing out in relief from each of the four sides, and with two looped handles springing upwards from the shoulders. The second is a colander (yen) of composite form, designed in the same lines as the archaic sacrificial colander illustrated in Fig. 45, which has been recently brought from Peking to be added to the museum collection. The upper part of the vessel, a receptacle of ovoid form with loop-handles decorated with a band of conventional scroll-work, is mounted upon a hollow tripod base displaying in threefold relief the lineaments of the t'ao-t'ieh ogre ; the receptacle which communicates inside with the hollow base is separated by a hinged plate pierced with five cross-shaped perforations, to allow the steam, generated by the fire underneath, to pass through freely. It is, in short, an archaic reproduction in bronze of the large colander of a Chinese kitchen, overlaid with a natural patina of malachite shades of green, which is described as being a sure guarantee of its age.

The table of contents of the *Chin Shih So* follows. It comprises :

FIG. 45.—SACRIFICIAL COLANDER. *Yen.* SHANG DYNASTY.
Used for steaming grain and herbs.
No. 1193-1903.

H. 15½ in., D. 10 in.

BOOK II.—Halberts, spearheads, swords, crossbows and other bronze weapons. From the Shang dynasty to the After Liang (A.D.907-922).

Measures of capacity, length and weight. From the Ch'in dynasty (B.C. 221-207) to the Yuan.

BOOK III.—Miscellaneous objects intended for ordinary use, mostly with inscriptions of date, such as basins and drinking vessels, oil lamps and pricket candlesticks, incense urns and cooking utensils, bells and gongs, girdle buckles, moulds for casting coins, Buddhist images and votive stupas, etc. From the beginning of the Han (B.C. 206) to the Yuan dynasty.

BOOK IV.—Coins and medals. From ancient times to the Yuan dynasty. With an appendix on foreign money.

BOOK V.—Seals, official and private. From the Ch'in dynasty to the Yuan.

BOOK VI.—Mirrors. From the Han dynasty to the Yuan. With a short appendix on Japanese bronze mirrors.

The above books are illustrated with fair woodcuts of the objects referred to and are consequently of a certain value from an artistic point of view. A second series of Chinese works on bronze antiquities neglects the forms and decorative designs of the objects, and devotes its sole attention to a critical examination and decipherment of the inscriptions. These books usually give facsimiles of the inscriptions carefully engraved from actual rubbings, accompanied by versions in the modern script, and commentaries on the decipherment. Each work is a *corpus inscriptionum* and supplies invaluable material for the study of the historical development of the Chinese script. Many archæologists have published their own collections, in connection occasionally with those of their literary friends and correspondents, in this form, but there is only space for a notice of three of the more important of their works here.

1. An old book of the Southern Sung dynasty (A.D. 1127–1279), by Hsieh Shang-Kung, reprinted in 1797 by Yuan Yuan, the author of the next work, under the title of *Hsieh Shih Chung Ting Kuan Shih*. The full title as explained in the preface, was " Critical Reading of Inscriptions on Bells, Tripods and Sacrificial Vessels of the Ancient Dynasties." It was originally printed from stone blocks in the Sung dynasty and reprinted in red ink in the reign of Wan Li

(1573–1619), while the present issue is an exact facsimile of the original edition cut in wood after a copy in the possession of the editor.

2. The important work of the above-named Yuan Yuan, a native of Yangchou, who lived A.D. 1763–1850. He was a classical and antiquarian writer of high distinction, and Viceroy of several provinces during his long official career. Chi Ku Chai was the name of his studio, and his work is entitled *Chi Ku Chai Chung Ting Yi Ch'i Kuan Shih,* "Chi Ku Chai Study of Inscriptions on Bells, Caldrons, and Sacrificial Vessels." Facsimiles of 560 inscriptions are given and criticised, as compared with 493, the number included in the preceding work. The preface is dated the 9th year (1804) of the reign of Chia Ch'ing.

3. A recent work published with the imperial imprimatur in the 21st year (1895) of the reigning Emperor Kuang Hsü, with the title *Chün Ku Chai Chin Wen,* "Chün Ku Chai Inscriptions on Metal," in three books, each divided into three fasciculi or volumes, by Wu Shih-fên, of Hai-fêng Hsien, in the province of Shantung, a literary graduate of the reign of Tao Kuang, who had risen to be Vice-President of the Board of Ceremonies before his retirement from official life. The inscriptions are arranged in this work in order according to the number of characters in each, ranging from one to 497 characters. The author belonged to a school of critics headed by P'an Tsu-yin, President of the Board of War, who investigated the records of antiquity from the study of actual specimens, in opposition to the older school, devoted to an endless verbal criticism of the inspired canon. One result of the work of the new school is the dictionary by Wu Ta-chêng, Director of the Court of Sacrificial Worship, published in 1884, which was cited in Chap. II. as a most useful supplement to the *Shuo Wên,* the old well-known dictionary of the ancient script, with the title *Shuo Wên Ku Chou Pu,* "Supplement to the Ancient Chou character of the *Shuo Wên.*" The characters are arranged under the 540 radicals of the older dictionary, are printed

in facsimile with all their variations, and with exact references to the bronze pieces from which they have been taken. It comprises over 3,500 characters, including variations, besides some 700 characters of rare occurrence and doubtful decipherment which are relegated to an appendix to await further researches. The book is indispensable for the study of ancient inscriptions on bronze.

Ancient bronzes are divided by Chinese archæologists into two great classes, the first class including the relics of the three ancient dynasties Hsia, Shang and Chou, the second class those of the Ch'in, Han and later dynasties. The year B.C. 221, in which Ch'in Shih Huang proclaimed himself "the first Emperor," is the dividing line between the two classes. The high value attributed to bronze in ancient times is proved by Yuan Yuan in the introduction to his book referred to above, with a long string of references to the nine canonical books. One of the lost books of the *Shu Ching* was called *Fen Ch'i*, the "Distribution of the Vessels," and is referred to in the preface, attributed to Confucius, in these terms :—

"When King Wu had conquered Yin, he appointed the Princes of the various States, and distributed among them the vessels of the ancestral temple. With reference to this there was made the *Fên Ch'i*."

King Wu was the founder of the Chou dynasty (B.C. 1122–249), to which period most of the ancient bronzes with inscriptions are attributed by archæologists of the modern school in China. A smaller·proportion is referred to the Shang dynasty with short inscriptions of archaic pictorial script, in which the name of the deceased to whom the piece was dedicated is generally one of the cyclical characters. The preceding Hsia dynasty is left unrepresented, in that no inscribed piece in modern collections can be certainly referred to it.

The author of the *Shuo Wên* refers in the preface to his dictionary, written in the year A.D. 99, to the bronze caldrons (ting) and sacrificial vessels (yi) which were frequently discovered in his time in the hills and valleys of the various provinces, and which contained inscriptions showing the development of the written script during

the older dynasties. Many such discoveries are recorded in the annals of the Han and succeeding dynasties, with occasionally somewhat crude attempts at the decipherment of the inscriptions by the literati of the time. The discovery was always regarded as a felicitous omen and written down by the historiographer in the book devoted to sacred prodigies. In the 5th month of the year B.C. 116 a tripod caldron was dug up on the southern bank of the river Fên in the province of Shansi, and the title of the reign of the emperor Wu Ti was changed to Yuan Ting (B.C. 116–111) in honour of the event. During the T'ang dynasty when a bronze caldron was unearthed in the 10th year of the K'ai Yuan period (722) the name of the city of Yung Ho, on the left of the Yellow River, where it was found, was changed to Pao Ting Hsien, "City of the Precious Tripod," to mark the occasion. After the accession of the Sung dynasty in 960 old bronzes were no longer regarded as sacred, the tombs of noble families were excavated for private collections and imperial museums, and epigraphic studies were industriously prosecuted, as proved by the many illustrated catalogues of the period which have been already referred to.

Bells (chung) and caldrons (ting) come first in the list of ancient Chinese bronzes, and their use is suggested in the old saying, *Chung ming ting shih*, " The bell sounds, the food is in the caldron," which goes back to patriarchal times. The typical figure of the latter, with a rounded swelling body posed on three curved legs and two upright handles, or " ears," is seen on the bas-reliefs of the Han dynasty, where it is often placed in a prominent position on the mat round which guests are gathered for a banquet. The word *ting* is occasionally rendered " tripod," but this is hardly applicable to a second not uncommon form which has a rectangular body of oblong section supported by four legs (Fig. 58). To call them " urns " would be an anachronism, as the Chinese never burnt incense before the introduction of Buddhism ; and besides, the early Buddhist urns were modelled in the shape of peaks of the sacred Sumeru

FIG. 46.—ANCIENT BRONZE BELL. CHOU DYNASTY.
With Inscription anterior to 7th Century B.C.

H. 27 in., Br. 18 in.

.mountains, before the Chinese *ting* was adopted by Buddhists for burning incense. In the present day it is the orthodox urn for the altars of all religions in China, a receptacle for the ashes of the "joss-sticks" of fragrant wood which are burned before every sacred shrine, in private houses as well as in temples.

The bell (chung) in ancient times used to be suspended in front of the banqueting hall, and it was sounded to summon the guests, either alone, or in accompaniment with other musical instruments in a band. In the ancestral temple it called the shades to the funeral meats prepared for the ghostly repast. It was clapperless and was struck outside near the lower rim by a wooden mallet. Its usua form and general scheme of decoration are illustrated in Fig. 46. This represents a large bronze bell of the Chou dynasty from the collection of Yuan Yuan, authenticated by two of his seals impressed in the left hand lower corner of the picture. It was photographed from a paper scroll which has been pencilled, in the usual Chinese fashion, with the outlines of the object in the exact size of the original, and afterwards filled in with actual rubbings in thin paper of the inscriptions and decorative details pasted on. The bell measures twenty-seven of our inches in height, eighteen inches across at the lower rim, and weighs eighty-eight lbs. The face and back have each eighteen bosses in strong relief, arranged in rows of three, separated by incuse bands of scroll design, and the rest of the surface is decor- ated with similar scrolls conventionally shaped in the form of dragons enveloped in clouds. The inscription, which is partially rhyming, is ranged in two panels on the front of the bell and reads as follows :

" I, Kuo Shu Lü, say : Grandly distinguished was my illustrious father Hui Shu, with profound reverence he maintained a surpassingly bright virtue, He excelled alike in the rule of his own domain and in his liberal treatment of strangers from afar. When I, Lü, presumed to assume the leadership of the people and to take as my model the dignified demeanour of my illustrious father, a memorial of the event was presented at the Court of the Son of Heaven, and the Son of Heaven graciously honoured me with abundant gifts. I, Lü, humbly acknowledge the timely gifts of the Son of Heaven and proclaim their use in the fabrication for my

illustrious father Hui Shu of this great sacrificial tuneful bell. Oh, illustrious mother, seated in majesty above, protect with sheltering wings us who are left here below. Peaceful and glorious extend to me, Lü, abundant happiness! I, Lü, and my sons and grandsons for ten thousand years to come, will everlastingly prize this bell and use it in our ritual worship."

For a full discussion of the inscription and its probable date the Chi Ku Chai Catalogue referred to above may be consulted. The writer of the inscription, whose name is not recorded in any of the annals that have come down to us, must have been a feudal prince of the small State of Kuo, the territory of which was on the south bank of the Yellow River, in the modern province of Honan. The " Son of Heaven " would be, of course, the reigning king of the Chou dynasty, whose gifts on such occasions usually included metal for casting sacrificial utensils. There were originally two States of Kuo, granted as hereditary fiefs to two brothers of King Wên, the virtual founder of the Chou dynasty. Western Kuo was absorbed by the State of Tsêng in the year B.C. 770 when the capital of the Chou was moved to the east. Eastern Kuo lasted nearly a century later, till it was invaded and conquered by the powerful state of Chin (Tsin) in the winter of B.C. 677, and the last Duke of Kuo fled to the Chou capital, leaving his lands to be annexed to the principality of Chin. The date of the bell must, therefore, be anterior to this last year, how much anterior it is difficult to determine, or to which of the two States of Kuo it is to be attributed.

The tripod vessels called *ting* may be illustrated by the reproduction in Fig. 47 of a Chinese woodcut in the *Chin Shih So*, the book on bronzes referred to above, representing the celebrated specimen preserved at a Buddhist temple on Silver Island (Chiao Shan) in the river Yangtsze, near Chinkiang. Many volumes have been written on this tripod, of which three are quoted in Wylie's *Notes on Chinese Literature*. As stated in the letterpress at the top, it is called the " Wu-Chuan Ting of the Chou Dynasty," and is kept at Chinkiang in the Chiao Shan temple. Its dimensions are 1·32 feet

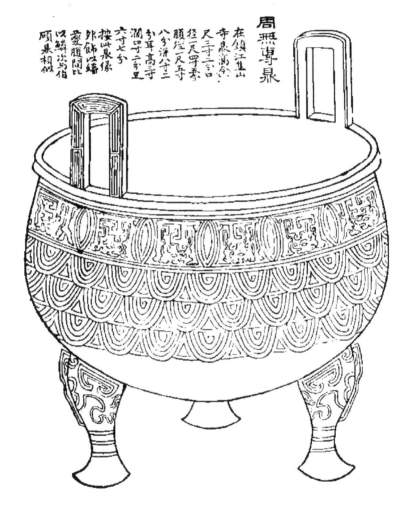

周無專鼎

顧鼎相似
以鮮淡為伯
按此鼎像
愛腹間
外飾怪蟠
分耳高寺
八分深分二
六寸七分
尺寸言口
闊寺二寸里
頤徑尺寺
徑尺罩素
帝鼎前衆
在頌江焦山

FIG. 47.—THE WU-CHUAN TING OF THE CHOU DYNASTY.
Preserved in Silver Island in the River Yangtsze.

H. 1⅓ ft., D. 1½ ft.

惟九月既望甲戌王格
于周廟烝于圖室司徒
南仲右無專入門立中廷
王呼史習冊命無專曰
官司紅王頤側弗作錫
女元衣帶束戈琱戟繡
緐彤矢篚勒鑾旂無專
敢對揚天子丕顯魯休
作尊鼎用享于朕列孝
句眉壽萬年子孫永寶用

具在焦山銘九十四字僧行敬
焦山志云鼎傳于吾鄉魏氏
不宜相攘嵩當國以不得此
鼎將眾之嵩敗魏氏恐字孫
終不保送焦山隱于癸酉冬日
在焦山曾見此鼎闇然渾古
今曲阜張潤浦明府自東
江取得拓本見貼卯纂刻之

FIG. 48.—INSCRIPTION OF THE WU-CHUAN TING (FIG. 47).
With Decipherment and Description.

high, 1·45 feet across at the mouth, 1·58 in diameter at the body, etc. It is decorated above with a band of scrolled design inclosing conventional dragons, succeeded below by a three-fold series of imbricated scales. The incuse inscription, which extends from the rim inside down to the base, is given in facsimile in Fig. 48, followed by a version in modern script, and a short historical note to the following effect :—"The inscription on the Chiao Shan tripod contains ninety-four characters. The Buddhist sramana Hang Tsai, in his *History of Chiao Shan*, says that this tripod was originally in the collection of his fellow-citizen Wei, till the Minister of State Yen Sung of Fên Yi, during his misrule of the empire, persecuted Wei, because the latter would not give up the tripod. After the overthrow and death of Yen Sung (in 1565), Wei, fearing that his descendants would not be able after his death to protect the tripod, presented it to the temple." The author of the *Chin Shih So* tells us that in the winter of the year *kuei-yu* (1813) he visited Silver Island, went to see this tripod and was struck with its archaic beauty. He had the inscription engraved for his book from a rubbing brought by him from the spot. The inscription, a facsimile of which is presented on a reduced scale in Fig. 47, is as follows :—

"In the ninth month on the day after full moon, *chia-hsü* of the 60 days' cycle, the King proceeded to the Ancestral Temple of the Chou (dynasty) and offered burnt sacrifice in the Picture Hall. Nan Chung, the Minister of Education, together with me, Wu Chuan, on his right hand, came in at the gate and stood in the middle of the audience hall. The King summoned the historiographer Yu to record his charge to Wu Chuan and said : ' Superintendent of Public Works appointed to drive away the rebels of the west, We present to you official robes with girdle and clasp, halbert and inlaid lance, badge with tasselled ribbons of silk, a sheaf of red arrows, bronze-mounted bridle and bit, and banners hung with bells.' I, Wu Chuan, dared to pronounce my grateful acknowledgments of the grand favours and gracious gifts of the Son of Heaven, and have made vases for wine and this caldron for offerings of sacrificial meats to my meritorious deceased father. May I be rewarded with length of days and may sons and grandsons for ten thousand years everlastingly cherish and use this."

With regard to the date of this inscription the critics generally refer it from the style of writing to the reign of Hsüan Wang (B.C. 827–782). The name of the maker the official Wu Chuan is not recorded in

the annals, but one of the odes of the period preserved in the *Shih Ching* celebrates the deeds of Nan Chung, the leader of an expedition against the marauding Hien-yun on the north-western frontier, and he is plausibly supposed to be the Nan Chung mentioned in the inscription as the Minister in attendance upon the King on this occasion. Li Shên-lan, the late Professor of Mathematics at the Imperial College of Peking, to whom the inscription was submitted, has calculated that the 16th year (B.C. 812) of this reign would be one in which the day after full moon in the ninth month coincided with the cyclical date *chia-hsü*.

The sacrificial bowl (p'an) of the Chou dynasty, which is illustrated in Fig. 49 is now in the Museum, and the historical interest of the long inscription of more than five hundred characters, shown in Fig. 50, makes it the most important piece in the Chinese collection. It was procured in 1870 from the collection of the Princes of Yi at Peking, who are lineal descendants of a son of the Emperor K'ang Hsi; and it was then enclosed in a wooden case lined with yellow silk painted with five-clawed dragons, like the piece which still covers the top of the wooden stand on which it is mounted. It is a wide shallow bowl, 33¼ inches in diameter, with a spreading side, two loop handles and circular foot. The handles spring from grotesque heads grasping in their jaws the rim of the bowl. The side is encircled by a broad band of conventional design displaying in relief the ogre's features (t'ao t'ieh) on a ground of rectangular spiral fret (lei wên) intended to represent scrolls of cloud. Above this band is a row of bosses, alternately tipped with gold and silver, while some of the details of the relief decoration are also inlaid with the same metals. The inscription inside would appear once to have been overlaid with beaten gold, as scratches made through the patina with a knife to bring out the characters produce lines of glittering yellow indicating a thick layer of gold. The inscription has not been found in any of the Chinese catalogues, and the decipherment which follows must consequently be accepted

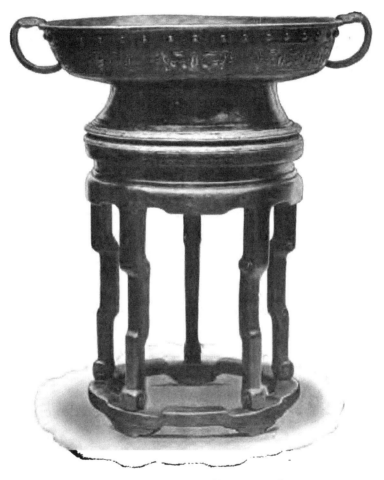

FIG. 49.—SACRIFICIAL BOWL. *P'an*. CHOU DYNASTY.
Bronze inlaid with Gold and Silver.
No. 174-'99.

H. 10¼ in., W. 2 ft. 9¼ in.

with caution. The epigraphy resembles closely that of the stone drums, an example of which has been given in Fig. 7 in Chapter II., although this inscription is two centuries or more later than that of the drums. The lines of the characters are firmly cut in the finished style of the official script of the period, and present a document which may be compared with those of the *Shu Ching*, the canonical " Book of History," and which runs :—

" In the first month of the King on the day *hsin yu* (58th of the sexagenary cycle) the Prince Marquis of Chin announced the subjugation of the Jung and was received in audience by the King. The King, having thrice rewarded him for his services, on the frontier, in the royal domain, and in the ancestral temple of the royal house, granted him an audience in the sacred hall of the palace, and again took part with the Prince of Chin in the sacrifice of the ancestral temple of the Chou dynasty."

" The King specially invested the Prince of Chin with the nine symbols of high rank. In his charge on the occasion the King spoke thus : ' Uncle, you have done grandly ! In ancient times among our royal ancestors reigned Wên, Wu, Ch'êng, and K'ang, who determinedly and warily were all diligent in their cultivation of virtue. Their fame was illustrious on the western borders and they overawed central China (Hsia) as well as the outer subjugated and barren wilds. The justice of their penal code struck all alike with awe and fear, so that in distant and near regions, at home as well as abroad, one virtue prevailed. In these times lived also your own accomplished ancestors, who loyally exerted their hearts in the service of our royal house, so that their great glory and grand deeds have been constantly recorded in the sworn archives, and proclaimed at the meetings of the heads of the clans, and their praises shall resound to the distant generations. In our own time, later, when harmony with heaven demands greater awe, the targets, as it were, have not been shot at with arrows, the silk cocoons have been left un-wound, and there has been truly a failure of virtue, with the result of disaccord of the powers celestial and terrestrial. The four quarters not being loyal (reverent) foreigners have also fallen away, and the Jung have made a great insurrection, carried off our beloved kinsmen, dispersed abroad our officers and people, destroyed and emptied the suburbs of our capital and our walled towns."

" The King said : ' Oh ho ! Formerly during the reigns of Li, Hsüan and Yu, down to P'ing and Huan, crossing flooded waters, as it were, without reverence and awe, they again were in danger of falling into the deep abyss and our royal house was again in trouble. Then again there was your ancestor Wên Kung, who was able to maintain the fame established by his accomplished predecessors and succeeded in checking our calamities. We also could not do less than fulfil our solemn pledges and our decrees are recorded in the annals of the State. The war chariots and teams of stallions were bestowed on him solely as rewards for his valour, the red bows and black bows were given for his prowess in the field, the

tablets and credentials of jade were presented to him as a kinsman of the King, while the chamberlains, thirty in number, the three hundred tiger life-guards, and the territories of the six cities of Wên, Yuan, Yin, Fan, Ying, and Wan were added as permanent appanages of the State of Chin. Thus also was your ancestor Wên Kung liberally rewarded with outside fiefs and thereby strengthened to undertake our gracious charge and become renowned among his fellow princes.' "

" The King said : ' Oh ho ! It is not I, the solitary man, who selfishly covet my own personal ease ; it is the Jung who, never satisfied, beguile the simple hearts of the people, and with flames and rude assaults treacherously attack our officers, so as to bring this trouble to you, my Uncle.' "

" The King said : ' Oh ho ! Uncle ! grand are your illustrious services which carry on and perpetuate those of your predecessors, and necessitate no change in the enduring royal charge. I, the solitary man, am indebted to you for my tranquillity, and I offer to you my felicitations, You have already been invested with the nine symbols of your rank, and I now charge you with the appointment of Superintending Prince (Po) of the Outer Regions, with power to make war, to chastise rebels, to punish the refractory, to lead troops, to have free access to Court and use of the State resources. As soon as the completion of our appointment shall have been reported to all the princes, if any one of them should dare not to follow, I, the solitary man, will signally punish him.' The Prince of Chin twice bowed with his head to the ground in obedient acknowledgment of the gracious charge of the Son of Heaven."

" The King said : ' Uncle ! Rest awhile. My appointment shall be forthwith made known. Do you reflect before taking it up on the means of emulating your accomplished ancestors and afterwards devote yourself to the task.' The Prince of Chin twice bowed with his head to the ground."

" In the second month of the year on the day kêng-wu (7th of the cycle) the Prince of Chin having returned to his home after his subjugation of the Jung, offered solemn sacrifice at the shrine of his ancestor the accomplished Prince T'ang Shu. On the following day ping-shên (8th of the cycle) he announced his successes at the shrine of his grandfather, and proclaimed his merits at the shrine of his father. On the day ting-yu (34th of the cycle) the sacrificial bowl ordered to be made was cast, inscribed with the gracious charge of the King. The Prince of Chin twice bowed with his head to the ground in reverent acknowledgment of the favourable charge of the King. May this bowl be handed down for ten thousand years and be everlastingly treasured and used by sons and grandsons ! "

The above long inscription gives a vivid sketch of the relations between the sovereign and one of his principal feudatories in the seventh century B.C., which might be filled in from the contemporary annals of the period which have come down to our times. The principality of Chin (Tsin), which is more or less represented by the modern province of Shansi, was originally conferred by King Wu

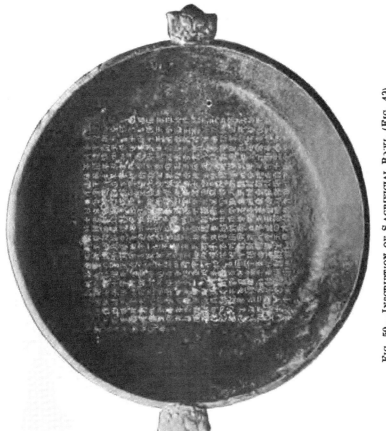

FIG. 50.—INSCRIPTION OF SACRIFICIAL BOWL (FIG. 49).
Attributed to the year B.C. 632.
No. 174-'99.

the founder of the Chou dynasty, on his son T'ang Shu Yu, whose shrine is referred to in the inscription. The most celebrated of his descendants was Wên Kung, who ruled the principality from B.C. 780 to 744, and is recorded to have come to the rescue of the royal house in B.C. 770, when it was driven eastwards by the barbarous hordes of the Jung. He was rewarded by the gift of six cities, comprising the part of the royal domain on the northern bank of the Yellow River, and of various other privileges detailed in the text. The royal charge to him on this occasion forms the last book but one in the *Shu Ching*, the canonical Book of Annals compiled by Confucius.

The name of the prince of Chin to whom the present charge was given is not mentioned in the text, where he is always addressed as " Uncle " being, as we have seen, by direct descent of the royal blood. Nor is the year given, but that is satisfactorily fixed by the mention of his appointment as *wai fang po*, or presiding chief of the feudal princes, for the defence of the frontier. This points to Ch'ung Erh, who lived 696–628 B.C., became prince of Chin in B.C. 635, after a long exile and many adventures, and was invested with the above appointment by King Hsiang in B.C. 632. He died four years later and was canonised with the title of Duke Wên, the " Accomplished." The nine gifts of investiture bestowed on him at the time as symbols of his rank would probably have been the following :—

1. Chariot and team of horses.
2. Robes of State.
3. Musical instruments.
4. Vermilion entrance doors.
5. Right to approach the sovereign by the central path.
6. Armed body guard.
7. Bows and Arrows.
8. Battle axes inlaid with gold.
9. Sacrificial wines.

There is a celebrated bronze bowl of nearly the same weight and dimensions as the above in the collection of the Hsü family at Yangchou, which is known as the *San Shih P'an*, or "sacrificial bowl of the San Clan." This has an inscription inside of 348 characters in nineteen columns, recording a sworn document defining the boundaries of certain additions to the territories of the fief, with the number of vassal agriculturists resident thereon. Another ancient inscription of the time records the particulars of loans of corn with promises of repayment after a fixed period. Bronze vessels seem to have been used to preserve sworn agreements of the kind in ancestral temples, as being less liable to destruction by fire than the tablets of bamboo which was the ordinary writing material of the time, the tablets being strung together in bundles and stored in repositories.

The bronze vessels used in the ancient ritual worship of ancestors, which were of the most varied form and design, may be divided into two great classes according to the nature of their contents. The first class would include the *tsun*, or wine vessels, being intended to hold the fragrant *ch'ang*, " bringing down the spirits," which was an alcoholic liquor fermented from millet mixed with odoriferous herbs. The second class, grouped under the ancient name of *yi*, or sacrificial food vessels, would include the rounded and oblong receptacles with covers, the shaped bowls and tazza-dishes, and all the other forms intended for the ritual offerings of cooked meats and vegetables, cakes and fruits, prepared for the shades of the departed.

The principal forms go back to a far distant antiquity and have become gradually moulded into fixed lines under the influence of that convention and routine which prevail in Chinese art. The introduction of Buddhism in the Han dynasty was the first impulse from an outside civilisation on an art which threatened to become stagnant from constant repetition, in the absence during so many centuries of rival schools to inspire progress. Some vases, it is

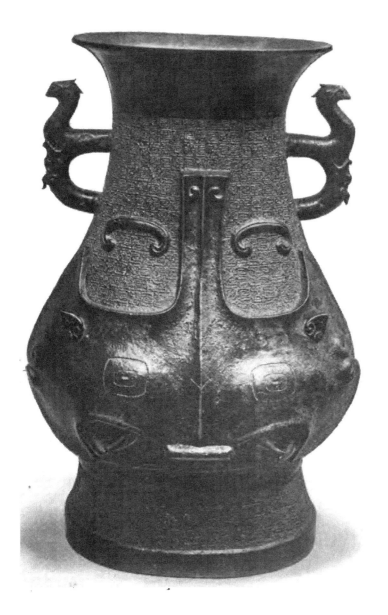

FIG. 51.—SACRIFICIAL WINE VASE. TSUN.
T'ao-t'ieh Ogre and other conventional Designs.
No. 193-'76.

H. 19¼ in., D. 12¾ in.

true, have a certain grace of form and purity of outline, but the majority are heavy, barbaric, of ill-balanced proportions; and even the happiest models are not free from a vague impression of clumsiness, of hieratic stiffness. The preoccupation of the artist, or rather the craftsman, has evidently been to respect the ritual canons by which he is bound down, to measure exactly the swelling of the body, the profile of the neck, the flare of the mouth, and the spread of the foot, so as to reproduce faithfully every line of decoration and symbolic design. The slender vases with trumpet-shaped mouths and some of the plain wine cups reveal a high plastic sense, and come within a shade of being perfect works of art; the touch that is wanting betrays the absence of the free spirit and love of pure lines which inspired the hand of the ancient Greek modeller in bronze.

The motives of decoration of Chinese primitive bronzes are of two kinds, geometric and natural. The geometrical motives, simple or complex, symmetrical or unsymmetrical, consist of scrolled grounds and bands of varied design, the most usual being the rectangular scroll known as the key-pattern, which is so frequently found also on Greek and Etruscan pottery. This is called in China *lei wên,* or " thunder scroll," and it often represents a background of clouds enveloping the forms of dragons and other storm powers of the air. Meanders of this kind occur in the primitive art of all countries and they afford no evidence of communication between Greece and China in ancient times. The natural forms of the second category are of more interest, from an artistic point of view, because they give an idea of the early Chinese interpretation of nature. The human figure never occurs in these primitive bronzes, and vegetable forms are very rare as motives of decoration, we see only sparse outlines of hills and clouds and occasional sketches of animals such as tigers and deer. The artist, in fact, neglects the ordinary animal world to revel in a mythological zoology of his own conception, peopled with dragons, unicorns, phœnixes, and hoary tortoises.

The Chinese genius is unrivalled in its original composition of *monsters*, fantastic and gigantic beings more powerful than man, resembling the most fearful visions of a bad nightmare. Perhaps the most malignant of these beings is the *t'ao t'ieh*, or gluttonous ogre, which has already been referred to as the special monster of old bronzes. It is seen in its most conventionalised form in the massive vase illustrated in Fig. 51, the body of which is moulded to display its lineaments in strong relief, with two enormous eyes and powerful mandibles armed with curved tusks. The tiger may have suggested the conception, as the king of wild animals and the chief opponent of the dragon in the eternal cosmic conflict of terrestrial and celestial powers. The handles of the vase are shaped in the form of dragons projecting from a ground of diapered clouds.

The sacrificial wine vessels illustrated in Figs. 52, 53 have been selected as the most ancient pieces in the collection, the inscriptions being referred to the Shang dynasty, which ruled China in the 2nd millennium B.C. The first is an ovoid jar (*yu*), of the shape used by the old kings for presents of wine to deserving subjects, with a cover surmounted by a knob, and a loop handle ending in dragons' heads. It is moulded with bands of archaic fret in low relief inclosing dragons' heads, and is inscribed inside with two hieroglyphic characters *Tzŭ Sun*, "Sons and Grandsons." The carved wood stand is incised with the cyclical number *ping*, showing that the piece was formerly in the imperial collection at Peking. The second is a libation cup (*chăo*) of conventional shape, with a helmet-shaped bowl standing on three curved feet fashioned like spear heads, encircled by a band of archaic scroll ornament ; it has a loop handle springing from a dragon's head, and two stems rising from the rim, terminating in knobs. It is inscribed, in archaic script, under the handle, *Fu Ssŭ*, *i.e.*, (Dedicated to a) father (named) Ssŭ. The carved wood stand is mounted with a medallion of old jade veined with black. This canonical libation cup is supplanted in the modern ritual by a ladle with a dragon handle,

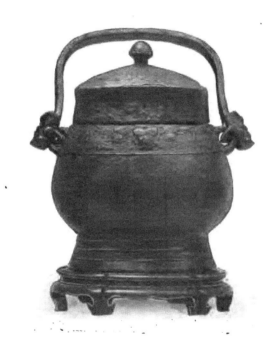

FIG. 52.—WINE JAR WITH COVER. YU. SHANG DYNASTY.
Archaic Fret with Dragons' heads.
No. 175–'99.

H. 11 in., L. 9¾ in., W. 5⅞ in.

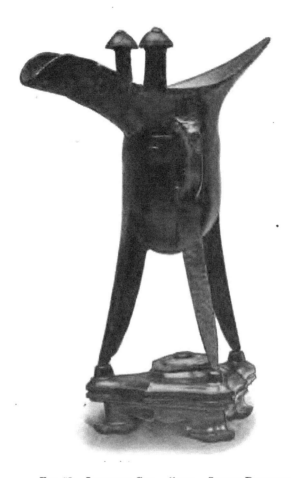

FIG. 53.—LIBATION CUP. CHUO. SHANG DYNASTY.
Archaic Scrolls and Cartouche Inscription.
No. 192-'99.

H. 8⅛ in., W. 6⅞ in.

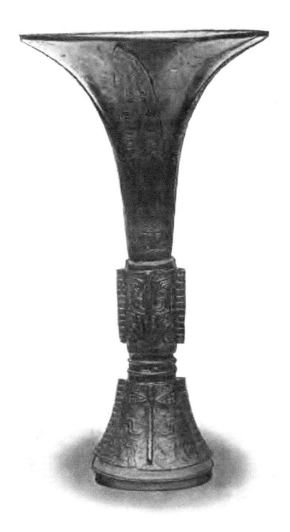

FIG. 154.—SLENDER TRUMPET-SHAPED VASE. KU.
With Vertical Dentated Ridges and Archaic scroll Ornament.
No, 184-'99.

H, 12 in., Diam. 6⅞ in.

but it is represented, as a survival, by the bridal wine cups of the present day which are often made of the same shape in silver, or silver gilt.

Another ancient form of sacrificial wine vase is the *ku*, with slender body, lightly spreading foot, and flaring trumpet-shaped mouth, a typical example of which is presented in Fig. 54. It is moulded with four vertical dentated ridges projecting from the sides of the stem and foot, between which appear in relief the lineaments of the *t'ao-t'ieh* ogre on a ground of fret representing clouds, and a similar design spreads up the neck in four conventional palm leaves. There is an archaic inscription *Fu Kêng*, " For my father Kêng," within a cartouche (*ya*), supposed by Chinese archæologists to figure the outline of the ancestral temple. This graceful bronze form, by the way, is often reproduced in recent times in monochrome porcelain invested with enamels of turquoise blue or imperial yellow.

Another class of sacrificial vases is modelled in the shape of animals, like the elephant vases (*hsiung tsun*) and the rhinoceros vases (*hsi tsun*), some of which are hollow inside to hold the wine, while others, of less ancient date, are solid and carry ovoid wine vases on their backs. The vase in Fig. 55 is an ancient form shaped in the form of a rhinoceros standing with ears erect and a collar round the neck, and is provided with a hinged cover on the back and a spout at the mouth. The wood stand is appropriately carved in openwork to represent water plants and rocks.

The curious wheeled wine vessels commonly called *chiu ch'ê tsun*, or " dove chariot vases," one of which is illustrated in Fig. 56, are of later date than the preceding, and are generally attributed to the Han dynasty (B.C. 202, A.D. 220). The bird of mythological aspect, which is supposed to represent a dove (*chiu*), has its tail curved downwards, and a trumpet-shaped vase-mouth strengthened by vertical ridges on its back ; it is engraved with scroll ornament and dragons, and displays on its breast a grotesque head moulded

in relief. Two wheels support it at the side, and a smaller one at the tail, adapting it to circulate on the altar during the performance of the ancestral ritual ceremonies.

Proceeding next to the class of bronze utensils intended for presenting offerings of cooked meats and vegetables, cakes and fruit, at ancestral shrines, we find an immense variety of forms illustrated in Chinese books, the mere names of which would fill several pages. The earliest materials employed in China for the purpose included clay, worked on the wheel, or moulded ; carved wood, plain or lacquered ; bamboo woven in thin strips, and willow in basketwork ; and some of the first bronzes were moulded in shapes characteristic of these various materials. The ancestral temple of to-day with its elaborate paraphernalia, including kitchens for the preparation of the sacrificial offerings, has been gradually developed from humble beginnings. One of the earliest bronze utensils, for example, the *yen* illustrated in Fig. 45, which is modelled after a pottery progenitor described in the *Chou Ritual*, combines all essentials in itself, being a kind of colander, or steamer, in which the food was first cooked and afterwards presented before the shrine. It consists of a three-lobed base, fashioned in the form of three *t'ao-t'ieh* heads with ogre-like features moulded in prominent relief outside, posed upon three cylindrical hollow feet, narrows at the waist, and expands above to form an ovoid receptacle with two upright loop handles which is decorated with a broad encircling band of archaic conventional scrollwork. The receptacle communicates with the hollow base in the interior, but is separated by a transverse movable plate pierced by five cross-shaped perforations, which is mounted with a loop handle in front and a hinge at the back. Several of these *t'ao t'ieh yen* are figured in the *Po Ku T'ou Lu* (Book xviii.) with inscriptions referred to the Shang and Chou dynasties, to the former of which the museum specimen would appear from its archaic type to belong.

The next utensil for meat offerings (Fig. 57) is attributed to the

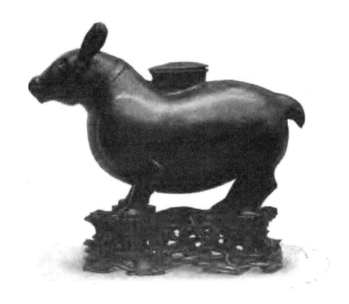

FIG. 55.—WINE VESSEL (HSI TSUN) MOULDED IN THE FORM OF A RHINOCEROS.
Used for Sacrificial Wine in the Chou Dynasty.
No. 206–'99.

H. 3½ in., L. 12 in., W. 6¼ in.

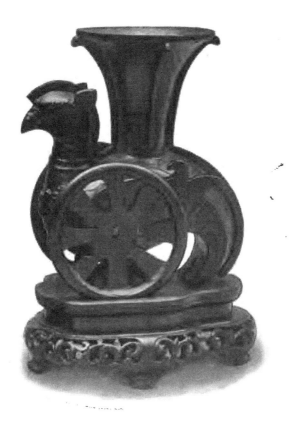

FIG. 56.—DOVE-SHAPED WINE VESSEL ON WHEELS—CHIU CH'E TSUN.
Han Dynasty (B.C. 202—A.D. 220).
No. 183-'99.

H. 6⅝ in., L. 5¼ in.

Chou dynasty (B.C. 1122–249.) It is a tripod bronze vessel of globular form, with two rectangular handles at the sides and a circular handle at the top of the cover, covered outside with bands of conventional scroll device repeated in low relief. The feet are roughly shaped in the form of the legs of an ox, and three oxen are posed in recumbent posture on the cover, giving rise to the peculiar name of *san hsi ting*, or "tripod of three victims," by which these vessels are generally known. The inscription engraved inside, in ancient script, which is repeated on the cover, is in two parts. The first part, within a cartouche (*ya*) figuring the outline of an ancestral temple, is supposed to be a semi-pictorial representation of the shade of the departed partaking of wine and food. The second part *Chu nü yi ta tzŭ tsun yi* is interpreted to signify "Vases and dishes provided for the heir apparent by the ladies of the royal household." Vases for wine with a similar inscription are given in some of the illustrated Chinese catalogues that have been quoted above.

The bronze incense burners of later times are often modelled in the lines of the ancient ancestral vessels, like the four-footed urn illustrated in Fig. 58, which came from the summer palace of Yuan Ming Yuan, near Peking, in 1860. The rims and four feet are fashioned in the shape of jointed bamboo stems; the sides of the bowl, the openwork cover, and the knob surmounting it are decorated with conventional dragons and scrolled clouds; and the two loop handles at the sides are also outlined in the form of dragons. The *ku t'ung lung*, "dragon of old bronzes," also known as *ch'ih lung*, is of peculiar form, with a slender lizard-like body terminating in a cleft curving tail, and four feet usually three-clawed. Its curling bifid tail is displayed in the foreground of Fig. 59, the picture of another incense burner, which is moulded in strong relief with the forms of a pair of these dragons, disporting in the midst of scrolled clouds and projecting their heads to make two handles for the urn. This incense burner (*hsiang lu*) is stamped

under the foot with the mark *Ta Ming Hsüan Tê nien chih, i.e.,*
" Made in the reign of Hsüan Tê of the great Ming dynasty." It
is a good example of the reign (1426–35), which is well known to
be celebrated for its artistic bronze work, so that the " mark "
is very often counterfeited. The story goes that a great fire in
the palace provided an inimitable blend of metals for the handi-
craft of the period. Many of the shapes of the urns, according
to a special Chinese book on the subject, were copied from porcelain
vessels of the T'ang and Sung dynasties, which were themselves
modelled after ancient bronze forms.

The earliest mirrors in China were made of bronze and are referred
to in the ancient dictionary *Shuo Wên* under the name of *ching.*
Their manufacture under the Chou dynasty has been already
noticed, and the white colour of the alloy which generally dis-
tinguishes them was attributed to the fact, quoted from the records
of the time, that the alloy contained as much as 50 per cent. of
tin. The mirror has a peculiar sanctity in the far east. The
spiritualistic mirror and the demon-compelling sword are the most
powerful symbols of the Taoist cult, and they have been adopted
as the principal insignia of the regalia in Japan. The magic
mirror makes hidden spirits visible and reveals the secrets of
futurity. Pure solar fire is obtained for the Chinese nature
worshipper by the use of a concave bronze mirror ; and the Taoist
herbalist fancies that he distils drops of dew from the full moon
upon the face of the plane circular mirror which he ties at night-
fall to a tree for the purpose.

The metal mirrors, which are generally circular in form, are
moulded on the back with mythological figures, animals, birds,
floral scrolls, and other ornamental designs, executed in strong relief.
Some of them have the curious property of reflecting from their
faces in the sunlight on a wall, more or less distinctly, the raised
decoration on their backs. This has been known to the Chinese for
many centuries, and it was long ago discovered accidentally by

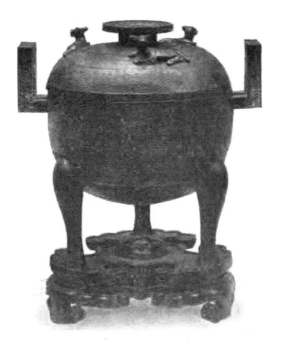

FIG. 57.—SACRIFICIAL UTENSIL FOR MEAT OFFERINGS—SAN HSI TING.
Of Conventional form with Three Recumbent Oxen on the Cover.
No. 191-'99.

H. 12 in., W. 12⅝ in.

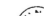

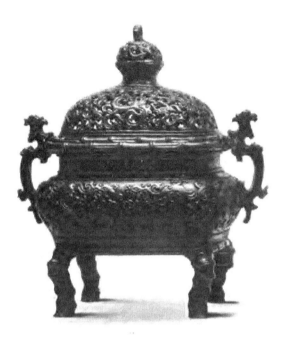

FIG. 58.—INCENSE BURNER—HSIANG LU.
Fashioned in the Form of a Four-legged *Ting*, with perforated Cover.
No. 900-'74.

H. 11½ in., L. 10 in., W. 7½ in.

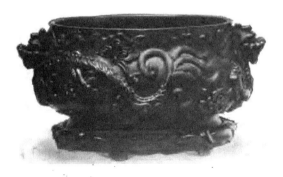

FIG. 59.—INCENSE BURNER. HSIANG LU. MOULDED DRAGONS.
Mark of the Reign of Hsüan Tè (1426-35).
No. 176 '99.

H. 3¼ in., W. 7⅞ in.

Japanese ladies, but it is only recently that these so-called magic mirrors of China and Japan have been investigated by European physicists in the *Philosophical Magazine vol. 2, Proc. Roy. Soc. xxviii., Annales de Chim, et de Phys., S. Série, T. xxi, xxii.* The investigators Brewster, Ayrton, and Perry, Govi, and Bertin, all agree in their explanation of the phenomena. They prove conclusively that the peculiar property of the magic mirror is due to the polishing and is accidental, although it can be easily produced artificially. It results from wavy irregularities of the reflecting surface produced in polishing, in consequence of uneven pressure from the back, and is entirely independent of chemical composition. The magic properties are exhibited even more beautifully than in the sunlight when divergent rays of artificial light are projected from the face of the mirror upon a white wall, when figures and designs appear sharply outlined by a bright light, which are quite imperceptible on the surface of the mirror.

Chinese books on bronzes always include a section devoted to the illustration and description of ancient mirrors of bronze and iron, which supplies valuable material for the chronological study of Chinese art, as many of the mirrors have inscriptions or marks of date. The relief decoration on their backs reveals the favourite mythological cult of the time. In the Han dynasty we find Taoist divinities, grotesque monsters, and natural marvels of happy augury like those on the contemporary bas-reliefs on stone, astrological figures of the four quadrants of the uranoscope, and the twelve animal signs of the solar zodiac. The mirrors of the T'ang dynasty (618–906) are mainly astrological, displaying the twenty-eight animals of the lunar zodiac, the asterisms to which they correspond, and other stellar signs, in addition to the above. The description of one of these, fifteen inches in diameter, illustrated in the *Chin Shih So*, may be quoted here. The moulded decoration is spaced in a succession of concentric rings, the centre of which is the usual boss, perforated for a silk cord. The first ring contains the four

figures of the uranoscope, the azure dragon of the eastern quadrant, the sombre tortoise and serpent of the north, the white tiger of the west, and the red bird of the south ; the second ring has the *pa kua*, the eight trigrams of broken and unbroken lines, used in divina- tion ; the third ring displays the twelve animals of the solar zodiac ; the fourth, the ancient names of the lunar asterisms in archaic script ; the fifth, the figures of the twenty-eight animals of the lunar zodiac, followed by their names, the names of the constellations over which they rule, and of the seven planets to which they cor- respond. The planets are arranged in the same order as in our days of the week, and the Chinese are presumed to have derived from the west their first knowledge of the division of the periods of the moon's diurnal path among the stars into weeks of seven days, about the eighth century, when they obtained also the animal cycles, which had been previously unknown to them. Their know- ledge of the twenty-eight lunar mansions is, however, far more ancient, and it has long been a disputed question whether these were invented in Chaldæa, India, or China, or derived from some other common source in Central Asia. Professor W. D. Whitney, in his studies on the Indian *Nakshatras*, or Lunar Stations, sums up the discussion by the conclusion that, " considering the con- cordances existing among the three systems of the Hindus, Chinese, and Arabians, it can enter into the mind of no man to doubt that all have a common origin, and are but different forms of one and the same system."

After the tenth century the mirror backs are moulded with decora- tion of more ordinary character, including sprays of natural flowers with birds and butterflies, conventionalised garlands of ideal flowers like the *pao hsiang hua*, or " flowers of paradise," fish swimming in waves among moss and water-weeds, men with trained lions, naked boys waving lotus blossoms, dragons and phœnixes disporting in the midst of floral arabesques, and the like designs, such as supply the usual motives of Chinese art of the period.

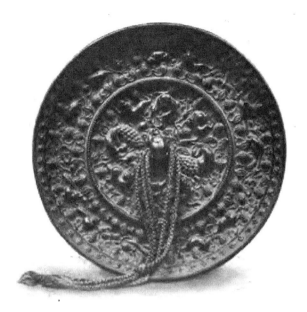

FIG. 60.—MIRROR WITH GRÆCO-BACTRIAN DESIGNS.
Han Dynasty (B.C. 202–A.D. 220).
No. 186–'99.

Diam 9⅛ in.

FIG. 61.—MIRROR WITH SANSKRIT INSCRIPTION.
Yuan Dynasty (1280–1367).
No. 202–'99.

Diam. 3¼ in.

Some of the motives of decoration were introduced from the Græco-Bactrian kingdom as early as the second century B.C., after the emperor Wu Ti had sent envoys to Central Asia, who penetrated to the Persian Gulf, and brought back with them some knowledge of Grecian and Indian civilisation to China. Professor Hirth's article *Ueber Fremde Einflusse in der Chinesischen Kunst*, Leipzig, 1896, may be referred to in this connection, being illustrated with the figures of several of the mirrors reproduced from woodcuts in Chinese books. One of these characteristic mirrors of the Han dynasty (B.C. 202–A.D. 220), is in the Museum Collection and is shown in Fig. 60. It is made of white bronze with a moulded decoration on the back known technically as *hai ma p'u t'ao, i.e.,* "Sea-horses and grapes." This is divided by a raised moulding into a central medallion and an outer band, filled with vine branches carrying bunches of grapes, and with winged horses and other monsters, peacocks and butterflies, in the intervals. A light floral scroll runs round the edge, and there is a knob in the centre fashioned in the form of a monster, pierced for the cord, which is braided of yellow silk, and knotted.

The smaller bronze mirror reproduced in Fig. 61 is of Buddhist origin, being inscribed with a Buddhist dharani, or invocatory formula,' pencilled in the neo-Sanskrit script of the Lama, or Tibetan, church. This form of Buddhism was formally adopted as the state religion of China during the Yuan dynasty (1280-1367), to which period this mirror is to be attributed.

Chang Ch'ien, the celebrated envoy of the Emperor Wu Ti in the second century B.C., is stated in his biography to have brought back reports of India and of Buddhism, but it was not till the year A.D. 61, in the reign of Ming Ti, that Buddhism was officially recognised in China. In this year the Emperor, after dreaming of a golden figure of supernatural proportions with a shining halo round its head, sent an embassy to India, which returned with two Indian monks bringing sacred books, paintings,

and images. A long succession of Indian missionaries followed in
their footsteps, gradually establishing a new school of art, which
has ever since retained, more or less, its old canonical lines.
This is strikingly apparent in the modelling of Buddhist bronze
figures, which are generally of graceful outline with flowing drapery
and Aryan features ; contrasting strongly with the Turanian
physiognomy and heavy lines of the orthodox Taoist type. Gilded
bronze is a favourite traditional material for the images of Sakya-
muni, the historical Buddha, which are modelled in square-spaced
lines after pictures drawn from measurements recorded in the canon.
His principal representations are :

1. *His Birth.*—An infant standing erect upon a lotus-thalamus, pointing upward
to heaven with his right hand, downward to earth with his left, according to the
tradition which tells us that he cried out at the moment, " I the only, most exalted
one ! "

2. *Sakya returning from the Mountains.*—Of ascetic aspect, with beard and shaven
poll, attired in flowing garments, and holding his hands in a position of prayer.
The ear lobes are enlarged, a sign of wisdom, and the brow bears the *urna*, the
luminous mark that distinguishes a Buddha, or a Bodhisattva.

3. *The All-wise Sakya.*—A Buddha seated cross-legged upon a lotus throne
resting the left hand upon the knee, the right hand raised in the mystic preaching
pose. The hair is generally represented as a blue mass, composed of short, close
curls, and a jewel is placed midway between the crown and forehead.

4. *The Nirvana.*—A recumbent figure lying upon a raised bench, with the head
pillowed upon a lotus.

5. *In the Sakyamuni Trinity.*—Either erect, or seated in the attitude of medita-
tion, with the alms bowl in his hands, between his spiritual sons, the Bodhisattvas
Manjusri and Samantabhadra, the three forming a mystic triad.

The eighteen Arhats, or Lohan, a group of the early apostles or
missionaries of the faith, are often moulded in bronze, each one
posed in a fixed attitude with his distinctive symbol or badge,
in the same way as our apostles are represented—Mark with a lion,
Luke with a book, etc. The number was originally sixteen, the
later additions being Dharmatrata, the chief of Kanishka's synod
of 500 Arhats, a lay devotee with long hair, a vase and fly-whisk
in his hand, a bundle of books on his back, gazing at a small image
of the mystic celestial Buddha Amitabha ; and Ho-shang, " The

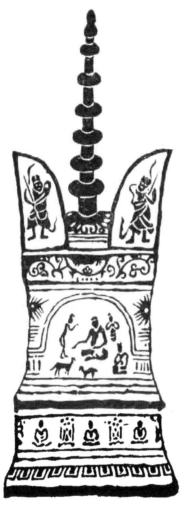

吳越王金塗墻

塔銅質塗金
狀如片瓦四丸
合成一塔從金
石契摹本張
芑堂云右金
塗塔畫象見
表忠譜高寸
重三十五両

FIG. 62.—VOTIVE STUPA OF GILDED BRONZE. A.D. 955.
H. 7¼ in., Wt. 3 lbs.

Monk," the familiar *Pu-tai Ho-shang*, " the Bonze with the Hempen Bag," the only one of the group born in China, where he represents the last incarnation of Maitreya, the Buddhist Messiah. This last, the Hotei of Japan, is an obese image with smiling features of Chinese type, holding a loosened girdle in one hand and a rosary in the other, and reclining on a bulging sack. He ranks as a Bodhisat, having only once more to pass through human existence to attain Buddhahood, and under this title, contracted *more sinico* to *pou-sa*, or *poussah*, has become proverbial in French as an emblem of contentment or sensuality, and given besides titular rank as the *dieu de la porcelaine*.

Bodhidharma is another Buddhist saint often moulded in bronze, the twenty-eighth and last of the line of Indian patriarchs and the first Chinese patriarch. The son of a king in southern India, he came by sea to China in 520, and settled in Loyang, where he is said to have sat still the whole time absorbed in silent meditation and to have earned the title of " The Wall-gazing Brahman." He is figured crossing a river on a reed plucked from the bank, or carrying in his hand a single shoe on his legendary spirit journey back to his native land after his death at Loyang in 529.

The most popular of all Buddhist divinities in China is Kuan Yin, often called the " Goddess of Mercy," who also ranks as a Bodhisat, and is identified with Avalokita, " The Keen-seeing Lord," the spiritual son of the celestial Buddha Amitabha, who shares with him the dominion of the Paradise of the West. The bronze effigy of Avalokita takes many forms. The four-handed form represents him as a prince sitting in the Buddha posture, with one pair of hands joined in devotional attitude, the others holding a rosary and a long-stemmed lotus flower. Another form has eleven heads, piled up in the shape of a cone, and eighteen, or even forty hands, grasping symbols and weapons, and stretched out in all directions to rescue the wretched and the lost ; and some of the manifesta-tions are endowed with a thousand eyes ever on the look-out to

perceive distress. In another shape as Kuan Yin the maternal, the favourite image of the domestic shrine, she appears with a child in her arms, and is worshipped by women desirous of offspring, who load her altar with *ex-voto* offerings of doll-like babes made of silk or moulded in ceramic ware for the purpose. Such images are often cast with a jewelled cross on the breast suspended on a necklace of beads and have been mistaken for representations of the "Virgin and Child."

Since the time of Asoka, the celebrated Indian raja, who is said to have erected 84,000 stupas to enshrine the sacred relics of the cremated Buddha, it has been the custom in all Buddhist countries to build these monuments, the principal forms of which have been already sketched in the chapter on architecture. At the same time it has been held to be a work of merit to mould miniature stupas in various materials in commemoration of the Buddha, and it may be of interest to give here (Fig. 62) an illustration of a Chinese votive stupa of gilded bronze taken from the *Chin Shih So.* It is described as being fashioned, as it were, of four tiles welded together to make the model stupa, which has a double square pedestal with winged corners at the top, inclosing a small hemispherical *garbha,* or dome, with a spire mounted with seven *chatra,* or umbrellas. It is about seven and a half inches high and weighs nearly three pounds. The base is encircled with seated figures of Sakyamuni Buddha, the upper corners with standing figures of swordsmen with waving garments which represent probably the celestial guardians of the eight points of the compass. The central panels contain pictures of four of the *jatakas,* which are stories of scenes in the life of Buddha during his former births. The scene in the picture exhibits the Mahasattva as heir-apparent offering his body to feed a starving tigress and its cub. The scene at the back is Chandrabrabha, the "moonlight king" cutting off his own head to save a Brahman. The other two on the sides represent King Sivika cutting off his flesh to rescue a dove from the clutches of a hawk, and Maîtribala

FIG. 63.—BUDDHIST TEMPLE GONG. A.D. 1832.
No. 877-'68.
H. 3 ft. 10 in., W. 2 ft. 10 in.

O

Raja cutting off his ears as food for a hungry demon, or yaksha. The stupa was found in the first year (A.D. 1573) of the reign of Wan Li of the Ming dynasty while digging a grave in the suburbs of Hangchou. Its date is shown by an inscription inside which reads :

"Ts'ien Hung-Shu, King of the State of Wu and Yueh, has reverentially made eighty-four thousand precious stupas and inscribed this in the cyclical year *yi-mao*."

Ts'ien Hung-Shu was the third ruler of the principality of Wu and Yueh, which had been founded with great splendour by his grandfather Ts'ien Chiao in A D. 907, with its capital at Hangchou ; and was carried on in nominal vassalage to the ephemeral dynasties which sprang up at this period, till it finally submitted to the rising Sung dynasty in 976. He reigned 947–976, and the cyclical year of the inscription corresponds to A.D. 955.

A musical gong is suspended under the verandah in the principal courtyard of every Buddhist temple in China and struck with a wooden mallet to call the bonzes to their frequent services. One of these massive gongs, which was presented to the museum by the officers of the 1st or King's Dragoon Guards in 1868, is illustrated in Fig. 63, with its suspending loops. Of foliated outline, with a prominent band round the rim, the centre displays a framed panel supported by a lotus blossom, and a boss in strong relief below, where the gong is struck. Within the panel is a Chinese inscription with a headline reading :—

"Presented as an offering to the Ch'üeh Shêng Temple."

The inscription arranged in three vertical lines beginning with the middle reads :—

"In the reign of Tao Kuang of the Great Ch'ing dynasty in the cyclical year jên-ch'ên (A.D. 1832), on the fortunate day the first of the first new moon, the retired scholar Miao Yin, together with the Prior of the Monastery, the Bhikshu Kuo Chien, reverently made this. Vows were recited praying that the merits of the makers of this instrument might last through the whole *kalpa*, and that every hearer of its tuneful melody might ultimately attain the Buddhahood. Om ! Tâna ! Tâna ! Katâna ! Svâha ! "

The reverse side is inscribed with the names of forty " devout

disciples," lay members male and female, of the community;
followed by a list of the religious names of seventeen " bhikshus,"
comprising no doubt the community of monks resident at the time in
the monastery attached to the temple.

Bronze has long been used in China for the fabrication of as-
tronomical instruments. The artistic style of these instruments is
shown in Figs. 64, 65, which are reproductions of two of the strik-
ing photographs for which we are indebted to Mr. J. Thomson.
They were taken at the Peking Observatory, which is the oldest in
the world, being 300 years older than the earliest European observa-
tory, founded by Frederick III. of Denmark in 1576, at which Tycho
Brahé made his remarkable observations. The Peking observa-
tory was built by Kublai Khan, the first emperor of the Mongol
dynasty, on the eastern wall of his new capital of Cambalu, the
modern Peking, and in the year 1279, the bronze instruments were
erected there which had been made for the purpose by Kuo Shou-
Ching, the celebrated astronomer and hydraulic engineer. He was
born in 1231, and his biography is fully recorded in the annals of the
period. The *Ling Lung Yi*, or Equatorial Armillary, made by him
is seen in Fig. 64. As described by Professor S. M. Russell in the
Chinese Times, 7 April, 1888, it consists of the following parts:—
Firstly, a massive horizontal circle, supported at four corners by
four dragons. Each dragon with one upraised five-clawed
palm supports the bronze circle, whilst round the other front
palm a chain is passed and fastened behind to a small
bronze pillar. With distended jaws, branched horns, flowing
manes and scaly bodies girt with flames they present a
very imposing appearance. *Secondly*, of a double vertical circle
firmly connected with the horizontal circle at its north and south
points, and supported below by a bronze pillar wrought with
clouds. These two circles are fixed. On the vertical circle, at
distance of 40° (*i.e.*, the latitude of Peking), are two pivots cor-
responding to the north and south poles. Turning round these

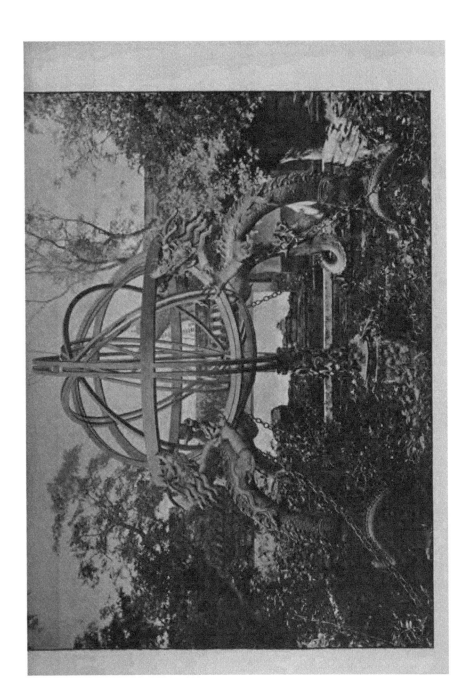

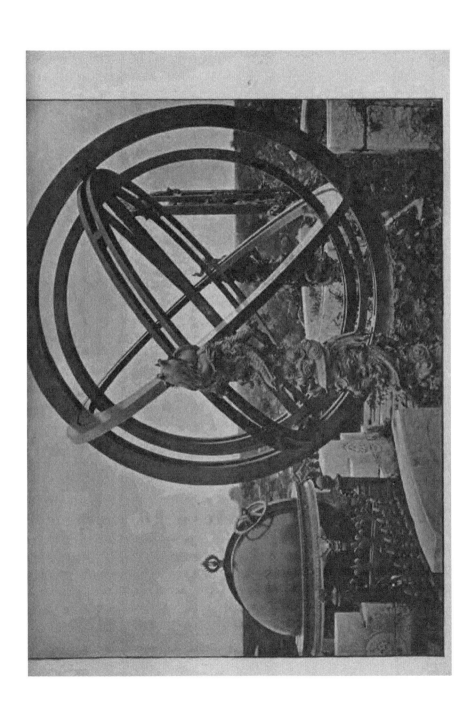

pivots are two circles, one double, corresponding to the solsticial
colure; the other single, corresponding to the equinoctial colure.
Midway, between the poles, is another circle, the rim of which is
let into the two colure circles. This circle corresponds to the
equator. Besides this circle, there is another slanting circle making
with it an angle of about 23½°, and intersecting it at the equinoctial
points. This corresponds to the ecliptic. All these circles turn
together round the polar axis. Finally, inside all these circles is
another double circle separately turning round the same axis.
This is the declination or polar circle. A hollow tube, through
which the heavenly bodies were observed, revolves between the
rims of this double circle. There were, probably, originally threads
across the tubes to define the line of sight. All the circles are
divided into 365¼°, a degree for each day in the year, and these
degrees are sub-divided into divisions of 10′ each.

The Mongol instruments were modelled after those of the Sung
dynasty, which had been set up at K'ai Fêng Fu, in the province of
Honan, about 1050 A.D. In the beginning of the present dynasty
when the Jesuit missionaries were promoted to positions in the
Astronomical Board at Peking, Père Verbiest reported them to be
worn out, cumbersome, overlaid with ornament and hard to turn,
and in the ninth year of the reign of K'ang Hsi, the year 1670, the
learned Jesuit was commissioned to make six new instruments.
These are of the same general character as the old Mongol instru-
ments, but are more accurate in their construction and easily ad-
justable. They were evidently made after the model of Tycho
Brahé's instruments and the circles are all divided into 360°,
instead of into 365¼°, and each degree into six parts. The observer
could read to 15″ by means of the diagonal scale and a moveable
divided scale. Two of Verbiest's instruments are shown in Fig. 65,
as they used to stand on the observatory tower at Peking before
they were torn up and carried off to Berlin, their firmly cut lines of
dark bronze contrasting so well with the white marble steps appro-

priately chiselled with scrolled designs interrupted by dragon and phœnix medallions. The equatorial armillary in the foreground is supported by two pillars worked with coiling imperial dragons in openwork relief enveloped in scrolled clouds. On the left is the *hun t'ien hsiang*, a revolving sidereal globe, six feet in diameter, displaying on its surface starred points in relief of varied magnitude touched with gold, representing the constellations of the sidereal heavens. The globe was turned round with the greatest ease by means of toothed wheels, one of which is visible in the picture.

A war drum of cast bronze in the museum collection, which is illustrated in Fig. 66, may be noticed next, as it has a Chinese inscription, although it is not, strictly speaking, an object of Chinese art. It comes from Peking and is engraved underneath with a Chinese date, in the script of the period, the inscription being :—

" Made on the fifteenth day of the eighth month of the fourth year (A.D.199) of the period Chien An."

Kettledrums of this peculiar form are a characteristic production of the Shan tribes between south-western China and Burma. They are known in China as *Chu-ko Ku*, " Chu-ko's Drums," after a famous Chinese general, Chu-ko Liang, who invaded the Shan country early in the third century, and one of them is still preserved in his ancestral temple in the province of Szechuan. Of circular form with bulging shoulder and flat top, displaying a star in the centre and four conventionalised tree-frogs near .the rim, it has four loops on the sides for suspension by cords. It is decorated with encircling rings in relief, filled in with narrow bands of hatched, wavy, concentric and corded ornament of primitive character, and with broader bands apparently derived from human and animal forms suggestive of elephants and peacocks.

The various processes of incrusting and inlaying the precious metals on bronze have long been known in China. The Chinese from the earliest times, like the other nations of the east, have

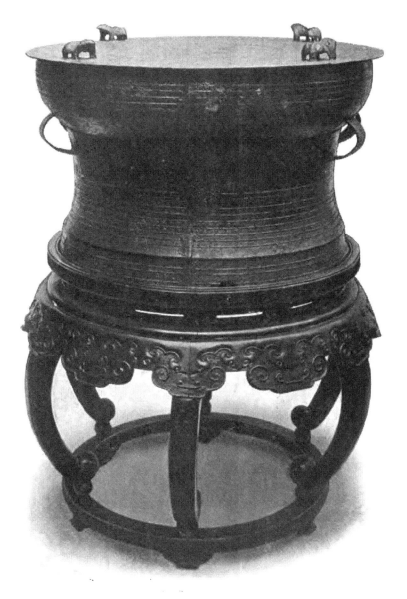

FIG. 66.—War Drum called Chu-Ko Ku. Inscribed A.D. 199.
No. 205-'99.

H. 15¼ in., Diam. 25¼ in.

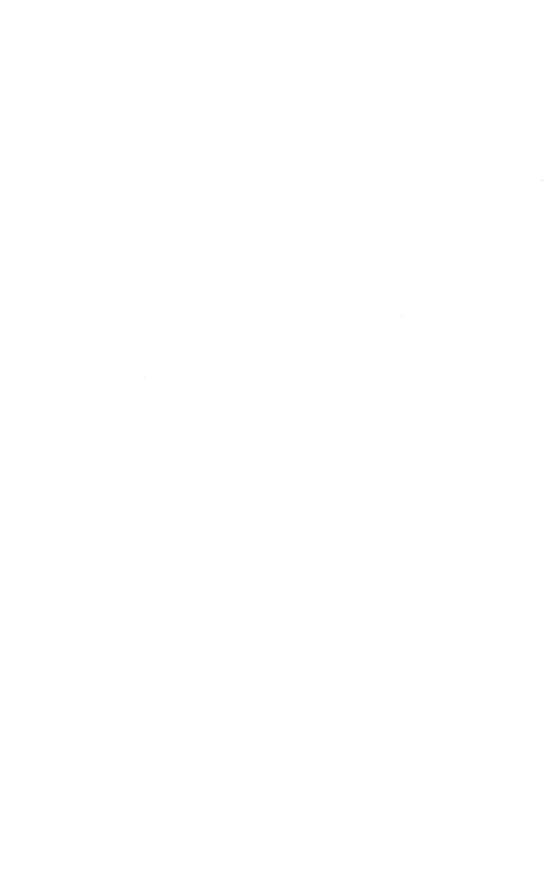

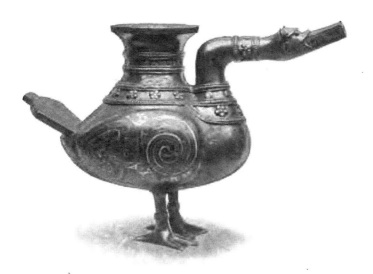

FIG. 67.—WINE VESSEL MODELLED IN THE FORM OF A DUCK.
Bronze incrusted with Gold and Silver.
No. 160-'76.　　　　　　　　H. 10 in., L. 15⅝ in.

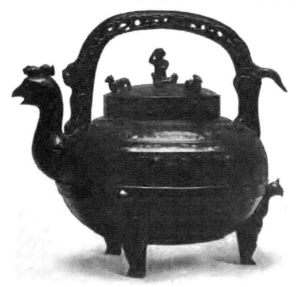

FIG. 68.—ARCHAIC WINE POT.
Bronze inlaid with Gold and Silver.
No. 227-'79.　　　　　　H. 8¼ in., D. 7⅜ in.

sought to enrich the surface of bronzes by this means and have been at least as successful as the Persians and Arabs, but there is no space here for a full discussion of all their methods.

The process of inlaying gold and silver wire in ornamental designs chiselled out for the purpose, which is commonly called *niellé*, is known to the Chinese as *chin yin ssŭ*, *i.e.*, " gold and silver thread-work." The author of the *Ko ku yao lun*, a well-known book on ancient art, published in 1387, carries back gold *niellé* work to the distant era of the Hsia, the first of the " three ancient dynasties," and says that some of the spear hafts and other bronzes of that time were beautifully inlaid with the precious metal in delicate lines as fine as hair. The finest silver *niellé* work known in China is attributed to a clever craftsman named Shih Sou, a Buddhist monk, who lived in the fourteenth century ; he made small vases for flowers and artistic bijoux for the scholar's writing table and usually inscribed his name underneath inlaid in silver wire.

Incrustation properly so called, that is to say, the application of the ductile metals on spaces scooped out and roughened by the graving tool on the surface of the bronze which is about to be incrusted, also goes back to a distant date, as we have already seen in the description of the sacrificial laver of the seventh century, B.C., illustrated in Fig. 49. Some of the old bronzes, as M. Paléologue observes, are so richly inlaid with gold and silver that the play of colour of the metallic surface almost attains to that of the finest porcelain : the brilliancy of the metals, softened and toned down by time, blends harmoniously with the deep shades of the patina, enchanting the eye with a wonderful effect of vibrating splendour. Some idea of the general style of the incrusted bronzes may be gathered from the two ancient wine vessels which have been selected for illustration. The first (Fig. 67), purchased in 1876 for £131, is moulded in the conventionalised form of a duck, the neck and beak serving as a spout, inlaid with gold and silver scrolls of mythic type, and ornamented in relief with beaded

bands and rosettes. The second (Fig. 68), is an archaic kettle-shaped vessel with a flattened globular body incrusted with triangularly spaced bands inclosing spiral designs with dragon's heads; the pierced handle is the serpentine body of a monster, the spout has the form of a phœnix head, with a small four-footed monster on the top, and the three feet represent phœnixes with outstretched wings; three small phœnixes are posed upon the lid and its moveable knob in the centre is fashioned in the figure of a monkey.

The Chinese make much use of gilded bronze. It is the traditional material of Buddhist images, but there is reason to believe that the art of gilding was known even before the introduction of Buddhism. The usual process is to soak the object to be gilded in a decoction of herbs and acid fruits to which saltpetre has been added to clean the surface; then to heat the metal, to rub it with mercury, and to apply the gold in the form of leaf on the surface thus amalgamated; the mercury is finally volatilised by fire and the work is finished by burnishing the gold that remains adherent so as to give it the required polish. The bronze beaker-shaped vase (*hua ku*), shown in Fig. 69, has been parcel gilt in this fashion, and is, moreover, inlaid with coral and malachite inserted in the tassels of beaded festoons which decorate its body; the neck and foot are moulded in relief and chased with four-clawed dragons pursuing jewels in the midst of scrolled clouds; the two handles are elephants' heads gilded, and the rims are chased with gilt bands of rectangular fret. The style, combining Chinese and Indian motives, resembles that adopted for the canonical vessels of the Lama form of Buddhism and this vase may have come from a "set of five" (*wu kung*) made for a Lama temple early in the present dynasty.

The goblet-shaped vase, one of a pair, reproduced in Fig. 70, is an example of hammered bronze work, attributed to the K'ang Hsi period (1662–1722); the outside is chased with ornament gilded on a

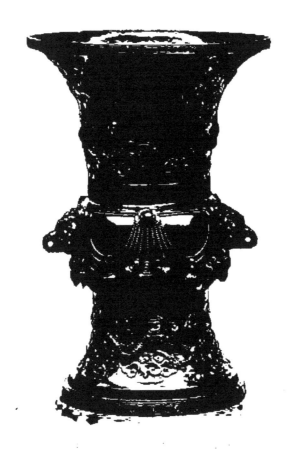

FIG. 69.—SACRIFICIAL VASE FROM A LAMA TEMPLE.
Bronze parcel-gilt, chased, and inlaid with Coral and Malachite.
No. 154–'76.

H. 9⅝ in., D. 6⅝ in.

FIG. 70.—GOBLET-SHAPED VASE OF HAMMERED BRONZE WITH GILDED ORNAMENT.
No. 199-'99.

H. 7⅝ in., D. 4⅜ in.

FIG. 71.—IRON STATUETTE COATED WITH MOSAIC OF REALGAR.
No. 838–'83.

H. 10¾ in.

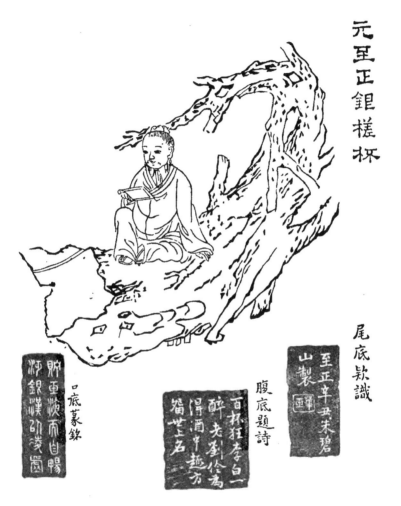

元至正銀槎杯

尾底欵識

至正辛丑朱碧
山製

腹底題詩

百林狂李白一
醉走到俗為
得酒中趣方
留芝石

口底篆銘

聊重煥而自暢
輝銀璞勿淺圖

FIG. 72.—RUSTIC WINE CUP OF SILVER.
With Inscriptions, dated A.D. 1361.

black ground, the inside deeply gilt ; the body of inverted cone shape rises with angular necking from a circular foot ; the decoration con-sists of spreading floral scrolls, with dragons and flaming jewels amid clouds on the necking.

The somewhat anomalous and grotesque figure, one of a pair, illustrated in Fig. 71, is made of iron, coated with a mosaic of thin plates of realgar, the natural red sulphide of arsenic, joined together by a cement of lacquer. They are probably memorial statuettes from a temple, dating from the Ming dynasty (1368–1643).

A woodcut of a quaint silver wine cup taken from the *Chin Shih So* may be inserted at the end of this chapter as an example of old Chinese plate. Marco Polo, the Venetian, and the French friars, who travelled overland through Asia in the thirteenth century, to be received at the court of the great Khan, tell us how his banqueting table used to be loaded with gold and silver vessels filled with kumiss and different kinds of wine, but very few specimens have survived to the present day. The one illustrated here (Fig. 72), under the heading of "silver rustic cup of Chih Chêng of the Yuan (dynasty)," is described as being made of silver in the form of the branch of an old tree hollowed out in the interior, with an opening at the end for pouring the wine in and out, and having the figure of a scholar reading a book seated upon it. At the other end is the inscription :—

"Made by Chu Pi-shan in the cyclical year hsin-ch'ou of the period Chih Chêng."

This corresponds to A.D. 1361, towards the close of the reign of the last emperor of the Yuan dynasty, of which Kublai Khan was the founder. The inscription is sealed with the "hall mark" of the maker *hua yü, i.e.,* "flowered jade." A short rhyming verse in curious script and a couplet in seal character are also inscribed underneath the cup, the former of which may be rendered :—

"A hundred cups inspired the poet Li Po,
A single bowl intoxicated the Taoist seer, Liu Ling :
Pray beware of a slip when full of wine,
A false step may mar the fair fame of a lifetime."

CHAPTER V.

Wood-carving is one of the most important of the industrial arts of China and is alluded to in some of the earliest records. Their architecture can be traced back to a period when the fabric was entirely built of wood, and even in the present day, when the walls of the building are filled in with stone and brick, the decoration of the interior of the hall is still entrusted to the wood-carver. He fills in the skeleton outline of beams and pillars with delicate tracery, supplies moveable partition screens of elaborately carved woodwork, lines the walls and ceiling with ornamental panels, and decorates the doors and windows with characteristic trelliswork designs. The motives employed in the designs depend on the class of building, but the groundwork is generally composed of floral scrolls taken from nature. In imperial buildings the floral scrolls are accompanied by bands and panels of dragons in clouds, phœnixes flying in couples and other mythological monsters, and the carving is executed in the dark heavy precious *tzŭ-tan* wood, derived from different species of *Pterocarpus*, which is prescribed for the purpose by sumptuary laws. For ordinary use there is a choice of many richly grained woods of almost equal beauty, such as the *hua-li*, the rose-wood of the Portuguese, the *t'ieh-li*, a variety of ebony, the *hung-mu* or "redwood," etc., which are produced in the south-western provinces of the empire and are also imported from Indo-China. The prevailing floral grounds are filled in with panels of figure scenes from history and romance, birds and animals, butterflies and other insects, emblems of riches and happiness, or with some other of the many motives affected by Chinese art generally.

For Buddhist and Taoist temples the woodwork is sculptured

FIG. 73 —STAND OF WOOD CARVED WITH LOTUS, ETC.
No. 1113-'74.

H. 22 in.

with sacred scenes and figures inclosed in scrolls of flowers, intermingled with the series of conventional emblems distinguishing the two religions. The introduction of Buddhism soon after the Christian era had a profound and far-reaching influence on the glyptic art of China. The earliest Buddhist pilgrims, who came overland from India, are said to have brought with them images of Buddha, as well as pictures of saints and Sanskrit manuscripts, and these images were taken as models, in connection with sketches drawn from measurements recorded in the ancient canon upon spaced diagrams with square-inch sections. The early missionaries coming from northern India introduced what is known as the Gandhara school of sculpture with its joint impress of Persepolitan and ancient Greek influences, and Chinese Buddhist figures have retained to this day a marked Aryan physiognomy, and an arrangement of folds in their drapery suggestive of their origin. They were made of gold, gilded bronze, jade, ruby, coral, and other precious materials, but the first Buddhist image is said by early tradition to have been carved in white sandalwood and the fragrant wood of the *Santalum album* is still imported from India into China for the purpose. Its old Chinese name *chantan*, derived from the Sanskrit *chandana*, is now generally contracted as *tan-hsiang*, or " sandal perfume," and it is offered in a pile of aromatic chips on the Buddhist altar, burnt as incense, or pounded into dust to be moulded into the perfumed joss-sticks which are lighted at every shrine. Sandal-wood is also a favourite material for the rosary of the Buddhist monk, the 108 larger beads of which are occasionally carved into figures of Buddha, and the eighteen smaller beads into miniature representations of the eighteen Lohan, or Arhats, a well-known group of his principal disciples (See Fig. 78). The art of sculpture in China was born, cherished, and developed in the service of religion. Buddhist and Taoist shrines are lavishly decorated from and to end, and the demand for idols and images, for the home as well as the temple, gives occupation to a

special class of workmen throughout the country. Their most im-
portant works are still enshrined in the temples for which they were
made, but a general idea of their character may be gained by an
inspection of the many productions of the nearly allied glyptic art
of Japan which have been brought to Europe in recent times.

China possesses a rich and abundant flora, the wild and cultivated
varieties of which supply the favourite art motives of the carver.
Some of the flowers are selected for their religious associations.
The lotus, or *lien hua,* a rose-coloured variety of the *Nelumbium
speciosum,* is sacred to Buddhism. It is the hieratic emblem of purity
as it develops its delicious jade-white rhizomes under the mud and
lifts its rosy blossoms unsullied in the air. The happy entrant
into paradise is seated upon its broad thalamus ; it, therefore,
forms the resting-place of Buddha. Its peltate leaves are usually
gemmed with sparkling rain drops, which are taken by the devout
Buddhist as emblematic jewels of his enlightenment ; although
the Japanese poet cited in Mr. Huish's *Japan and its Art* (p. 127),
protests—

> " Oh ! Lotus leaf, I dreamt that the whole earth
> Held naught more pure than thee,—held naught more true :
> Why, then, when on thee rolls a drop of dew
> Pretend that 'tis a gem of priceless worth ? "
>
> HEUZEN, A.D. 835–856.

The lotus, intertwined with another water plant with berried
fruit, is pleasingly carved in open-work in the stand shown in Fig. 73,
which was probably originally intended for the suspension of a
medallion picture of jade, or some such object of glyptic art.

The Taoists take as their sacred plants the manifold floral em-
blems of longevity, the *summum bonum* of their mystic cult. The
most prominent position is given to the peach, the tree of life of
their Kun-lun paradise, whose fruit, ripening but once in 3,000
years, is celebrated as conferring on mortals the coveted gift of im-
mortality. Another constant emblem is the sacred branching fungus
called *ling chih,* the *Polyporus lucidus* of botanists, distinguished

by its brightly variegated colours and by its durability. Next come the grouped trio *Sung, Chu, Mei,* the Pine, Bamboo, and Prunus, the first two because they are evergreen and flourish throughout the winter, the prunus because it throws out flowering twigs from its leafless stalks up to an extreme old age.

The wild plum, *Prunus Mumei,* is the ordinary floral emblem of winter ; the tree peony, *Pæonia Moutan,* of spring ; the lotus, *Nelumbium speciosum,* of summer ; and the chrysanthemum, *C. indicum,* of autumn : these flowers are constantly associated in decorative work as the *Ssu Chi Hua,* " Flowers of the Four Seasons." So, again, are the " Flowers of the Twelve Months," although this group varies in different parts of China. One series of these monthly emblems is artistically rendered in the floral sprays which decorate the lower border of the lacquered screen pictured in Fig. 74, the tale of which, proceeding in Chinese fashion from right to left is :—

1. February. Peach Blossom. *T'ao hua.* Amygdalus persica.
2. March. Tree Peony. *Mu tan.* Pœonia Mutan.
3. April. Double Cherry. *Ying t'ao.* Prunus pseudocerasus.
4. May. Magnolia. *Yü lan.* Magnolia Yulan.
5. June. Pomegranate. *Shih liu.* Punica granatum.
6. July. Lotus. *Lien hua.* Nelumbium speciosum.
7. August. Pear. *Hai t'ang.* Pyrus spectabilis.
8. September. Mallow. *Ch'iu k'uei.* Malva verticillata.
9. October. Chrysanthemum. *Chü hua.* C. indicum.
10. November. Gardenia. *Chih hua.* Gardenia florida.
11. December. Poppy. *Ying su.* Papaver somniferum.
12. January. Prunus. *Mei hua.* Prunus Mumei.

Another series of these floral emblems is displayed in a corresponding position on the back of the screen. There are two of these screens of the same character in the museum which are magnificent examples of Chinese decorative art of the eighteenth century. Both are of lacquered wood, in twelve folds, largely decorated on both sides with incised and raised details, painted

with coloured and gilded lacs, set in a background of lustrous black. The rest of the broad border of the one before us (Fig. 74) is filled with vases and baskets of flowers and fruit, interspersed with censers, bells and sacrificial vessels shaped after ancient bronze models. The border is defined round the edge of the screen by a running line of rectangular fret, succeeded by a narrow band of floral diaper ; and, inside, by a band of trellis interrupted by medallions containing alternately phœnixes and longevity (*shou*) characters. This last band, which suggests a conjecture that the screen was made for an empress of the period, serves as a frame for the central picture, which is a Taoist scene representing the well-worn theme *Chu Hsien Ching Shou,* "The Taoist Genii worshipping the God of Longevity." There is no space here to distinguish the motley crowd of devotees, who are seen crossing the Taoist Styx in frail boats and on rustic bridges, or riding aloft upon the clouds, with the various attributes by which they may be recognised. Singly, or in groups, all are wending there their way towards the mountain paradise where the god is seated upon a rock under the branches of a pine. He is seen better on Fig. 75, where the two central panels of the screen are reproduced on a larger scale, as Shou Lao with protuberant brow. A deification of Lao Tzŭ, the founder of the Taoist cult, he holds a *ju-i* sceptre tipped with an effulgent jewel. Three youthful attendants stand near by, holding his pilgrim's staff, book, and towel. Close at hand are a handmill for pounding the *elixir vitæ,* a dish of peaches, a vase of branched coral, a clump of fungus (*Polyporus lucidus*) growing on the rocks, and a pair of deer and of storks, his familiar animals, stand in front. The two figures in friendly converse in the middle of the panel represent the familiar *Arcades ambo* of the cult, the "Twin Genii of Union and Harmony," one holding a palm-leaf with a gourd tied to his girdle, the other with a manuscript roll and a besom. Below them stands the shepherd hermit Huang Ch'u-p'ing, changing stones into sheep with his magic wand for the edification of his brother, who is leaning on his

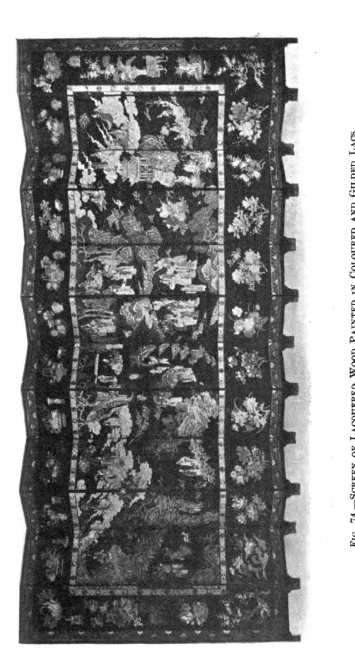

Fig. 74.—Screen of Lacquered Wood Painted in Coloured and Gilded Lacs.
The Taoist Genii worshipping the God of Longevity.
No. 163-'89.

H. 8 ft. 2½ in., L. 19 ft. 3 in.

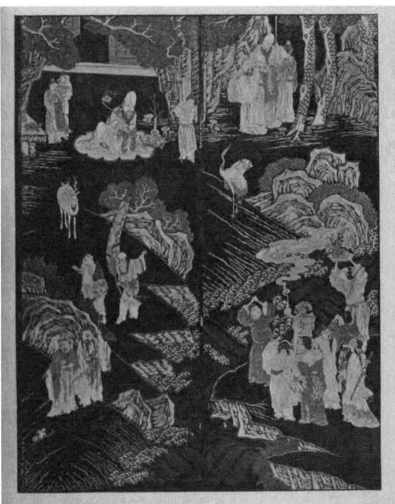

FIG. 75.—TWO CENTRAL PANELS OF SCREEN IN FIG. 74.
No. 163–'89.

staff behind—a similar scene is painted on a Chinese *kakemono* in the British Museum collection. The group at the top of the right-hand panel seems to be Lao Tzŭ with pilgrim's staff, Buddha holding a book, and Confucius in front, with a fourth figure in questioning pose at the side. Below we have the well-known group of the eight genii, *Pa Hsien*, so constantly associated in Chinese art as the eight Taoist immortals, the members of which are distinguished by their attributes. Among these attributes the feather fan of Chung-li Ch'uan, the sword of Lü Tung-pin, the gourd of Li " with the iron crutch," and the basket of flowers held up by Lan Ts'ai-ho are conspicuous in the picture. The reverse of the screen is decorated in the same artistic style with a succession of oblong panels containing landscapes, scenes with figures, pictures of birds flowers and fruit ; the apparatus of the four liberal arts, writing, painting, music, and chess ; sacred relics and emblems of the Taoist and Buddhist religions.

The second screen,which was bought in 1885 for £1,000 is larger, more imposing, and, perhaps, even more artistically finished. The broad border is filled with vases and baskets of flowers and fruit, together with a varied collection of the manifold apparatus of old literature and art known technically as *Po Ku*, the " Hundred Antiques." The narrow bands defining the border are composed of a diaper of conventional peony scrolls and a series of the archaic dragons called *ch'ih-lung* in pairs guarding the sacred fungus ; succeeded by a continuous line of rectangular fret, framing the main picture. This is composed of a mountain scene with rocks, pines and blossoming trees, flowers and birds of realistic aspect, in connection with illustrations of mythological story, the general character of which may be gathered from the two panels which are reproduced in Figs. 76, 77, although on too small a scale to do full justice to the original. The *first* exhibits a pile of open rock-work with peonies, roses, lilies, begonias and wild asters, and a couple of pheasants perched upon it ; shaded by branches of fir,

bamboo and blossoming prunus, overspread with cloud scrolls, and parrots flying underneath. The *second* displays the rolling crested waves of an ancient sea, laden with scrolls and precious objects, above which towers a two-storied pavilion supported by banks of clouds, representing the T'ien T'ang, the celestial paradise of the Taoists. Two supernatural animals are rising from the waves, revealing on their backs the magic arithmetical squares which form the base of ancient speculations in Chinese numeral philosophy; the *lung ma*, or "dragon-headed horse," on the left, the *shên kuei*, or "divine tortoise" on the right. Under banks of clouds ot the top a stork is flying bringing a "rod of fate" in its beak, and the picture is completed with branches of pine and flowering peach and cherry. The reverse of this beautiful screen is charged with fan-shaped and oblong panels containing landscapes or flowers, accompanied by inscriptions in verse pencilled in different styles of script; surrounded by bands of phœnixes in pairs with peonies, and of dragons in connection with longevity (*shou*) characters.

In addition to ordinary woods *bamboo* is much used for carvings throughout the far East. The jointed hollow stem is worked, which is smooth and straight, as well as the roots. which are knotted, distorted and compact in structure. The nature of this wood, which is hollow in the interior, limits it to a certain variety of forms, although the graceful curves of its outline appeal strongly to the artistic eye. The most common objects in collections carved in bamboo are *pi-t'ung*, "brush pots," and *chên-shou* "hand rests." The *brush pots* are cylinders made by a cross-section of the stem, cut in such a way that the natural partition at the knot between two joints forms the bottom of the barrel-shaped receptacle which holds the brushes. The decoration is carved in open-work, or in high relief, in the firm fibrous structure of the wood, which is occasionally two inches in thickness. Sometimes sprays of flowers wind round the circumference of the cylinder, sometimes dragons

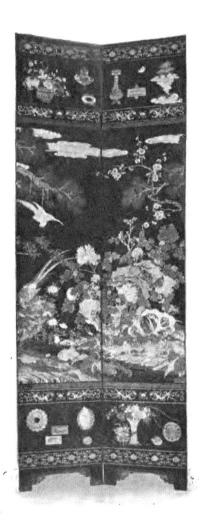

IG. 76.—TWO LEAVES OF LACQUERED TWELVE-FOLD SCREEN PAINTED IN COLOURS.
No. 130-'85.

H. 8 ft. 10 in., Entire L. 21 ft.

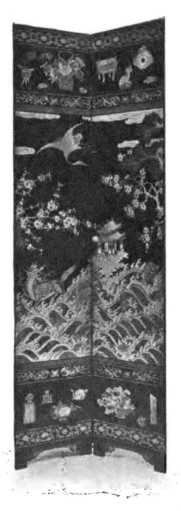

FIG. 77.—TWO LEAVES OF LACQUERED TWELVE-FOLD SCREEN PAINTED IN COLOURS.
No. 130-'85.
H. 8 ft. 10 in. Entire L. 21 ft.

or phœnixes ; usually we find figure scenes from ancient Chinese history or mythology, accompanied perhaps by literary quotations in verse. The typical *hand rest* is an oblong section of one side of a joint cut longitudinally so that the hand of the writer may be guided by the straight edge while his wrist is supported by the convexity, which is lightly incised with some simple decoration ; the shape is cherished as a survival from ancient times, when such slips of bamboo were in common use for writing and were strung together into books, before the introduction of woven silk and paper as more convenient materials for the scribe.

The Chinese have the highest appreciation of *ivory* as a material for glyptic work. The connoisseur always looks at the intrinsic properties of the medium and its effects in bringing out the skill of the craftsman which ennobles it. There is no material more satisfying to a delicate and refined taste than ivory, with its seductive body of translucent hardness passing into paler but warmer and softer tones, a milky transparent substance reflecting all the varied play of colour of a piece of amber. The clever workman in China, as in other countries, strives to give full value to the grain, the polish and the veins, and to endow the harder cortical layer with a bright lustre of mellow finish. This is vividly shown in the charming hand rest reproduced in Fig. 78, in which the yellow harmony of the surface reflections above contrasts strongly with the softer tones of the figures carved in relief underneath. The picture shows the under-part of the hand rest, with small angular feet at the corners, as it lies imbedded in its stand. The figures represent the well-known Buddhist group of Eighteen Lohan, or Arhats, with the animals, vehicles and other attributes by which they may be recognised. Maitreya, the Buddhist Messiah, is conspicuous near the top, broadly seated on a throne upheld by three demons. The upper surface of the hand rest, shaped after the natural curve of a bamboo slip, is artistically engraved with a picture of rushes and wild geese, with

one of the birds flying in the air above. A short stanza is incised at the side, commemorative of the Eighteen Arhats, with the signature of the artist attached, *Hsiang Lin K'o, i.e.,* "Carved by Hsiang Lin." This is a "hall mark," or *nom de plume,* and requires further research to get at the individuality of the artist, but signatures on ivory carvings in China are so extremely rare that it is worthy of notice.

The style of carving of the piece just described is like that of the Imperial Ivory Works founded within the palace at Peking towards the end of the 17th century in connection with the Kung Pu, the official "Board of Works." It is on record that the emperor K'ang Hsi established, in 1680, a number of factories, *tsao pan chu,* and brought up practised craftsmen for the various branches of work from all parts of the empire. The list comprised the following departments : 1, metal foundries ; 2, fabrication of *ju-i* sceptres ; 3, glass works ; 4, clock and watch manufactory ; 5, preparation of maps and plans ; 6, fabrication of cloisonné enamels ; 7, fabrication of helmets ; 8, work in jade, gold and filigree ; 9, gilding ; 10, ornamental chiselling of reliefs ; 11, manufacture of ink-stones ; 12, incrusted work ; 13, works in tin and tin-plating ; 14, ivory carving ; 15, wood engraving and sculpturing ; 16, fabrication of lacquer ; 17, chiselling movable type ; 18, fabrication of incense burning sets ; 19, manufacture of painted boxes ; 20, joiners and carpenters ; 21, lantern manufactory ; 22, artificial flowers ; 23, works in leather ; 24, mounting pearls and jewels ; 25, chiselling metals ; 26, armourers ; 27, manufacture of optical instruments. These *ateliers* which lasted for a century or more, were closed one by one after the reign of Ch'ien Lung, and what remained of the buildings was burned down in 1869.

Canton is another well known centre of ivory workers, but its productions, although marvels of technical ingenuity and patient workmanship, are more distinguished for bizarre complexity of pattern than for artistic feeling. One of their elaborately carved balls,

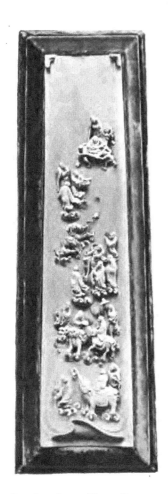

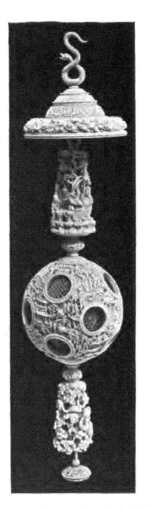

FIG. 78.—IVORY HAND REST CARVED
WITH THE EIGHTEEN BUDDHIST ARHATS.
No. 1074-'71.
H. 10$\frac{5}{16}$ in., W. 2$\frac{1}{2}$ in.

FIG. 79.—IVORY BALL CARVED IN CONCEN-
TRIC SPHERES OF OPEN-WORK DESIGN.
No. 380-'72.
H. 18 in., W. 4$\frac{3}{4}$ in.

composed of a number of concentric spheres, is illustrated in Fig. 79. The crude ball of solid ivory is first pierced in several directions through the centre, and then divided into spheres by means of cutting tools with stops on the handles introduced into the holes ; these spheres are next revolved in turn to be cut in open-work into diapers of varied pattern. The ball before us, crowded outside with garden pavilions and bridges, trees and flowers, is mounted with a cover of floral design, topped with a snake for suspension ; and hung with two pendants ; of which the upper figures the old story of the emperor who is said to have refused to interrupt his game of chess to listen to the urgent report of a general waiting with saddled horse behind ; while the lower pendant is carved with a trellis-work of grape vines and squirrels.

Canton is in all probability the source of the many imposing architectural models executed in ivory and other precious materials which are exhibited in the galleries of the Museum. Some of these models, which have been transferred from the India Section, were, according to the labels attached to them, presents sent by the Emperor of China for Josephine, wife of the First Consul Bonaparte. The vessel in which they were being conveyed to Europe was captured by a British ship of war. After the Treaty of Amiens, in 1802, the restitution of the presents was offered, but declined, and they were deposited for a time in the Museum of the East India Company. One of the presents, which is illustrated in Fig. 80, represents a Buddhist temple, picturesquely posed on the slope of a steep hill, with pavilions, pagodas, bridges, gates and other details delicately carved in ivory and enclosed within an ivory railing of floral design. Mandarin visitors are wandering through the grounds, or drinking tea and playing chess in the garden kiosques. The trees are made of gilded metal with coral blossoms and jewelled fruit, the birds, insects and flowers are worked in filigree inlaid with kingfishers' plumes. There are storks shaped in mother-of-pearl, and ponds with waves cunningly worked in the same material containing clumps of lotus,

ducks and fish, with anglers on the banks. It is evidently a fête day and shaven monks are seen officiating as hosts on the occasion.

The model shown in Fig. 81, which is executed in the same style as the preceding, in ivory, carved, pierced, and partly coloured, was given to the Museum, in 1885, by the Right Rev. Dr. Gott, Bishop of Truro. It is a group of pavilions in ornamental grounds, with figures of Chinamen and ladies, including rockeries and lotus ponds with boys fishing. The *pai-lou* gateway, of characteristic outline, is flanked by dryandra trees and a group of prunus in blossom, pines with storks, and bamboos. The principal pavilion, built on a raised platform mounted by three flights of steps, is two-storied, with trellised walls and pillared railed verandahs. A flaming jewel tops the roof, and fish-dragons project from the corners of the eaves, which are hung with bells and lanterns. An oval plaque suspended in front is inscribed *Ch'ang Huai, i.e.,* " Abode of Happiness."

Works in *tortoise-shell* and varieties of *horn* with elaborate designs of similiar handiwork are also executed, mainly in Canton. The two substances are closely related in quality and methods of work. Both are softened by warm water and also by dry heat, and are then easily stretched and bent, pressed and moulded, split apart and welded together, properties on which the art of working them depends. Tortoise-shell, *tai-mei,* comes principally from *Chelonia imbricata,* the loggerhead turtle, a native of the Malay Archipelago and Indian Ocean, and is brought to Canton from Singapore, which is the principal market for its thirteen yellow and brown luminous plates. The workman with his tools, a file, chisel, small saw, and especially iron pincers with broad smooth blades, sits beside a charcoal stove in which he heats the pincers with which he welds the plates together. A fair example of his craft, a tortoise-shell work-box intended for European use, is illustrated in Fig. 82. It is decorated in broad panels with pro-cessions of mandarins in picturesque surroundings, framed with a

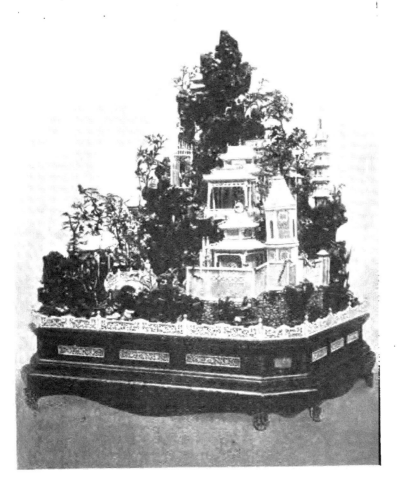

FIG. 80. —MODEL OF A BUDDHIST TEMPLE.
Details carved in Ivory and other Materials.
No. 9347.

H. 3 ft. 5 in., L. 2 ft. 9¼ in.

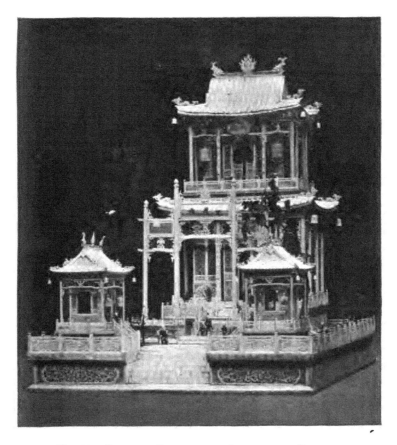

FIG. 81.—GROUP OF PAVILIONS IN ORNAMENTAL GROUNDS.
Model carved in Ivory, etc.
No. 318-'85.

H. 3 ft. 4 in., L. 3 ft. 7½ in.

trelliswork of bamboo, floral sprays and palm leaves. The panel on the lid displays a Buddhist temple with many courts and wide grounds containing *pai-lou* gateways, stupas and bridges, through which a mandarin is riding on horseback, with a state umbrella held over his head, accompanied by a long retinue of attendants.

Passing on to industrial art work in *horn*, the only branch that need be alluded to here is the carving of rhinoceros horn. This is chiefly done at Canton, the horns of the one-horned Indian rhinoceros and of the two-horned Sumatran rhinoceros being imported by sea for the purpose. In former times the material was obtained by hunters in Yung ch'ang Fu and other parts of the province of Yunnan, and also in the borders of Annam and Siam, where both of the above species were found. Marsden, in his *History of Sumatra*, states that the horn is esteemed there as an antidote against poison, and on that account made into drinking cups. This belief in the peculiar virtues of the horn is ancient and widely spread. Ctesias, writing in the fifth century, B.C., describes the great one-horned Indian rhinoceros and the wonderful medicinal properties of the cups made from its horns. These horns were brought to China as early as the Han dynasty, and the old writers descant on the prophylactic power of the material as well as on its decorative value. During the T'ang dynasty the official girdle of the period was studded with carved plaques of rhinoceros horn, of amber or golden-yellow transparent tints veined with black. These were the colours most highly esteemed for art work generally, red grounds coming next, while black opaque horns were only used to make shavings for medicine. The presence of poison was said to be revealed by the exudation of a white humour from the cup, or from the surface of a rod of rhinoceros horn put into the liquid to test it.

A carved cup of rhinoceros horn is illustrated in Fig. 83, elevated into a kind of cornucopia upon a wooden stand, elaborately carved in open-work with symbolical designs of Taoist character. The cup is decorated outside with branches of pine and polyporus fungus,

and with the figure of a gigantic toad-like dragon at the top of a waterfall below which carp are swimming—emblematic of literary triumph, whereby the persevering scholar becomes a mandarin. The stand rises from a clump of bamboos, branched fungus and pines, underneath which, on the right, Bodhidharma is seen with a single shoe in his hand returning, in spirit, to his native land, and on the opposite side a group of deer. It is pierced, above, with interlacing branches of pine, bamboo, and sacred fungus, mingled with blossoming peach and other flowering trees ; and in the meshes of the network are posed two groups, a Buddhist hermit, above, accompanied by a lion, and another, in the middle, with an attendant monk carrying his *patra* almsbowl. The artist revels in the mythologies of two religions to lift up a cup destined, as it were, to hold a draught of the *elixir vitæ*, the draught of longevity of the Taoist mystic dreamer.

FIG. 82.—TORTOISE-SHELL BOX CARVED WITH FIGURE SUBJECTS.
No. 636-'77.

H. 4. in., L. 10⅛ in.

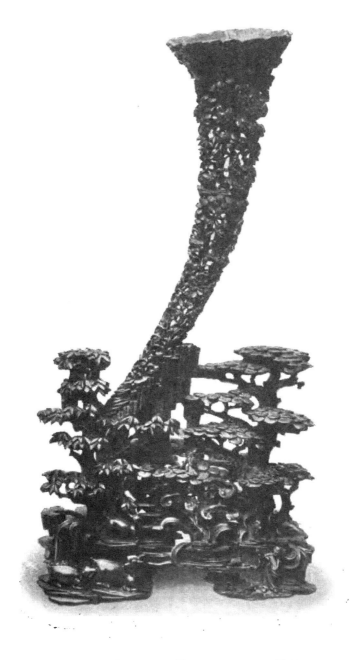

FIG. 83.—CUP OF RHINOCEROS HORN MOUNTED ON PEDESTAL.
Carved with Buddhist and Taoist Mythological Subjects.

CHAPTER VI.

LACQUER.

Lacquer has furnished a prized material for one of the earliest industrial arts of the Chinese, but we have no exact records of its origin, nor of the steps of its development from being a mere preservative coating for woodwork to its culminating point as a medium for artistic work of the highest order. Lacquer is not like our copal varnish, an artificial mixture of resin, fatty oils and turpentine, but in reality a ready-made product of nature. It is derived mainly from the *Rhus vernicifera*, D.C., the lac tree, or *ch'i shu* of the Chinese, which is cultivated throughout Central and Southern China for the purpose. This tree, when the bark is cut or scored with a pointed bamboo style, exudes a white resinous sap, which becomes rapidly black on exposure to the air. The sap is drawn from the tree during the summer at night, collected in shells, and brought to market in a semi-fluid state, or dried into cakes. The raw lac, after pieces of bark and other accidental impurities have been removed by straining, is ground for some time to crush its grain and give it a more uniform liquidity. It is then pressed through hempen cloth and is a viscid evenly flowing liquid ready for the lacquerer's brush.

There are three processes in the manufacture of lacquer. The *first* is the preparation and coloration of the lac; the *second*, its application by spatula and brush in successive layers, never less than three, nor more than eighteen, waiting for each layer to dry before the next is put on; the *third*, the decoration of the lacquered surface with artistic designs painted with the brush, worked in sensible relief, or carved and modelled in the soft ground before it

has cooled. Wood is the usual basis of lacquered articles, well seasoned and carefully prepared, so that the shaped object is sometimes as thin as a sheet of paper. Any joints or accidental cracks are filled in with a lute composed of chopped hemp and other materials, a sheet of broussonetia paper or silk gauze is pasted on, coated with a mixture of burnt clay and varnish, and the surface is smoothed down with a whetstone. The process of lacquering now commences, but the numerous details connected with the laying on, polishing and drying of the different layers of lac, until the final coat is reached, need not be described here. They are the work of the skilled artisan, whose business it is to produce a smooth dark-gray lustrous background for the superstructure of decoration which has yet to be added by the artist. The artist having selected for the motive of his design a landscape or figure scene, birds and flowers, fishes and water weeds, or the like, sketches it in outline with a paste of white lead, fills in the details with gold and colours, and superposes a coat of transparent lacquer. If parts of the design are to be in relief they are built up of a putty composed of lacquer coloured and tempered with other ingredients. In all fine lacquers gold predominates so largely in the decorative scheme that the general impression is one of glow and richness. The finest gold lacquers are left undecorated and owe their beauty to a multitude of tiny metallic points shining from the depths of a pellucid ground.

The raw lac is coloured with a variety of materials in China, used singly, or in combination. The finest yellow transparent lac, called *chao ch'i*, which is used as a medium for metallic gold in imitations of avanturine and other grounds, as well as by the decorators as a final coat for their pictures, is coloured with gamboge. Another yellow, the *hua chin ch'i*, " painters' golden lacquer," of amber tone, which is chiefly used to mix with pallet colours, owes its tint to an addition of pig's-gall and vegetable oil. The best red lacquer is *chu ch'i*, " cinnabar lac," and is made by grinding native cinnabar (*chu sha*) with the raw lac : an inferior red colour is

produced by the substitution of colcothar. The many varieties of black lacquer, *hei ch'i*, are all prepared by adding iron sulphate, or iron filings mixed with vinegar in different proportions, to the purified raw lac, and stirring to expel the excess of water. Different grades of chestnut brown, *li sê*, are made by mixing together the last two, the cinnabar and black lacquers. Golden yellow, *chin sê*, is made with powdered gold, or its brass substitute; silvery white, *yin sê*, with silver dust. A greenish-yellow is derived from orpiment, the yellow sulphide of arsenic; a deeper and fuller green by the mixture of orpiment with indigo from the *Polygonum tinctorium*; a carmine red from the safflower, the *Carthamus tinctorius*; blacks from different kinds of charcoal, animal and vegetable. The inner layer of the *haliotis* shell furnishes mother-of-pearl for inlay of iridescent plates and for flecks of glistening dust; gold, and gold alloy of graded silver tone, and tin-foil, are also among the materials commonly used for incrustation.

There is a complete collection of the materials of which lacquer is made in the botanical museum at Kew, and a number of specimens in various states of manufacture. These include sections of the tree from which the lac exudes; the lacs themselves of various colours, from light gray, green, and yellow, to brown and black; the hempen cloth, silk, and paper in which the object is cased, the clays and colours used, the stones, brushes, tools, and even the drying press. There are several plaques to illustrate the processes of manufacture and a case showing fifty various methods of lac-quering sword sheaths. The specimens exhibited come from Japan, but the technique of Japan differs little from that of China in this branch of art. Japan first learned the art from China, although the Japanese have since brought it to a height of per-fection that the Chinese have never attained. Professor J. J. Rein, in his *Industries of Japan*, shows that the *Rhus vernicifera* has not been found growing wild in Japan, and that the methods and utensils used in Japan are precisely the same as those which

have been used for centuries in the lacquer industry of China, and his conclusion may be accepted, that :—

"As the Japanese owe all their other art industries to China and Korea, we may be safe in concluding that the lacquer art also, and probably the lacquer tree with it, became known to the Japanese from their western neighbours just after the commencement of the third century, or, after their first expedition to Korea."

Much has been written on the history and high qualities of Japanese lacquer, and deservedly, for its artistic superiority is incontestable. Chinese lacquer has been, on the contrary, neglected and almost unnoticed and it is necessary to turn to Chinese books for some notes on the subject.

The *Ko ku yao lun*, a learned work on antiquities, literary and artistic, in thirteen books, by Tsao Ch'ao, which has already been cited, was published in the reign of Hung Wu, the founder of the Ming dynasty, in the year 1387. Lacquer is noticed in the beginning of Book VIII, under the heading *Ku ch'i ch'i lun.* "Description of ancient lacquer work " as follows :—

" 1. *Ancient Rhinoceros Horn Reproductions. (Ku Hsi P'i).*"

" Among the cups and other articles of old carved lacquer fashioned after those of rhinoceros horn, the best are reddish-brown in colour with smooth polished surface, like fine earthenware underneath, the lacquer is lustrous, of strong substance and thin. The variety of a lighter red tint resembling the fruit of the cultivated Shantung jujube (Zizyphus communis) is known commonly as ' jujube lacquer.' There are also some in which the carving is deeply cut and in strong relief, but these are classed lower."

" The old production of Foochow, which is yellow in colour with finely polished surface, and is decorated with designs in rounded relief, is known as ' Foochow lacquer.' It is solid and thin, but rare and difficult to find. The lacquer is mottled with clouds."

" During the Yuan dynasty (1280–1367) a new manufactory was established at Chia-hsing Fu, in the province of Chekiang, at Hsi-t'ang Yang-hui, which produced a large quantity of lacquer, carved for the most part deeply and in high relief. But the body is generally wanting in solidity, and the yellow ground, especially, easily chips and breaks off."

" 2. *Carved Red Lacquer (T'i Hung).*"

" Cups and other articles of carved red lacquer are not classed as old and new, but distinguished according to the depth of the cinnabar coating, the bright tone of the red, the fine polish and solidity of the lacquer. The heaviest are the best. The sword rings and the perfume receptacles modelled in the shape of flowers and

fruit are finely executed. Some pieces of yellow ground are sculptured with land-scapes and figure scenes, flowers and trees, flying birds and running animals, cleverly designed and delicately finished, but very easily chipped and damaged. The red lacquer when the cinnabar coat is thin is of inferior value."

" During the Sung dynasty (960–1279) the utensils intended for the imperial palace were generally made of gold and silver lacquer with plain uncarved surface."

" Under the Yuan dynasty at Hsi-t'ang Yang-hui, in the prefecture of Chia-hsing, Chang Ch'êng and Yang Mao gained a great reputation for their carved works in red lacquer, but in much of it the cinnabar coating is too thin and does not wear well. In the countries of Japan and Liuchiu, however, they are extremely fond of the productions of these two craftsmen."

" In the present time at Ta-li Fu, in the province of Yunnan, there are special factories of this lacquer, although much of their production is a spurious imitation. Many of the noble families of Nanking have real specimens in their houses. There is one kind in which the lacquer is entirely cinnabar red ; another kind in which black is used in combination with the red. Good specimens are very valuable, but there are many later imitations and great care is required to distinguish them."

" 3. *Painted Red Lacquer* (*Tui Hung*)."

" The imitations of carved red lacquer are made by working the design in relief with a kind of putty made of lime and simply lacquering it over with a coat of cinnabar lac, hence the name of *tui hung*. The principal things made are sword rings and perfume cases of floral design, which are worth very little money. It is also called *chao hung*, or ' plastered red,' and is now very common at Ta-li Fu in the province of Yunnan."

" 4. *Lacquer with Gold Reliefs* (*Ch'iang Chin*)."

" The cups and other ware painted with gold designs in relief are strongly lacquered and artistically decorated in choice specimens of the craft. In the beginning of the Yuan dynasty (1280) an artist named P'êng Chün-pao, who lived at Hsi-t'ang, became celebrated for his paintings in gold on lacquer, and his land-scapes and figure scenes, pavilions and temples, flower sprays and trees, animals and birds, were all alike cleverly designed and finely finished. At Ning-kuo Fu, in the adjoining province of Kiangnan, the lacquerers of the present day decorate the lacquer with pictures pencilled in gold (*miao chin*) ; and in the two capitals (Nanking and Peking) also, the workshops turn out a deal of lacquer decorated in the same style."

5. *Pierced Lacquer* (*Tsuan Hsi*).

" Cups and other specimens of pierced lacquer, in which the body is strong and solid, are generally old pieces dating from the Sung dynasty, in which the gold decorations of figure scenes and picturesque views have been pierced through with a drill or a metal borer, so as to complete the designs in open-work."

6. *Mother-of-Pearl Incrustations* (*Lo tien*).

" Lacquer ware inlaid with mother-of-pearl is a special production of the province of Kiangsi, being made at Lu-ling Hsien, in the prefecture Chi-an Fu. The articles

specially made here for the imperial palace during the Sung dynasty, and the older productions generally, are all very strongly lacquered. Some of the best are strengthened by the inlay of a network of copper wire. Through the whole period of the Yuan dynasty rich families were accustomed to have lacquer made for them here, which was solidly put on, and the figure decoration was perfectly designed and beautifully finished."

"The modern work of Lu-ling, on the contrary, is plastered with lime and pigs blood mixed with vegetable oil, and is not strong but very easily damaged. Some use starch obtained from rhizomes of the lotus, which is still weaker and wears off more quickly. The only good work to-day is that made in private houses, which is fairly strong and lasting. Old houses in the several departments of Chi-an Fu often contain beds, chairs, and screens, incrusted with mother-of-pearl figures of beautifully finished execution, which excite universal admiration. Among the things made here at the large houses are round boxes with covers for fruit, hanging plaques with inscriptions, and chairs of Tartar fashion, which are hardly inferior to the old work, because, no doubt, they are of home manufacture."

The above quotations are sufficient to prove that all the branches of lacquer-work now carried on in China can be traced as far back at least as the Sung dynasty, and that the chief centre of manufactory at that period was Chia-hsing Fu. This is an important city situated about half-way between Hangchou, the capital of the Southern Sung, the Kingsai of Marco Polo, and Soochou, which also became later celebrated for its productions of lacquer.

For a few notes on the craft under the Ming dynasty, which succeeded the Yuan in 1368, another book, the *Ch'ing pi ts'ang*, " Collection of Artistic Rarities," may be cited. This is a little work in two fasciculi, on antiquities, pictures, brocaded silks, ancient bronzes, porcelain, lacquer, seals, jewels, and miscellaneous objects of art, by Chang Ying-wên, who wrote the last page on the day he died. It was published by his son Chang Ch'ien-tê, who wrote the preface, which is dated 1595. There is a curious notice, by the way, in the second part of this book of a loan exhibition, called *Ch'ing Wan Hui*, " Exhibition of Art Treasures," which was held in the province of Kiangsu in the spring of the year 1570, the objects being contributed for the purpose from the collections of four of the principal families of the province. After some remarks

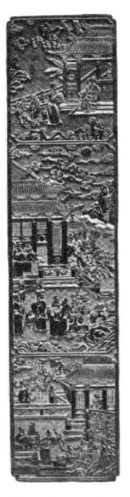

FIG. 84.—BOX OF RED AND BLACK LACQUER CARVED WITH FIGURE SUBJECTS.
No. 983-'83.

L. 2 ft. 1¼ in., W. 6⅝ in., H. 4 in.

on lacquer of the Yuan and Sung, which confirm what has been quoted above, the author proceeds :—

" In our own Ming dynasty the carved lacquer made in the reign of Yung Lo (1403–24) in the Kuo Yuan Ch'ang factory, and that made in the reign of Hsüan Tê (1426–35), not only excelled in the cinnabar colouring and in the finished technique of the body, but also in the literary style of the inscriptions which were etched underneath the pieces. The inscription *Ta Ming Yung Lo nien chih,* ' made in the reign of Yung Lo of the Great Ming,' was etched with a needle and filled in with black lac. The inscription *Ta Ming Hsüan Tê nien chih* ' Made in the reign of Hsüan Tê of the Great Ming,' was engraved with a knife and filled in with gold. The craftsmen in their skill with the knife rivalled their predecessors of the Sung and succeeded in establishing a new school of glyptic art. The lacquer ware of thin body flecked with powdered gold, the lacquer work incrusted with mother-of-pearl, and the lacquer inlaid with plaques of beaten gold and silver, these three kinds are especially admired, even by the Japanese. The spurious imitations are of coarse heavy make and easy of detection."

The accompanying illustration (Fig. 84) is taken from the top of an oblong box of carved red and black lacquer, which appears from its style to date from the Ming dynasty. The decoration, arranged in three panels, with rounded indented corners, is executed in bold black relief, filled in with a delicately diapered background of cinnabar red. The large oblong panel in the middle displays an imperial procession wending its way by moonlight through a mountain valley towards a two-storied pavilion in a terraced garden with deer. The Emperor, seated in a two-horse chariot, conducted by two men on foot, is accompanied by others carrying banners and screens and ushered by the usual retinue with staves, parasols, ducks in dishes, maces and halberts. The square panel above has a picture of an old man seated on the steps of his doorway to receive a scholarly visitor, who is approaching with two attendants, one carrying a lamp, the other a bundle of scroll pictures. The square panel below is a companion picture, suggestive of war contrasted with the arts of peace, showing a bowman who has just transfixed with his arrow the eye of a phœnix on a carved screen. The sides of the box are decorated with bands of peony scrolls and phœnixes. The rims are bound round in the fashion of the time with protective collars of white metal.

During the troubles at the close of the Ming dynasty the art of lacquering was neglected, but it revived under the patronage of the Emperors K'ang Hsi, Yung Chêng and Ch'ien Lung. In this last reign the learned Jesuit Père d'Incarville, correspondent of the French Academy, wrote his interesting *Mémoire sur le Vernis de la Chine*, which was published, with eleven illustrations taken on the spot, in the *Mémoires de Mathematique et de Physique présentés à l'Academie Royale des Sciences* (Vol. iii., pp. 117-142, Paris, 1760). His paper is a valuable account of the industry at Canton, the productions of which, he confesses, are inferior in artistic value to those of Japan, and he adds :—

"Si en Chine les Princes et les grands ont de belles pièces de vernis, ce sont des pièces faites pour l'Empereur, qui en donne, ou ne reçoit pas toutes celles qu'on lui présente."

Chinese lacquer is divided into two classes : painted lacquer, *hua ch'i*, and carved lacquer, *tiao ch'i*. The chief centres of the manufacture of painted lacquer in the present day are Canton and Foochou. Carved lacquer was made principally at Peking and Soochou, but nothing of any artistic value has been produced at eithei of these places since the reign of Ch'ien Lung. Both kinds of lacquer are occasionally inlaid, or incrusted, with mother-of-pearl, ivory, jade, lapis lazuli, and other materials.

Canton has long been celebrated for its lacquer. The Arabian traveller Ibn Batuta, who was there about the year 1345, notices the lacquer made in this city in his time ; he admires its lightness, brilliancy, and solidity, and tells us that it was already exported in large quantities to India and Persia. It is still made there in large quantities for export ; but the successive coats of lac are put on too hurriedly, so that the modern work is not remarkable for its solidity ; while the chief aim of the artist seems to be to cover the whole surface with figures and floral scrolls, brushed on with gold and silver, so that the decoration is profuse and over-elaborate rather than artistic in its character. The ground is nearly black,

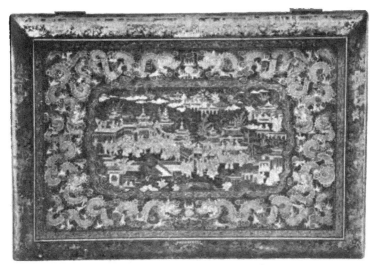

FIG. 85.—LID OF A BOX OF CANTON LACQUER.
Painted in two Shades of Gold in a Black Ground.
No. 177-'98.

L. 17⅝ in., W. 12¼ in.

FIG. 86.—FAN AND CASE OF CANTON LACQUER.
No. 621-'68.
L. of Fan 11 in., Case L. 12¼ in., W. 3 in.

the gold used in the decoration is toned down to a paler shade when required by alloying the precious metal with silver.

The lid of a box of Canton lacquer is illustrated in Fig. 85, painted in two shades of gold on a black ground. The lid is decorated with a picturesque garden scene with figures of ladies and mandarins, inclosed within a foliated oblong frame, surrounded by a band of coiling dragons ; the rounded edge is encircled with similar subjects ; the sides of the box are covered with a leafy scrollwork, interrupted by shaped compartments also containing garden scenes. The fan and its lacquered case, shown in Fig. 86, are delicately decorated in the same profuse style with foliated panels containing terraced buildings and gardens, set in a diapered background, overlaid with flowers, butterflies and varied emblems of Chinese art and literature.

·The ewer and cover illustrated in Fig. 87 are examples of older Chinese lacquer work on metal, being fashioned of lead and lacquered black, incrusted with diaper ornament in iridescent mother-of-pearl, and with groups of birds and flowers shaped in pearl and coloured ivory posed in plain panels. The picture screen reproduced in Fig. 88 is also composed of black lacquer incrusted with mother-of-pearl, but the details of the decoration indicate Tongking as its place of origin, where the technique is closely allied, perhaps affiliated, to that of Canton. The borders are framed with panels of conventional design filled with an array of symbols, literary, Buddhist, and Taoist, delicately inlaid in the Cochin-Chinese manner ; the centre is decorated with naturalistic clumps of flowers—on one side a flowering bulb of narcissus and branches of prunus with a spray of peony blossom, on the other sides chrysanthemums and panicled grasses with two kinds of grasshoppers. These floral combinations represent autumn and winter, and suggest the idea of a companion screen decorated with flowers of spring and summer.

Foochou lacquer is more pleasing to an artistic eye than that of Canton and resembles more closely in technique the gold lacquer of

Japan. The basis is more carefully fashioned in bold undercut relief and the details are brought out most effectively by the smooth shining coat, shot with tiny points of gold, with which it is invested.

As M. Paléologue justly says :—

"The lacquer of Foochou is most seductive to the eye from the purity of its substance, the perfect evenness of its varnished coat, the lustrous or deep intensity of its shades and the power of its reliefs, the breadth of the composition and the harmonious tones of the gold grounds and painted brushwork. A large panel, six feet high and three or more in breadth, is sometimes entirely covered with a scholarly and delicate decoration of soft melting tone, in which the figures, shaped in coral or pearl, are detached in gentle relief on the ground, while the landscapes roll out in the far distance, revealing luminous depths of colouring."

We have, unfortunately, nothing so important for illustration here, only a little tray, Fig. 89, cleverly shaped in the form of a lotus leaf, resting on an openwork network of lotus leaves and blossoms entangled with a panicled reed underneath, while one stem with a blossom pierces the tray. It is lacquered in green, brown and yellow, and is further enriched with powdered gold in the manner characteristic of Foochou.

The third kind of lacquer which remains to be noticed is the carved lacquer, *tiao ch'i*. The finest specimens of this carved work having been the productions of the imperial factories in the palace at Peking noticed on p. 116, it is commonly known to collectors as *Peking* lacquer. The prevailing colour is a vermilion red derived from finely ground cinnabar, the red sulphide of mercury found in many parts of China, hence the alternative name of cinnabar lac which is often applied to it : but this is not so appropriate, as in some pieces, like the example which has been illustrated in Fig. 84, the red is employed in combination with other colours, and in other rare specimens of sculptured lac cinnabar is not used at all. During the Sung and Yuan dynasties, as we have seen already, carved red lacquer was produced in several other localities, as well as a variety of spurious imitations in which the reliefs were worked in a compost of lime and simply brushed over with a coat of red lacquer.

Peking lacquer is represented by a series of remarkably fine

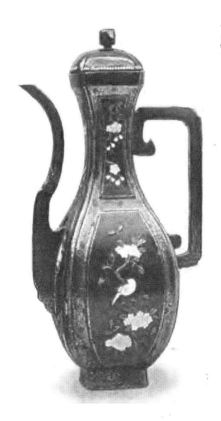

FIG. 87.—EWER AND COVER OF METAL LACQUERED BLACK INCRUSTED
WITH MOTHER-OF-PEARL AND IVORY
No. 41–'76.

H. 14¼ n., W. 4¾ in.

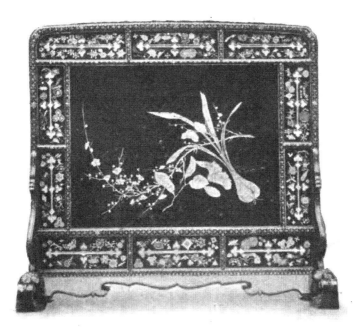

FIG. 88.—SCREEN OF BLACK LACQUER INCRUSTED WITH MOTHER-OF-PEARL.
No. 121-'78.

H. 2 ft. 7 in., L. 2 ft. 10 in.

FIG. 89.—TRAY OF FOOCHOU LACQUER SHAPED AS A LOTUS LEAF
No. 278-'96.

H. 3 in., L. 11¾ in., W. 9⅜ in.

examples in the Museum collection. Some of them were brought from the Summer Palace of Yuan Ming Yuan which was sacked during the Anglo-French Expedition in 1860 ; among them a pair of imposing vases, over three feet high, covered with five-clawed imperial dragons, attributed to the reign of Ch'ien Lung (1736–95), the culminating epoch of the art. One of the pair is illustrated in Fig. 90. It is decorated with nine dragons, a mystic number, whirling through scrolled clouds enveloping parts of their serpentine bodies, in pursuit of jewels of omnipotence, which appear in the midst of the clouds as revolving disks emitting branched rays of effulgence from their surface. The decoration is completed by a foliated band round the base and rings of rectangular fret encircling the rims. The neck is strengthened by a collar of gilded metal.

The emperor Ch'ien Lung had a special fancy for carved lac and had all kinds of objects made for the palace during his reign ; large screens, *fêng-p'ing*, with twelve folds eight feet high ; spacious couches or divans, *ch'uang*, fitted with small tables ; larger tables and chairs of formal outline for the reception hall ; in addition to an infinite variety of smaller objects, useful and ornamental. Some of the finest of the small art objects produced in his reign were chiselled in a soft buff-coloured lac ; in others the buff was used in a diapered background as a foil for the principal decoration which was made to stand out effectively in vermilion relief. A variety of choice pieces of painted lacquer is said to have been made at the palace factory at the same time, and some ten rare specimens from this source in the possession of the Vicomte de Semallé were declared to be worthy to figure in the best Japanese collection. They were little cups of graceful lobed outline, light in weight and delicately modelled ; one was peacock blue shot with tones of green, iridescent and intense as an enamel ; another of the palest pink relieved by touches of coral red, described as an unrivalled combination of soft tints ; another of the purest and deepest black, the beautiful black so appreciated in Japan ; a fourth, in the same collection, of

avanturine lac, with a lotus delicately incrusted in gold and silver was characterised as a marvel of taste and finish.

In some cases the ground of cinnabar lac is covered with several shades of brown applied in even layers, and the crust while still warm is carved with a sharp knife, with the result that the several layers of colour are distinctly seen in the finished work. The emperor Ch'ien Lung had a series of pictures carved in this style, in 1766, with battle scenes commemorating the victories of his generals in Eastern Turkistan, some of which have found their way to European collections. Their form is similar to that of the Chinese Pietra Dura Picture with background in diaper of cinnabar lac in the museum which is illustrated in Fig. 91. The figures are carved in white jade, the temple, trees, and other details in variously coloured jade, malachite, and imitation lapis lazuli. The motive is a Taoist scene representing the approach of a pilgrim to the Taoist paradise. The divinity Shou Lao is standing under a pine, on the left, holding a *ju-i* sceptre, his attendants, in procession, carrying a staff with scroll tied to it, a peach as the fruit of life, a pilgrim's gourd, and the box of good gifts held by two acolytes in the rear— the genii of union and harmony. Another acolyte on the bank of the " isles of the blessed " eagerly awaits the arrival of a boat laden with flowers and jewelled fruit, the offerings of the female divinity Hsi Wang Mu.

A richly decorated box with cover of carved red lac inlaid with variously coloured stones which show out effectively on the coral background is illustrated in Fig 92. The box, modelled in the shape of a flattened peach, is carved in relief with sprays of the same fruit and flowers and with bats flying in the intervals, projected from a diapered background. The cover, completing the outline of the peach, and carved with similar designs spreading round the sides, is also ornamented in relief with sprays of peaches and a couple of bats, the stems being shaped in wood, the fruit, flowers and other details inlaid in green and yellow jade, lapis lazuli, turquoise,

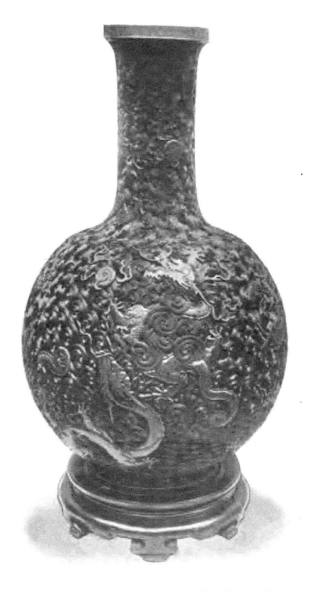

Fig. 90.—Vase, one of a pair, of Carved Red Peking Lacquer.
From the Summer Palace. Decorated with Nine Imperial Dragons.
No. 10–'83.
H. 3 ft. 1½ in., D. 23½ in

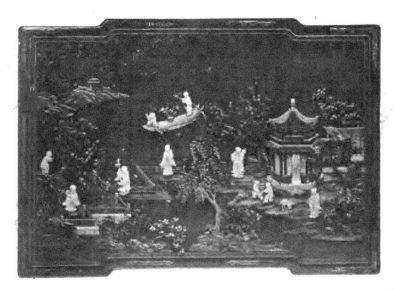

FIG. 91.—PIETRA DURA PICTURE OF THE TAOIST PARADISE.
Diapered Ground of Cinnabar Lac incrusted with Jade, Malachite, and Lapis Lazuli.
No. 5559-'01.

H. 2 ft. 6¾ in., W. 3 ft. 7 in

and amethystine quartz. Boxes of this kind are intended to hold fruit or cakes for presentation on birthdays or other auspicious occasions. The peach appears in the form and decoration as the fruit of life, a symbol of longevity ; and the bats (*fu*), as punning symbols of happiness (*fu*) ; emblems of good wishes for the recipient of the contents, who is not, by the way, expected to keep the box.

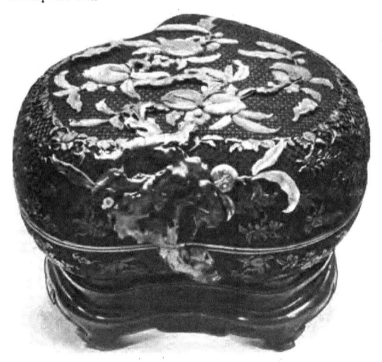

Fig. 92.—Box and Cover, Peach-shaped, Decorated with Fruit and Flowers. Chiselled Red Lac, inlaid with Green and Yellow Jade, Lapis Lazuli, Turquoise and Amethyst.

No, 129-'83,

H. 6½ in., L. 15¼ in.

CHAPTER VII.

Jade is ranked by the Chinese as the most precious of precious stones. I The character *yü*, composed of three horizontal lines united by a central perpendicular line, originally a picture of three pieces of jade strung together by a cord, is the radical of a natural group of compounds relating to gems and their attributes. I The material with its finely polished surface and varied tones of colour is idealized as the quintessence of creation, forged from the rainbow into thunder-bolts for the storm-god, to whom are attributed the weapons in the shape of jade axes and celts which are occasionally laid bare by heavy rain on the surface of the ground. It is also the traditional food of the Taoist genii, and it is, moreover, endowed by the Chinese with many magic and curative properties, as it was by other ancient nations.

The name jade is derived from the Spanish *piedra de hijada*, or "stone of the loins," through the French *pierre de l'ejade*, which is said to have been changed to *le jade* by a printer's error when the word was as yet unfamiliar. It was first brought to England from Spanish America by Sir Walter Raleigh, who always uses the Spanish name for the stone in his books, while he magnifies its many virtues. Under the heading of jade two distinct minerals are included by scientific mineralogists, as well as by the Chinese. The first, known as *nephrite*, or kidney-stone, because it was often worn as a charm against kidney diseases; and also as axe-stone, having been fashioned into axe-heads both in prehistoric times all over the world and in modern times in New Zealand and Alaska; is a silicate of lime and magnesia, belonging to the amphibole or hornblende group of minerals. The second, called *jadeite*, a word

FIG. 104.—FISH DRAGON VASE CARVED IN RED AND VARIEGATED WHITE AGATE. No. 1540.-'82.
H. 8 in., W. 6¼ in.

7911.

FIG.* 103.—STATUETTE OF SHOU LAO CARVED IN GREEN-TINGED ROCK CRYSTAL. No. 1564.-'82.
H. 7 in., W. 4¼ in.

X

coined by Damour in 1863, after his analysis of some of the emerald green jade recently brought from the Summer Palace at Peking, which had been distinguished by Jacquemart as *jade impérial*, is essentially a silicate of sodium and aluminium, belonging to the pyroxene group. Some of the prehistoric celts discovered in Brittany and the lake-dwellings of Switzerland, in Asia Minor and Crete, were found to be made of jadeite, but its most striking and typical examples were the *fei-ts'ui* jade of the Chinese, so called from its resemblance to the plumes of the kingfisher which they incrust on jewellery, and the celebrated *quetzalitzli* of the pre-Columbian Mexicans, a stone named after the gorgeous feathers of the *Trogon resplendens* which the chieftains wore in their head-dress.

Nephrite and jadeite agree in being composed structurally of an interwoven mass of very fine fibres, on which their singular toughness and compactness, as well as their uneven splintery fracture, depend. Their matted fibrous structure make them more difficult to fracture than any other substances in the mineral world, although in hardness they range only from 6 to 7 in Mohs' scale, nephrite being 6 to 6·5, or slightly harder than felspar, while jadeite is 7, the same hardness as quartz. Jadeite is occasionally partially crystalline, visible with a hand lens, one variety being so granular as to resemble sugary marble in structure, and another of more translucent body, called "camphor jade," being remarkably like crystallised camphor. The two minerals differ in chemical composition and microscopically; and also when heated before the blowpipe, nephrite becoming white and cloudy and fusing with difficulty, while jadeite fuses easily and colours the flame bright yellow, indicating the presence of sodium. The readiest means of distinction is the determination of the specific gravity of the crude or worked object, nephrite being usually within the limits 2·9–3·1, whereas jadeite is much heavier (sp. gr. = 3·3), and chloromelanite, a dark green variety of jadeite rich in iron,

as much as 3·4. Both minerals take a fine polish when worked, with a subdued waxy lustre which is likened by the Chinese to that of mutton fat or congealed lard, and which is especially characteristic of nephrite. Both minerals are theoretically white when pure, but in nature they show an extensive and varied suite of colours, due either to the uniform coloration of the mass, or to the inclusion of foreign particles causing streaks, spots, veins, or marbling, of one or several shades of colour, contrasting with the plain ground. .

The colour of *nephrite* depends mainly upon the amount of iron present. It is usually of some shade of green, deepening as the proportion of iron increases. Many tints of green occur, including gray-green, sea-green or celadon, lettuce-green, grass-green and dark green like boiled spinach. Gray nephrites often have a bluish, reddish or greenish tinge. In yellow nephrite the yellow is generally of greenish tone. Black jade is usually a nephrite thickly charged with inclusions of chromic iron. Reds and browns are due to impregnation with iron peroxide, and are considered to denote natural stains in the material, or accidental changes of the surface from weathering, rather than to be essential colours of jade. Uniform grounds of soft tone resembling cream and whey are highly esteemed by the Chinese connoisseur, and still more highly a pure limpid white compared to mutton fat, in which iron is entirely absent.

Jadeite is often not distinguishable from nephrite by mere inspection, but generally its colouring is brighter and more vivid. The body is usually more translucent, but, on the other hand, it is occasionally partially crystallised, a distinctive characteristic when it occurs. One of the most characteristic grounds is of a uniform lavender colour, another is bright apple-green. The natural pebbles of jadeite sometimes exhibit a colourless nucleus enclosed in a red crust, which produces the effect of a fine sheen, and which is due to the penetration of iron from the clay in which

they are found embedded. | The most precious jadeite of all is white strewn with more or less sharply defined spots of brilliant emerald green. | The spots and veining which often accompany the variously tinted grounds are due to the presence of a small amount of chromium distributed irregularly through the mass—the element which gives its colour to the true emerald. The emerald green jadeite is the typical Chinese *fei-ts'ui*, an archer's thumb ring or bracelet of which may be worth many hundred ounces of silver.

The Chinese classify jades under three headings : the first, under the general name of *yü*, comprises nearly all nephrites, wherever obtained; the second, *pi yü*, " dark green jade," resembling somewhat deep green serpentine, includes nephrites brought from Barkul and Manas in Sungaria and from the vicinity of Lake Baikal, as well as jadeites of somewhat similar tint said to come from the mountains of Western Yunnan ; the third, *fei ts'ui*, originally applied to the emerald green variety, is now extended to all other jadeites, most of which are imported from Burma, with the exception of the dark green variety alluded to above.

Most of the nephrite carved in China comes from Eastern Turkestan. It is either quarried in the mountain ranges of Khotan and Yarkand, where it is found *in situ*, or picked up as water-worn pebbles from the beds of the rivers which flow down from these mountains. The most productive primary deposits are in the Belurtág, the " jade mountains " of the Chinese, on the upper waters of the Tisnab river about eighty miles from Yarkand, which have been recently explored by the Russian geologist Bogdanovich. The Manchu author of the *Hsi Yü Wên Chien Lu*, a description of Chinese Turkestan written in 1777, says that the precipitous mountain sides are here entirely made of jade, and describes how the Mohammedan natives ride up on yaks beyond the snow limit, light fires to loosen the jade, and dig out large blocks with their picks, which are rolled down the precipice into

the valley below. In the twenty-ninth year (1764) of Ch'ien Lung the governor of Yarkand forwarded to the Emperor thirty-nine large slabs of this jade, sawn on the spot, weighing altogether 5,300 lbs., to make sets of twelve musical stones called *ch'ing* used in imperial ceremonies ; as well as a quantity of smaller pieces for the ordinary stone chimes, which are made of sixteen " carpenter's squares " of graduated thickness hung in two rows on a frame and struck with an ebony mallet. The gigantic monolith of the tomb of Tamerlane in the Gur Emir mosque at Samarkand probably came from the same source.

The principal rivers regularly "fished" for jade pebbles are the upper waters of the Yarkand Daria, and the Yurungkash, " White Jade," and Karakash, " Black Jade," Rivers of Khotan. For some purposes the lapidary prefers a water-worn pebble, which has been perhaps ground by nature into a quaint appropriate form, covered with a rind attractively coloured by oxidation, and besides has had its strength attested by its survival. Nephrite has been found to occur in many of the other rivers flowing from the K'unlun Mountain, the traditional source of jade, as far east as Lake Lob. It was discovered by Russian geologists *in situ* in 1891, still further east in the province of Kansu on the north of the K'unlun range, between Kuku Nor and the Nan Shan mountains, where the nephrite was cloudy to translucent and of a light green, milk-white, or sulphur-yellow colour. This is interesting as the first record of the discovery of yellow jade *in situ*. Chinese books give Lan-t'ien in the adjoining province of Shensi as one of the sources of jade, but the supply seems to be exhausted as it is said to be no longer produced there.

With regard to the colours preferred by the Chinese the Manchu author cited above says in his description of Yarkand :—

" There is a river in its territory in which are found jade pebbles. The largest are as big as round fruit dishes or square peck-measures, the smallest the size of a fist or chestnut, and some of the boulders weigh more than five hundred pounds. There are many different colours, among which snow-white, kingfisher-feather

green, beeswax yellow, cinnabar red, and ink black, are all considered valuable; but the most difficult to find of all are pieces of pure mutton fat texture with vermilion spots, and others of bright spinach green flecked with shining points of gold, so that these two varieties rank as the rarest and most precious of jades."

In the imperial ritual worship of heaven, earth, and the four quarters, votive objects of jade are always used, arranged after an elaborate colour symbolism which reminds one of that of the ancient Babylonians. A perforated round symbol (*pi*) of cerulean tint is used in the worship of heaven, an octagonal symbol (*tsung*) of yellow jade for earth, an oblong pointed tablet (*kuei*) of green jade for the east quarter, a tablet in the form of half of the last (*chang*) of red jade for the south, a tiger-shaped symbol (*hu*) of white jade for the west, and a semicircular symbol (*huang*) of black jade for the north quarter. The jade worn by the emperor who officiates as high priest must always correspond in colour, and so must the silks and the victims sacrificed before the altars.

In the *Ritual of the Chou dynasty* jade is constantly referred to as the material used for precious vessels of all kinds, for insignia of rank worn by the sovereign and conferred by him on the feudal princes, for votive offerings and presents, and for many other objects. Special officials were appointed in charge of the jade treasury, etc. For a royal funeral they had to provide food jade (*fan yü*), a bowl of pounded jade mixed with millet for the chief mourner, (*han yü*) a carved piece of jade to put in the mouth of the corpse, and jade offerings (*tsêng yü*) in the shape of a number of perforated medallions, which were placed inside the coffin.

There are many special Chinese works on jade. The most extensive is the *Ku yü t'ou pu*, " Illustrated Description of Ancient Jade," a catalogue in 100 books, with more than 700 figures, of the collection of the first emperor of the Southern Sung dynasty, which was compiled in 1176 by an imperial commission headed by Lung Ta-yuan, President of the Board of Rites. A MS. copy of this catalogue was discovered in 1773, and the current edition was printed six years later with a preface dedicated to the Emperor

Ch'ien Lung. The following table of contents will give some idea
of its wide scope and of the large variety of objects fabricated in
jade in former times by Chinese craftsmen.

1. State Treasures, Insignia of Rank, Sacrificial Symbols, Imperial Seals.
 Books 1-42.
2. Taoist Amulets, Talismans, Charms. Books 43-46.
3. Chariot Ornaments, Official Costume Pendants. Books 47-66.
4. Apparatus for the Study. Ink-palettes, Brush-handles and receptacles,
 Ju-i Sceptres, etc. Books 67-76.
5. Censers for burning incense and fragrant woods. Books 77-81.
6. Wine Ewers, libation cups and drinking cups. Books 82-90.
7. Sacrificial Vessels and Dishes. Books 91-93.
8. Musical Instruments. Books 94-96. · .
9. Furniture, Jade Pillows, Screen Pictures, etc., including a large upright
 bowl, 4½ feet high, holding twenty gallons of wine, of white jade marbled
 with shaded greens, carved with scrolled clouds and three-clawed dragons.
 Books 97-100.

A large jade bowl, or cistern, rivalling in size the one just re-
ferred to stands in one of the courtyards of the imperial palace at
Peking. It is noticed in the travels of the celebrated friar Oderic,
who started on his long journeys through Asia in April 1318, as
related in Yule's *Cathay and the Way thither* (Vol. I. p. 130.) :—

"The palace in which the Great Khan dwells at Cambaluk (Peking) is of great
size and splendour. In the midst of the palace is a certain great jar, more than
two paces in height, entirely formed of a certain precious stone called *Merdacas*,
and so fine, that I was told its price exceeded the value of four great towns. It
is all hooped round with gold, and in every corner thereof is a dragon, represented
as in act to strike most fiercely, and this jar has also fringes of network of great
pearls hanging therefrom, and these fringes are a span in breadth. Into this
vessel drink is conveyed by certain conduits from the court of the palace; and
beside it are many golden goblets from which those drink who list."

The jar, mounted so lavishly with gold and pearls, disappeared at
the fall of the Mongol dynasty, and was stripped of its ornaments.
It was found again in the 18th century in the kitchen of a Buddhist
temple in the vicinity, where the ignorant monks were using it as
a receptacle for salted vegetables. The emperor Ch'ien Lung
bought it of them for a few hundred ounces of silver and composed
an ode in its honour to be engraved inside the bowl in which he

tells the story. It is a tall bowl with flat bottom and upright sides, shaped like one of the large pottery fish-bowls, called *yü kang*, which the Chinese use in their gardens for gold fish or lotus flowers, and is boldly carved outside with grotesque monsters and winged horses disporting in sea waves.

The Mongol emperors of Hindustan were also very fond of jade and it is well known that beautiful carvings were produced under their patronage in white and sage-green nephrites, and were often incrusted with rubies, emeralds and other precious stones, for which the soft tints of the jade afford a most effective background. The jade materials were originally imported into India from Eastern Turkestan, and were derived probably from the same districts from which the Chinese get their supplies of crude jade. After the Chinese conquest of Eastern Turkestan many of these Indian carvings were imported into Peking, and it is not uncommon to find such a piece in a European collection of characteristically delicate and graceful Indian work incised with a Chinese inscription in verse attesting its origin, and with the imperial seals of Ch'ien Lung attached. Much of the finest Chinese work was executed in the palace at Peking during his reign, and we are told that the imperial work-shops of the period included a special branch called *Hsi Fan Tso*, or "Indian School," which was devoted to the reproduction of Indian work. The jewelled jades of China, which are occasionally met with, mostly date from this period, and were perhaps mainly inspired from the same source. They are usually flat plates, intended to be mounted as small screen pictures, and are carved out of white jade and incrusted with figure scenes or other details, inlaid in rubies, amethysts, lapis-lazuli and emerald-green jadeite, cut in thin slices or set *en cabochon*, and are etched with gilded lines to complete the designs. The soft looking jade ground makes an inimitable foil for the brilliant colouring of the inlaid jewels.

The Chinese have always drawn their chief supplies of jadeite, including the precious emerald green *fei-ts'ui*, from Burma, where it is found in abundance about the headwaters of the Chindwin and Mogaung tributaries of the Irrawaddy river. It is mined by wild Kachins, bought by Chinese dealers and shipped to Canton to be carved by Chinese lapidaries. The value of the stone depends on the colouring, and especially on the lustre and brilliancy of the bright green which is irregularly distributed in flecks or veins through the white matrix, although it sometimes occurs in sufficient quantity to furnish a bead of purest emerald tint. Lavender jadeite is almost as highly appreciated, whether of uniform tint, or flecked with green ; and so also is red of translucent tone, when it occurs in a band or stratum which can be carved in openwork like a cameo, so as to reveal and contrast effectively with a background of typical shade. Another variety of Burmese jadeite is called poetically by the Chinese *hua hsüeh tai tsao,* " moss entangled in melting snow," its white crystalline matrix looking like frozen slush being veined with clouds of shaded greens. The bowl illustrated in Fig. 93 gives a fair idea of the appearance. It was selected for the illustration as an example of jadeite, and the diagnosis has been obligingly confirmed by Professor W. Gowland, who has determined its specific gravity to be 3·343.

Canton, Soochow, and Peking are the chief centres of the fabrication of jade in the present day. The sketch of the principal processes of manufacture which follows has been taken on the spot from actual observation in the workshops at Peking. It is not easy to make it quite clear without plates, but I may be permitted to mention that the various processes of work will be fully illustrated by a native artist in water colours in Mr. Heber Bishop's *magnum opus* on jade, which is shortly to be published at New York, in connection with the catalogue of the splendid collection bequeathed by him to the Metropolitan Museum.

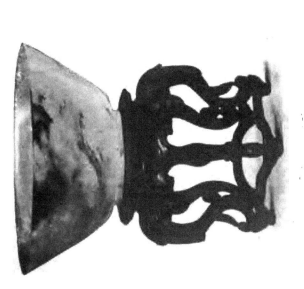

Fig. 93.—Bowl of Jadeite.
Granular Whitish Ground with Green Markings.
No. 1577-'82. H. 2¼ in., D. 5⅜ in.

Fig. 94.—Vase of White Jade (Nephrite) Shaped
as a Finger-Citron.
No. 1685-'82.
H. 4½ in., W. 4⅓ in.

CHINESE METHODS OF WORKING JADE.

The Chinese lapidary has all the tools of his art, an art which may be traced back to ancient Chaldæa and Susiana, from which it seems to have spread at some unknown period westwards to Europe, southwards to India, and eastwards to China. The modern lapidary has invented no new tools. The European craftsman only adds to the power of the old tools by the use of a continuous lathe and increasing its rapidity of revolution by means of steam and electricity; the Chinese craftsman does the same by patient industry, as he sits alone for long days beside his table, working a reciprocal treadle with his feet so as to have his hands free for glyptic work. The tools of the craft are many, but as the Chinese say, they all owe their efficiency to the biting power of the abrasives with which they are anointed. These abrasives are prepared by various preliminary processes of pounding, grinding, and sifting, and are made into pastes with water ready for use. Four kinds are used in Peking, increasing in power, being—(1) " yellow sand," quartz crystals; (2) " red sand," garnets or almandin, used with the circular saws; (3) " black sand," a kind of emery, used with the lap wheels, etc.; and (4) " jewel dust," ruby crystals from Yunnan and Tibet, with which the leather wheel is smeared which gives the final polish to the jade.

The crude block of jade is first sawn round with a four-handed toothless iron saw worked by two men, to " strip off the peel." It is next roughly shaped with one of the circular saws, a graduated series of round discs of iron with sharp cutting edge, fitted to be mounted on the wooden axle of the treadle and put by it into vertical revolution. The prominent angles left by the saw are ground down and the piece is further shaped by a set of small solid iron rings mounted in turn on the end of the same horizontal spindle, after which the striated marks of the grinding are removed by a set of little polishing wheels worked in similar fashion by the rocking pedals. The object is now shaped ready to be carved in artistic

relief with the lap wheels, or to be pierced through and through with the diamond drill and subsequently cut in open fret-work designs with the wire saw, the wire being inserted into holes pierced by the drill for the purpose.

The lap wheels, which are little iron discs like small flat-headed nails, and are consequently called " nails" by the Chinese lapidary, are hammered into the hollow end of a light iron spindle which is kept in motion by a leather strap worked by the treadles. The diamond drill is worked by hand and is kept in revolution by the usual string-bow wielded by the right hand of the operator, while he holds the jade in his left ; the cup-shaped head-piece of the drill is fixed above to a horizontal bar, on which a heavy stone weight is hung as a counterpoise to give the necessary pressure. Another phase of the diamond drill is exhibited in the boring of smaller objects, which are floated upon boat-shaped supports in a bamboo tub of water while they are being bored ; the cup-shaped head-piece of the drill now rests in the left palm of the craftsman, who keeps it pressed down as he works the string bow with his right hand.

Another instrument used by the jade worker for hollowing out the interior of small vases and the like is the tubular drill, a very ancient instrument in all parts of the world. In China it consists of a short iron tube, grooved in two or three places to hold emery paste, which is mounted on the same light iron spindle as the lap wheels. As it works it leaves behind a core, which has to be dug out by little gouges, and a number of other instruments of varied shape are provided to be worked on the same lathe, for a further scooping out of the interior of a vase that has been previously bored by the tubular drill.

The fabric of the piece of jade has now been fashioned and carved with relief designs and openwork decoration, but it still requires a prolonged polishing of the surface to bring out the intrinsic merit of the material. The harder the jade the more it will repay the

patient handiwork of the craftsman, who must carefully rub down all scratches and angles left by wheel or saw, as he follows every curve and intricacy of a complicated carving. He must go over the ground again and again to attain in hard stone the fluent lines and delusive softness of the perfect piece, which should seem to have been modelled by the most delicate touch in some soft and plastic substance. The Chinese connoisseur likens a finished work in white jade to liquescent mutton fat, or to congealed lard, shaped as it were by the fire. The polishing tools are made of fine-grained wood, dried gourd skin, and ox leather, and are charged with the ruby-dust paste, the hardest of all. For polishing the surface there is a graduated series of revolving wooden wheels, from fifteen inches in diameter downwards, which are mounted upon a wooden spindle and worked upon the reciprocal treadle lathe. For searching out the deeper interstices of the carved work there is a selection of wooden plugs and cylinders of varied size and shape fitted to hold the abrasive, down to the smallest points, which are cut out of the rind of the bottle gourd. The revolving wheels which give the final polish are bound round with ox leather stitched together with hempen thread.

ANCIENT OR TOMB JADE.—The Chinese antiquary classes ancient jade among the most precious of his archaic treasures. The object becomes gradually softened at the surface while buried underground and, at the same time, is impregnated with a variety of new colours, which the possessor delights in bringing out by gentle friction, inclosing it with bran in a silk bag, carrying it about with him in his sleeve, and at every spare moment giving a touch of extra polish to the piece. The Chinese call ancient jade *han yü*. The word *han* used here, which means "held in the mouth," was originally applied to the jade which was in former times put into the mouth of a corpse before burial, and its meaning has been subsequently extended to include all kinds of jade objects found in ancient tombs; as well as to

sacrificial vessels, insignia of rank, and amulets, which may have been accidentally buried and are afterwards unearthed. Prehistoric axes and celts of jade, made of jadeite as well as nephrite, have been discovered in many parts of China. They are commonly called *yao chan*, or "medicine spades," and are supposed to be relics of Taoist herbalists of mythological days. It may be taken for granted that the jade used in their production was generally obtained from local sources. The "jade question" which exercised the ethnological world in Europe some years since has been solved by later discoveries of material *in situ*, and it seems hardly necessary to pose a new one for China, even if we had sufficient space for its discussion.

CARVINGS IN JADE AND THEIR USES.—These cover a wide range in Chinese art. A native writer, after a description of ancient jade objects, of imperial patents and historical seals, insignia of rank, girdle buckles and other details of a mandarin's costume, coming down to the present day, proceeds with a further summary of modern carvings which may be cited here. Among the large things carved in jade, he says, we have all kinds of ornamental vases and receptacles for flowers, large round dishes for fruit, wide-mouthed bowls, and cisterns; among smaller objects, pendants for the girdle, hairpins and rings. For the banquet table there are bowls, cups, and ewers for wine; as congratulatory gifts a variety of round medallions and oblong talismans with inscriptions. Beakers and vases are provided to be frequently replenished at wine parties, a wine pot with its prescribed set of three cups for bridal ceremonies. There is a statuette of the Buddha of long life to pray to for length of days, a screen carved with the eight immortal genii for Taoist worship. *Ju-i* sceptres and fretwork mirror-stands are highly valued for betrothal gifts; hairpins, earrings, studs for the forehead, and bracelets for personal adornment. For the scholar's study the set of three (*san shih*), tripod, vase, and

FIG. 95.—IMPERIAL JU-I CARVED WITH DRAGON AND PHŒNIX.
No. 1567-'82.

L. 12¼ in.

U

box, is at hand for burning incense ; for more luxurious halls sculptured flowers of jade and jewels in jade pots are arranged in pairs, displaying flowers appropriate to the current season of the year. Combs of jade are used to dress the black tresses of beauty at dawn, pillows of jade for the divan to snatch a dream of elegance at noon. Rests for the writer's wrist lie beside the ink pallet, weights are made for the tongue of the dead laid out for the funeral. Rouge pots and powder boxes provide the damsel with the bloom of the peach, brush pots and ink rests hold the weapons of the scholar in his window. The eight precious emblems of good fortune—the wheel of the law, conch-shell, umbrella, canopy, lotus-flower, jar, pair of fish, and endless knot—are ranged on the altar of the Buddhist shrine ; pomegranates bursting open to display the seeds, sacred peaches, and Buddha's hand citrons, appear as symbols of the three all-prayed-for abundances—of sons, of years, of happiness. Linked chains of jade are tokens of lasting friendship, jade seals attest the authenticity of important documents. There are beads for the rosary to number the invocations of Buddha, paper-weights for the writing-table of the scholar, tassel ornaments for the fan screen hiding the face of the coquette, and keyless locks of jade for clasping round the necks of children. Among other things may be mentioned mortars and pestles for pounding drugs, thumb rings for protecting the hand of the archer from the recoil of the bowstring; jade mouthpieces for the pipes of tobacco smokers, and jade chopsticks for gourmands.

The work of the glyptic artist in jadeite, the *fei-ts'ui* of the Chinese, covers much the same ground, but the objects produced are smaller and rarely measure a foot either in height or breadth. A set of incense burning apparatus carved in lustrous white jadeite richly flecked with emerald green is valued at 10,000 ounces of silver, a pair of bangles at 1,000, and an archer's thumb-ring of fine " water " is almost as costly. Snuff bottles are cunningly cut, cameo fashion, out of pebbles with variegated layers into designs suggested

by the natural veining of the stone, and stoppered with buttons
of contrasted tone fitted underneath in the usual way with little
spoons of ivory. The eighteen small beads and other appendages
of the official rosary are preferably made of jadeite, so is the tube
for the peacock's feather worn in the hat of the decorated mandarin,
and hair-pins of infinite variety figure in the headdress both of
Manchu and Chinese ladies, besides flowers and butterflies of
fei-ts'ui sewn on bands of velvet. In the courtyard of the palace
at Peking, he concludes, melons carved in jadeite are hung on
trellis-work in the midst of artificial foliage, and vases of curiously
naturalistic form have been fashioned in the imperial workshops
there simulating growing cabbages or whorls of palm leaves.

The vase of white jade in Fig. 94 illustrates the fancy of the
Chinese for natural forms, being modelled in the shape of a branch-
let of the Buddha's-hand citron (Citrus decumana) carrying fruit
and foliage. Another favourite form for a vase is the blossom of
the Magnolia Yulan, the white jade being highly polished to emulate
the peculiar pulpy whiteness of the petals of this beautiful flower.
The *ju-i* sceptre, which has been already alluded to, derives its
peculiar form from the sacred fungus called *ling-chih*, the *Polyporus
lucidus* of botanists, one of the many Taoist emblems of longevity.
The sceptre from the Wells Bequest shown in Fig. 95 is made of
white jade, mottled at one end and marked with a spot of red. It
is carved in relief with an imperial dragon in clouds coiling round
the handle in pursuit of a flaming disc poised on the rim of the
blade, and opposite with a phœnix which is projected in undercut
relief on the top of the blade. A rosary is shown in Fig. 96, which
was brought from the Summer Palace near Peking in 1860. It is
composed of 108 amber beads divided by three large beads of
emerald green jadeite, and three strings of small corundum beads
ten in each, with a central plaque and pendants of jadeite mounted
in silver gilt inlaid with blue kingfisher plumes.

The magnificent brush cylinder (pi-t'ung) of white jade seen in

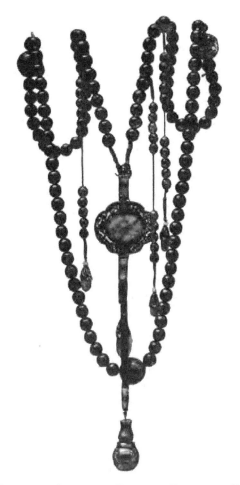

FIG. 96.—ROSARY OF AMBER AND CORUNDUM BEADS WITH PLAQUES
AND PENDANTS OF JADEITE.
No. 1126-'74.

Fig. 97, and the jade vase which follows in Fig. 98, are also part of the valuable Wells Bequest to the Museum. Both pieces are deeply and artistically carved in undercut relief with occasional pierced openwork. The *brush pot* is decorated with mountain scenes enlivened with pines, dryandras and blossoming prunus trees, repre‑senting the end of the expedition of King Mu of the Chou dynasty to the far west ; in the background his eight celebrated chariot horses (pa chün ma) are returning to their grazing grounds ; in the foreground the baggage oxen are seen being led back to their stalls. The *vase* is enveloped with berried plants, Polyporus fungus heads, and wild chrysanths, springing from open rockery, revealing the archaic form of a three-clawed lizard-like dragon (chih lung) emerging from the meshes ; it is effectively posed on a stand of olive-green jade carved with a floral decoration of the same character.

The stately twin-cylinder vase of white jade illustrated in Fig. 99 is taken, with permission, from Mr. G. Salting's fine collection. It is modelled in the lines of one of the ancient bronze receptacles for arrows which used to be given as rewards for military prowess under the name of champion vases. The grotesque monsters of fabulous mien which figure as supporters of the cylinders are in‑tended to represent an eagle (ying) perched upon the head of a bear (hsiung), suggesting in a punning way the words *ying-hsiung*, or " champion," and thus giving a honorific name to the vase. The coiled dragon which spans the twin covers, the looped handles at the back, and the details of the banded decoration of the two cylinders are all of archaic bronze design.

The vase and cover illustrated in Fig. 100 is a typical example of the dark green nephrite called *pi yü*, which came from the Summer Palace, Peking, in 1860. Of oblong section, with rounded projecting corners ending in circular feet, it has two looped dragon handles holding loose rings. The body is carved in low relief with encircling bands of fret, and with six longevity (shou) characters below, each

one flanked by serpentine dragons. The cover is surmounted by five archaic dragons executed in pierced work.

The carved stone slab in Fig. 101, though not of jade, shows one of the usual motives of the jade carver, and the ordinary way of mounting his work as a screen picture. The carving here is executed in steatite of three strata. The composition represents the paradise of the Taoist, the hill of immortality (*shou shan*) covered with pavilions towering into the clouds from the isles of the blessed, surrounded on all sides by the cosmic ocean; a pair of storks is seen flying across the clouds above, one of the birds carrying a rod of fate in its beak.

CARVINGS IN OTHER HARD STONES.—Albert Jacquemart, who was an enthusiastic admirer of the artistic merits of *jadeite*, in his criticism of lapidary art, describes it under the name of *jade impérial* as a peerless gem, almost rivalling an uncut emerald when green, and more effective than the richest of agates when variegated with mingled shades of green and white. The subtle attractions of *nephrite* are not so apparent to the European eye as they are to the Chinese. The purest jade, as M. Paléologue observes, possesses intrinsically neither the brilliancy of rock-crystal, nor the varied colouring of carnelian, nor the rich tints of the sardonyx, nor the luminous iridescence of the onyx and oriental agate; the waxy lustre which is its peculiar quality allows only, on the contrary, to the most delicate and finished work, a certain vague translucency, which leaves it dull beside the quartz stones with their rich varied tones and vibrating play of colour. These last stones, it may be added, are by no means unappreciated by the Chinese, who work them on the same treadle bench and in the same lines of glyptic art as jade, so that they need only be briefly noticed here and illustrated by one or two examples selected from the Wells Bequest to the Museum.

A beautiful double vase of rock-crystal artistically carved in relief with openwork is shown in Fig. 102. The smaller vase of rustic shape fashioned in the form of the trunk of a pine, spreads

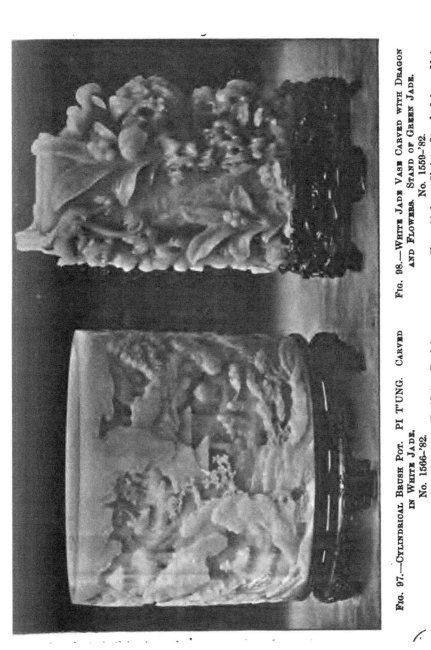

FIG. 97.—CYLINDRICAL BRUSH POT. PI T'UNG. CARVED
IN WHITE JADE.
No. 1566-'82.

H. 6⅞ in, D. 8 in.

FIG. 98.—WHITE JADE VASE CARVED WITH DRAGON
AND FLOWERS. STAND OF GREEN JADE.
No. 1550-'82.

Vase, 8¼ in. × 5⅜ in.; Stand, 6 in. × 3¼ in.

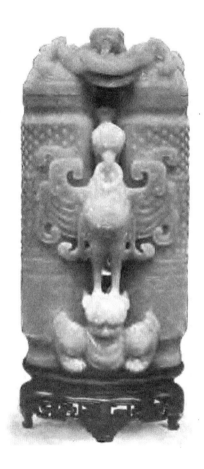

FIG. 99.—JADE HONORIFIC VASE OF TWIN CYLINDER FORM.
In the Salting Collection.

H. 11½ in., W. 4¾ in.

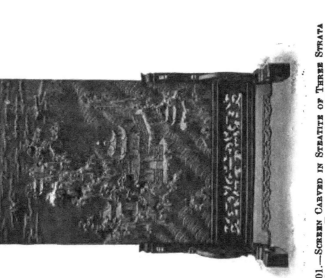

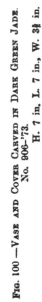

FIG. 100 —VASE AND COVER CARVED IN DARK GREEN JADE.
No. 906·'73.

H. 7 in, L. 7 in., W. 3¼ in.

FIG. 101.—SCREEN CARVED IN STEATITE OF THREE STRATA
WITH A TAOIST SCENE. No. 1071·'52

H. 1 ft. 11 in., W. 1 ft. 3 in.

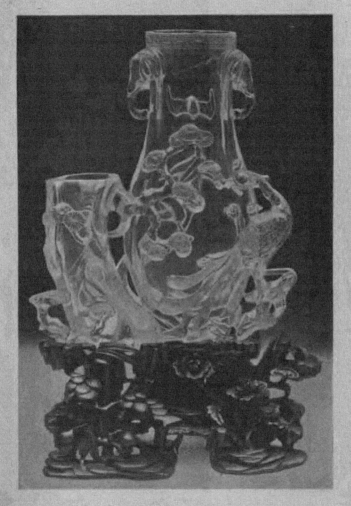

FIG. 102.—DOUBLE VASE OF ROCK CRYSTAL.
Carved with Elephant-Head Handles, Phœnix, Bat, and Symbolical Foliage.
No. 1610–'82.

H. 8¼ in., W. in.

out branches to decorate the sides of the larger ovoid vase, which has elephant-head handles, and is balanced by a phœnix holding a branch of sacred fungus in its beak. The base is filled in with fungus heads and bamboo sprays, a flying bat in the background shows through in the picture, and a light band of rectangular fret round the rim finishes the decoration. The stand is carved in rosewood with symbolical floral designs of the same character.

The group of three Taoist figures in Fig. 103 is carved in rock crystal tinged green with chlorite. It represents Shou Lao, the deity of longevity, an aged figure with protuberant brow and flowing beard, holding a *ju-i* sceptre in his hand, accompanied by two youthful attendants, one carrying a sacred peach, the other a branch of Polyporus lucidus, the constant attributes of the deity.

The vase of red and variegated white agate reproduced in Fig. 104 is carved into a cluster of three fishes, two of which are perforated to hold water. The fishes, posed erect upon a wood stand carved with waves, are represented in the act of springing into the air to become dragons, the transformation being indicated by their horned heads and sprouting limbs. A fish dragon vase, *yü lung p'ing*, of this kind is a favourite shape for the scholar's table, inciting him by its symbolism to further study. The well-worn story has it that the fish becomes a dragon by succeeding at last after persevering efforts in scaling the cataracts of the Yellow River at the Dragon Gate, and is lauded as a type of the successful scholar, who gets his name inscribed at the competitive examination for degrees on the Dragon List, which is the first step in the ladder of official rank in China.

Milton Keynes UK
Ingram Content Group UK Ltd.
UKHW021845180823
427137UK00004B/134